About this book This provocatively 'short' history of the shadow opens with a reappraisal of the contribution to the subject that can be teased out from comments by Pliny the Elder and Plato. Pliny's myth of the origin of art, which identifies the birth of artistic representation as having taken place in a Corinth potter's home, and Plato's myth of knowledge, set forth by the philosopher in the celebrated allegory of the cave, both deal with the shadow – the dark spot that by its presence confirms an absence. But the shadow can also be understood to be the present 'other' of the body, a fact enforced by the rule of light, so that the shadow can even be seen to be a form of self-representation. Indeed, according to J. C. Lavatar in the 18th century, it was the shadow of the face, not the face itself, that was the soul's true reflection.

In our own century, German Expressionist film-makers have used shadow metaphorically to give added – often malevolent – meaning to the nature of 'projection'. More recently, Andy Warhol, in his 66 *Shadows* canvases, and Joseph Beuys, in a shamanic Happening photographed as *Action Dead Mouse*, have in turn explored the idea of the shadow as the hyper-realized revelation of utter human emptiness and as the self's awesomely powerful *doppelgänger*.

Victor I. Stoichita explores these recent engagements with the nature of the shadow by way of the myth of Narcissus, writings on art by Alberti, Vasari and others, a self-portrait by Poussin, a lake-garden by Monet, and many further curious and absorbing undertakings made by artists since Antiquity. The result is a wholly original and compelling invitation to reconsider the very basis of representation in Western art.

About the author Victor I. Stoichita was educated in Bucharest, Romania, and later gained both a PhD from the University of Rome and a Doctorat d'Etat from the Sorbonne in Paris. He is currently Professor of History of Art at the University of Fribourg, Switzerland. His publications include *Visionary Experience in the Golden Age of Spanish Art* (Reaktion, 1995) and *The Self-Aware Image* (1997).

A Short History of the Shadow

Victor I. Stoichita

REAKTION BOOKS

Published by Reaktion Books Ltd
79 Farringdon Road, London EC1M 3JU, UK

First published 1997, reprinted 1999

Translated by Anne-Marie Glasheen

Cover and text designed by Humphrey Stone
Photoset by Wilmaset Ltd, Birkenhead, Wirral
Printed in Great Britain by
BAS Printers, Over Wallop, Hampshire

British Library Cataloguing in Publication Data:

Stoichita, Victor I.
 A short history of the shadow. - (Essays in
 art and culture)
 1. Shades and shadows 2. Perspective 3. Shadows
 in art

 I. Title
 701.8'2

ISBN 1 86189 000 1

Published with the contribution of the Council of
the University of Fribourg, Switzerland

Contents

Introduction

We know very little about the birth of painting, said Pliny the Elder in his *Natural History* (xxxv, 14). One thing, however, is certain: it was born the first time the human shadow was circumscribed by lines. It is of unquestionable significance that the birth of Western artistic representation was 'in the negative'. When painting first emerged, it was part of the absence/presence theme (absence of the body; presence of its projection). The history of art is interspersed with the dialectic of this relationship.

At the time that Pliny was outlining his treatise (during the first century AD), the pictorial image was already – and had been for some time – more than just the outline of a dark spot. The shadow had been integrated into the area of a complex representation to suggest the third dimension – volume, relief, the body. Initially (to the author of the *Natural History* as well as to his artistic contemporaries) the shadow–image was no more than a distant memory, a half-mythical, half-historical fact, a sign of its origins that had to be perceived (or recognized) but which was constantly evaded: what – asked one of Pliny's contemporaries – would have been the result if no one had done more than his predecessors? The reply was: 'the art of painting would have been restricted to tracing a line round a shadow thrown in the sunlight' (Quintilian, *Institutio oratoria*, x, ii, 7).

This inaugurative statement, borne out by several sources, can be compared to another account, one that establishes the Western theory of knowledge: Plato's myth of the cave. Plato imagines primitive man imprisoned in a cave (*The Republic*, 517–19); he can do no more than stare at the back of his prison – on the wall of which are projected the shadows of an external reality, the existence of which he does not even suspect. Only by turning around and facing the world of the sun can he gain access to real knowledge.

Pliny's and Plato's myths are parallel accounts that do not communicate on the level of discourse but which facilitate a dialogue on the hermeneutic level. If they have never been

studied together, it is probably due primarily to the highly risky nature of such an enterprise. Plato and Pliny speak of different things within different contexts. However, several factors would justify their being read as a dialogue: they both deal with myths of origin (with Pliny the myth of art and with Plato the myth of knowledge); the myth regarding the birth of artistic representation and the one regarding the birth of cognitive representation are centred on the motif of projection; this early projection is a dark spot – a shadow. Art (real art) and knowledge (real knowledge) are its transcendence.

The relationship with the origins (the relationship with the shadow) characterizes the history of Western representation. This book aims to trace the milestones of that history. Since it is the study of a negative entity it should come as no surprise that little has been said about it so far. In fact, this is the first time such an inquiry has been undertaken in any coherent way. Our conception of history – Hegel's, that is – and our conception of representation – Plato's in fact – have enabled and encouraged us to approach the *history of light*[1] from different angles but have circumvented the possibility of a *history of the shadow*, and it was Hegel himself who indirectly delineated the nature of this ambiguity:

> But one *pictures* being to oneself, perhaps in the image of pure light as the clarity of undimmed seeing [*die Klarheit ungetrübten Sehens*], and then nothing as pure night – and their distinction is linked with this very familiar sensuous difference. But, as a matter of fact, if this very seeing is more exactly imagined, one can readily perceive that in absolute clearness [*in der absoluten Klarheit*] there is seen just as much, and as little, as in absolute darkness, that the one seeing is as good as the other, that pure seeing is a seeing of nothing. Pure light and pure darkness are two voids which are the same thing. Something can be distinguished [*unterscheiden*] only in determinate light or darkness (light is determined by darkness and so is darkened light, and darkness is determined by light, is illuminated darkness), and for this reason, that it is only darkened light [*getrübtes Licht*] and illuminated darkness which have within themselves the moment of difference and are, therefore, *determinate* being [*Dasein*].[2]

Consequently, it is only from a strictly Hegelian viewpoint that the study of the relationship between shadow and light

can be fully justified. In terms of pictorial representation, we could say that only a history of *chiaroscuro* has any chance of success.[3] Moreover, to study only the shadow within this perspective would entail a double challenge targeting the positive representation of light as a positive absolute given being as well as the light–darkness dialectic. However, the history of the shadow is not the history of nothingness. It is one way of gaining access to the history of Western representation through the door revealed by the myths of origin themselves. In accordance with the point of departure outlined by these two different but parallel accounts (Pliny's on painting and Plato's on knowledge), this book can be placed where the history of artistic representation and the philosophy of the representation converge, hence the difficulties the author was forced to confront.

Recent studies on the history of art have drawn attention to the need for an in-depth approach.[4] There are other early writings that provide us with food for thought, even today, when it comes to the scientific projection of the shadow in painting or its symbolism.[5] But it is anthropology that seems to have outstripped the endeavours of all the other disciplines, since the most significant contributions made to understanding the importance of the shadow to the primitive mind date from the beginning of our own century.[6] And yet, what is still missing is any real attempt to establish, at the risk of a multiple focalization, the place occupied by reflections on the shadow at the heart of the discourse on representation in Western culture. Aware of the risk, the author has nevertheless undertaken this task. This was facilitated by friends and colleagues who offered encouragement, facts and the chance to discuss the issues that emerged: Oskar Bätschmann, Astrid Börner–Nunn, Helmut Brinker, Caroline Walker Bynum, Matei Candea, Christa Döttinger, Thierry (and Claire) Lenain, Didier (and Grazia) Martens, Serguisz (and Kasa) Michalski, Reinhard Steiner, Anca Vasiliu, Susann Waldmann, Jeannette Zwingenberger. Catherine Schaller, Anita Petrovski and Loyse Revertera provided assistance when it came to documentation, thus shortening the time of the book's gestation. The ideal working conditions provided by the Library of the Zentralinstitut für Kunstgeschichte in Munich were indispensable, as was the congeniality of the staff (here I would like to mention Dr Thomas Lersch in particular), without whom this book

9

would never have reached a happy conclusion. The manuscript benefited enormously from having been carefully and constructively read by Victor Alexandre Stoichita, Catherine Candea, Elena Lupas, William W. Bellis, Didier Martens and Thierry Lenain. Finally, I would like to thank my family for their unwavering understanding and support. I dedicate this book to my wife Anna Maria and our children Pedro and Maria, in memory of our 'shadow hunts' and our walks in Ecuvillens.

1 The Shadow Stage

Let us begin by turning to Pliny:

> The question as to the origin of the art of painting is uncertain and it does not belong to the plan of this work. The Egyptians declare that it was invented among themselves six thousand years ago before it passed over into Greece – which is clearly an idle assertion. As to the Greeks, some of them say it was discovered at Sicyon, others in Corinth, but all agree that it began with tracing an outline around a man's shadow and consequently that pictures were originally done in this way, but the second stage when a more elaborate method had been invented was done in a single colour and called monochrome, a method still in use at the present day (*Natural History*, XXXV, 15).[1]

He retraces his steps a little further on:

> Enough and more than enough has now been said about painting. It may be suitable to append to these remarks something about the plastic art. It was through the service of that same earth that modelling portraits from clay was first invented by Butades, a potter of Sicyon, at Corinth. He did this owing to his daughter, who was in love with a young man; and she, when he was going abroad, drew in outline on the wall the shadow of his face thrown by the lamp. Her father pressed clay on this and made a relief, which he hardened by exposure to fire with the rest of his pottery; and it is said that this likeness was preserved in the Shrine of the Nymphs ... (*Natural History*, XXXV, 43).[2]

Let us endeavour to summarize Pliny's assertions. The very fact that in his book he twice returns to the same myth is thought provoking. In the first extract the author discusses the origins of painting and in the second that of sculpture. It would therefore seem likely that artistic representation in

general can be traced back to the primitive shadow stage. These origins (*initiis*) are defined as 'uncertain' (*incerta*), in other words he acknowledged their mythical nature. History (6000 years) and geography (Egypt) appear to cast doubt on the origins. Pliny's aim was to shed light on this 'uncertain' origin through a founding account free of any precise temporality. In the first fragment (xxxv, 15), which deals exclusively with painting, we are told how it began (*picturae initiis*) with the encircling of a shadow (*umbra hominis lineis circumducta*). This example is evoked in order to weaken, if not invalidate, the hypothesis that the roots of Greek art were to be found in Egypt. According to legend, both to the Egyptians and the Greeks (*omnes*), painting originated *ille tempore* from shadow. Reading between the lines, what Pliny said was this: the Greeks discovered painting, not by looking at Egyptian works of art but by observing the human shadow.

The primitive nature of the first act of representation described by Pliny resides in the fact that the first pictorial image would not have been the result of a direct observation of a human body and its representation but of capturing this body's projection. The effect of the shadow is to reduce the surface volume. In Pliny's opinion, this first and fundamental method of transposition and reduction was therefore restricted to nature itself. Initially, there was no intervention on the part of the artist. A representation of a representation (an image of the shadow), the first painting was nothing more than a copy of a copy. In Pliny's text, the Platonism of this conclusion is, however, only implicit.

It is not difficult to detect in the myth recounted in the *Natural History* a kind of three-part theory: early Greek painting, Egyptian painting, the shadow. If the author is able to play around with these three parts by inverting their relationship, it is because of the presence, within the three elements of the theory, of representation through two-dimensional projection. It is through this that Pliny interprets the conventions of the early image. The perfect profile of the Egyptian painting (illus. 1) and that of the archaic Greek one (illus. 2) are the product of a projection that excludes foreshortening and which involves conventions such as that of the shoulder in the background being level with the one in the foreground or that of the face being represented in profile but with an eye seen from the front.

1 The soul and the shadow coming out of the grave at daybreak, *c.* 1400 BC, papyrus of Neferoubenef, Musée du Louvre, Paris.

2 Attic black-figure pyxis, *c.* 580–570 BC. Musée du Louvre, Paris.

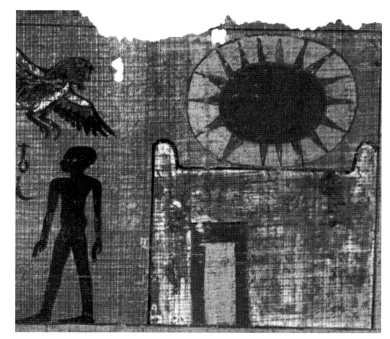

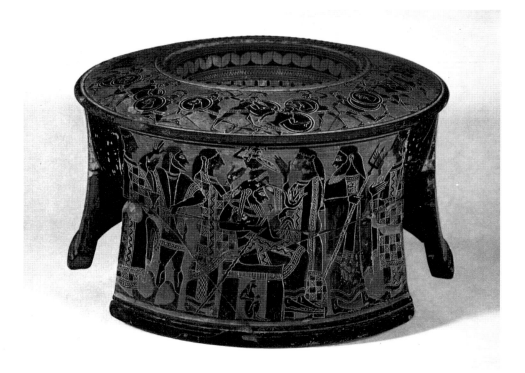

The first conclusion to be drawn from this interpretation is that Pliny's approach can be placed at the crossroads of history and artistic mythology. The author, no doubt familiar with an advanced pictorial form such as that found in Pompeian art (Pliny died in AD 79, the year Vesuvius erupted), explained early art, I mean Egyptian art, then ancient Greek art and the black figures on a red background through the fable of the outlined shadow. The fable uses a myth of origin to interpret a historical fact (early painting).

In the final part of Pliny's text there are clues to the crucial stages in the evolution of painting from the early 'shadow stage' to its great achievements. We learn that the basic contour of the shadow was quickly replaced by a mono-chrome painting that was gradually perfected, although the signs of its mythical origins were never completely erased. Somewhere else (xxxv, 11), Pliny tells us that it would not be until the advent of the great artists that the stereotype of the flat projection would at last be replaced by relief and that shading would abandon its primary function as a matrix of the image to become a means of expression:

> Eventually art differentiated itself [se ars ipsa distinxit], and discovered light and shade, contrasts of colours heightening their effect reciprocally. Then came the final adjunct of shine, quite a different thing from light. The opposition between shine and light on the one hand and shade on the other was called contrast [tonon], while the juxtaposition of colours and their passage [commissuras] one into the other was termed attunement [harmogen].

In Quintilian's opinion, it was Zeuxis (Institutio oratoria, 12, x, 4) who was responsible for inventing the rational relationship between light and shade (ratio umbrarum et luminum).

While in the first passage (xxxv, 15) Pliny considers the shadow as the origin of pictorial representation, in the second (xxxv, 43) he omits the discourse on the two-dimensionality of pictorial representation in order to concentrate on the art of volumetric shapes, that is that of sculpture. The second extract of the Natural History offers a rich scenario able to provoke a chain reaction in the mind of the reader. But in the final analysis, nothing in this account is certain; it is mysterious and nocturnal, leaving everything in it wide open to conjecture. The author does not explain why the young woman moulds

the image of her lover, why her father gives it the volume it lacks, or, finally, why this likeness is placed in the temple. Equipped with the tools of the myth's hermeneutic, we can however hazard a hypothetical interpretation focused on the magical function of the process depicted.

The event that inspired the first semblance to be created was the departure of the loved one. The legend does not tell us why he was leaving nor where he was going, it only tells us that he had to travel a long distance (*abeunte illo peregre*). The shadow helps the young woman capture (*circumscripsit*) the image of her departing lover by creating a replacement. The issue raised here is considerable, for in fact it highlights a metaphysical quality of the image whose origins should be sought in the interruption of an erotic relationship, in a separation, in the departure of the model, hence the representation becomes a substitute, a surrogate.

It should come as no surprise therefore that a century after Pliny, another author, Athenagoras, recounts the same story thus:

> The manufacture of dolls was inspired by a young woman: very much enamoured of a man, she drew his shadow on the wall as he slept; then her father, charmed by the extraordinary likeness – he worked with clay – sculpted the image by filling the contours with earth.[3]

What is fairly apparent from both texts is that the primary purpose of basing a representation on the shadow was possibly that of turning it into a mnemonic aid; of making the absent become present. In this case the shadow's resemblance (*similitudo*) to the original plays a crucial role. Another possible function stems from the fact that the image/shadow is *somebody's* image; it both resembles and *belongs* to the person whose image it is. The constantly changing real shadow of the beloved man will escort him on his travels, while the image of his shadow, captured on the wall, will remain a memento opposed to the movement of the journey and therefore will have a propitiatory value. The real shadow accompanies the one who is leaving, while his outline, captured once and for all on the wall, immortalizes a presence in the form of an image, captures an instant and makes it last.

In support of this interpretation it should be noted that Pliny's text describes an authentic method of projection

capable of *verticalizing* the shadow. Unlike the other variations of the myth (see the first extract from Pliny and the one from Quintilian's *Institutio oratoria*), this last one says that the beloved's face (*facies*) was projected onto a wall (*in pariete*) with the help of a lamp (*lucerna*). Two vital functions of this surrogate image are thus brought together: the likeness (which is essentially a question of 'face') and its verticality. The projection casts the shadow and it is the cast shadow that provides the support for the final resemblance (*similitudo ex argilla*). This first creation therefore (in Athenagoras' case, the first doll) is not, at least as far as Pliny is concerned, a recumbent figure of any sort (a notion, in fact, alien to the spirit of Greek art). On the contrary, it is a statue (*statua*), i.e. an upright figure. The lapidary details pertaining to the mechanism of verticalization are extremely important, since Pliny would certainly have been aware – as more than one passage from his work indicates – of a whole early metaphysics on the shadow (particularly on the shadow recumbent on the earth) and of its links with death.[4] On close examination the text reveals its hidden meaning: on the eve of her beloved's departure, Butades' daughter 'captured', so to speak, the image of her lover in a verticality meant to last forever. Thus she exorcized the threat of death, and his image – making up for his absence – kept him for ever 'upright', i.e. 'alive'.

It is easy to see these lines as a mixture of erotic exorcism[5] and propitiatory practice, undertaken to avert the death of the departed loved one. But Pliny's text immediately raises an additional question, for it specifies that the potter's daughter outlined only her beloved's face on the wall (*umbram ex facie eius*); it makes no mention of the outline of the whole body. Is this an oversight or, at this stage of the representation, is the ellipsis of the body intentional? For it is a well-known fact that Pliny combined several sources without always having understood them completely.[6] Consequently, any attempt at interpretation is fraught with serious difficulties. We should also take into account the fact that, to Athenagoras, the statue/doll seemed to reproduce the whole of the young man's body, that in the first of Pliny's extracts (*Natural History*, xxxv, 15) it is generally stated that painting 'began with tracing an outline round a man's shadow' (*umbra hominis*), and that, more or less at the same time, Quintilian

specified unequivocally that this procedure involved bodily shadows thrown in the sunlight (*umbrae quam corpora in sole feciessent*). It would seem, therefore, that the Plinian scenario illustrates a particular variation that gives us no opportunity to explain changes that might be attributable to chance or, on the other hand, that might be concealing a particular meaning. Be that as it may, let us attempt to examine this text more closely.

Pliny tells us that the enamoured (*capta amore*) young woman's initial idea (*primus invenit*) was to capture the image by outlining the shadow. The representation at this first stage is comparable to a double 'un-realization'. We are told, in fact, that the young woman did no more than keep her lover's shadow near her. The shadow projects the model onto the wall and reduces the being to an appearance. This shadow is not 'the body', it is by double virtue the *other* of the body (like a 'spectre', like a 'head').

The intervention of the father (the potter Butades) endows this fantasy with a new reality. These lines, which would probably have been of great interest to Freud, are however not without ambiguity. The father gives the spectre a consistency. He places clay where there was nothing but the outline of a shadow; he gives the shape a relief (*typum fecit*) and then hardens the form in the fires of his kiln (*induratum igni*). The first level of realization of this early un-realization is thus attained. The shadow now has consistency.[7] What Pliny does not state clearly, though, is whether in the course of this process of 'completion' Butades gives his daughter's fantasy a body as well as volume. A literal interpretation of Pliny's text (contradicted, however, by Athenagoras' 'doll') would lead us to conclude that Butades created a kind of medallion in relief portraying the head of his daughter's lover. In the following sentence Pliny goes on to specify that this figure (*typus*) was placed in the kiln 'with the rest of his pottery' (*cum ceteris fictilibus*), as though it were a pot. This scenario would indicate that the birth of clay modelling and that of the painted image are one and the same, the link being the potter's workshop.[8] A moment later he goes on to formulate the following interpretational hypothesis: not only is Butades' intervention a tangible step (the potter gives volume to the flat image of the attached shadow) but it is also a symbolic step. The 'clay likeness' (*similitudo ex argilla*) made by Butades

conforms to a famous poetic topos, reliably illustrated by Cicero in his *Tusculan Disputations* (I, 52):

> the body is as it were a vessel or a sort of shelter for the soul (*corpus quidem quasi vas est aut aliquod animi receptaculum*).

In his classic study on the cult of the soul, Erwin Rohde unequivocally demonstrated how the Greeks symbolically linked shadow, soul and a person's double.[9] If these links still work for Pliny, as I think they do, this would indicate that the result of the collaboration between the potter and his daughter was the symbolic creation of a 'living' double, a surrogate figure difficult to understand without visualizing the ritual actions we exert over it. And indeed, this hypothesis becomes meaningful through the clay likeness being transferred to the temple at Corinth, as mentioned by Pliny. However, there is room in the text for further speculation, which can only be resolved by reading between the lines. One is led to surmise that the Plinian relationship is based on an earlier text, summarized or only partially quoted by the author. But by so doing, Pliny has probably sacrificed the genuine temporality of the account, which originally might have consisted of several stages. I do not think I am mistaken if I say that in this act of temporal compression, Pliny has eliminated an important episode located somewhere between the young woman creating the silhouette and the final likeness being installed in the temple. This episode, without which the meaning of the extract is greatly diminished, is the death of the beloved.

Since I have already taken more than one risk in the interpretation I am advancing, I should like to go one step further and suggest that the episode of the lover's death would have taken place prior to the intervention of the potter. For the sake of clarity, the whole story should have progressed as follows:

1. The girl creates a surrogate image, which has a dual purpose: it must remind her of the face of the lover who is leaving (to go to war) and must exorcize the danger he is in.

2. The young man dies (probably heroically, probably on the battlefield). This episode does not appear in the text.

3. (Because the beloved dies) the father creates a

semblance (*similitudo ex argilla*) whose function is to duplicate the one who has disappeared. This double has a 'soul' (in the form of a shadow) and a 'body' (in the form of the receptacle of this soul).

4. The clay semblance becomes a cult object in the temple at Corinth.

If this is not the case then I can find no other valid reason to explain the development of the plot that in the extract from the *Natural History* leads from the nocturnal capturing of the shadow to the temple.

If we accept this interpretation of Pliny's story, it becomes clear that the fable simply moulds the great story into a myth. For the story recounted by Pliny as a legend is in truth the story of the surrogate image. This true story (related as a fable by Pliny) begins in Egypt (as acknowledged by the first of the extracts from the *Natural History*, xxxv, 15) and bears all the hallmarks of Pliny's myth: shadow, double, death. Let us attempt a brief reconstruction of this 'great story', rejected by Pliny in favour of the fable.

Egyptologists and Hellenists agree that in Egypt as well as in Greece, the statue stood in for either a god or a dead person.[10] The statue as a substitute for a deceased person was destined to be considered as being alive. The famous Egyptian *ka* was the soul of the statues representing death. As Maspéro reminds us in his classic study, the shadow was how the Egyptians first visualized the soul (*ka*). In this case it was a 'clear shadow, a coloured projection, but aerial to the individual, reproducing every one of his features'. And the black shadow (*khaïbit*), having been regarded in even earlier times as the very soul of man, was subsequently considered to be his double.

The relationship between the two variations of the shadow is interchangeable: while the man is alive his black shadow is an externalization of his being. Disappearing the instant he dies, the function of the double is taken over by the *ka* as well as by the statue on the one hand and the mummy on the other.[11] It is in Greece that we see the crucial translation of this notion of the double. Jean-Pierre Vernant has studied the relationship between the ancient funereal figure and the theme of the noble death (*kalos thanatos*), 'that which ensures the young warrior – who, in the prime of life, falls on the

battlefield – everlasting glory by immortalizing what he was in the eyes of subsequent generations: his name, his exploits, his career, the heroic end that establishes him once and for all as a man of excellence, one of the noble dead (*agathos anér*)'.[12] It is in the light of these considerations that I think the elliptical Plinian legend must be understood, particularly its ending, which suggests a cult of the 'clay semblance' that reproduces, includes and accommodates the 'shadow' of the young man, who in all probability is forever absent.[13]

It will therefore be necessary to recognize in the double that Butades fashioned from the shadow, a *colossus* (in the ancient sense of the word) that was in no way indicative of its size but which betokened something that had been erected, raised, something that was durable and alive.[14] On the other hand, the silhouette traced by the young woman was only an *eidolon*, an image without substance, the intangible, immaterial double of the one who was leaving. Once the image is captured on the wall, time stands still. The *shadow/time* relationship as illustrated by the nocturnal scenario in Pliny's version of the myth (which contrasts sharply with the diurnal, solar version related by Quintilian) is formulated in a very characteristic manner: a shadow in sunlight denotes a moment in time and no more than that, but a nocturnal shadow is removed from the natural order of time, it halts the flow of progress.

Pliny's fable appertains to the origins in as much as it extends and offers an alternative to the Egyptian metaphysics of the image. It is its substitute because it recounts an adventure that belongs, in essence, to ancient Greece, and which the author of the *Natural History* does not embrace in its entirety since it was a question of the *colossus* incorporating the *eidolon*.

'SHADOWS, REFLECTIONS AND ALL THAT SORT OF THING'

'Imagine an underground chamber, like a cave with an entrance open to the daylight and running a long way underground. In this chamber are men who have been prisoners there since they were children, their legs and necks being so fastened that they can only look straight ahead of them and cannot turn their heads. Behind them and above them a fire is burning, and between the fire and

the prisoners runs a road, in front of which a curtain-wall has been built, like the screen at puppet shows between the operators and their audience, above which they show their puppets.'

'I see.'

'Imagine further that there are men carrying all sorts of gear along behind the curtain-wall, including figures of men and animals made of wood and stone and other materials, and that some of these men, as is natural, are talking and some not.'

'An odd picture and an odd sort of prisoner.'

'They are drawn from life,' I replied, 'For, tell me, do you think our prisoners could see anything of themselves or their fellows except the shadows thrown by the fire on the wall of the cave opposite them?'

'How could they see anything else if they were prevented from moving their heads all their lives?'

'And would they see anything more of the objects carried along the road?'

'Of course not.'

'Then if they were able to talk to each other, would they not assume that the shadows they saw were real things?'

'Inevitably.'

'And if the wall of their prison opposite them reflected sound, don't you think that they would suppose, whenever one of the passers-by on the road spoke, that the voice belonged to the shadow passing before them?'

'They would be bound to think so.'

'And so they would believe that the shadows of the objects we mentioned were in all respects real.'

'Yes, inevitably.'[15]

There is probably no other story in the whole history of philosophy that is as popular as Plato's simile of the cave in *The Republic* (514a–15c). And yet it is a highly problematic episode, a scenario whose clarity is more than relative, a 'tableau' in the final analysis, easier to destroy than to accept. The fact that the whole theory of Western cognitive representation is based on this strange scenario is highly significant.

The 'installation' of the cave is complicated, and the cruel staging of the cognitive plot is blatantly sadistic. Plato has the

perverse vision of a philosopher who enjoys the spectacle of ignorance as much as he enjoys the quest for knowledge (515d):

> Suppose one of them were let loose, and suddenly compelled to stand up and turn his head and look and walk towards the fire; all these actions would be painful and he would be too dazzled to see properly the objects of which he used to see the shadows . . . and if on top of that he were compelled to say what each of the passing objects was when it was pointed out to him, don't you think he would be at a loss, and think that what he used to see was more real than the objects now being pointed out to him?

Compared to its innate cruelty, what is really striking about the 'tableau' created by Plato is the prominence he bestows on visual activity, considered to be equivalent to cognitive activity. In effect, the scopic desire in the simile of the cave, precedes, represents, indeed symbolizes the desire for knowledge. However you look at it, the Platonic scenario is the philosophical inventing of a culture that, for centuries to come, was to be 'oculocentric'.[16] Moreover, it is only within the limits of such a culture that one can accept (as does the over-indulgent 'Stranger' in Plato's dialogue) the notion that fettered prisoners were motivated neither by hunger nor thirst but exclusively by their desire to know/see. Bearing in mind that these poor wretches would have had more urgent material needs, then touch, taste and smell should have mediated – in the process of knowledge and in the somewhat rapid discovery – that the world of projected shadows was only a second-degree world. They would probably not have waited for the philosopher to subject them to further torment by 'compelling them to stand up and turn their heads, etc.' only to blind them in the end with the light of true knowledge.

In extremis, conscious maybe of the scopic exclusivism of his cognitive scenario, Plato introduces an auditive element, 'the wall of their prison opposite them reflected sound'. This is just an adjunct to reinforce a primitive illusion of a visual order – the aim of any installation being no more than a momentary make-believe that the 'shadows' are the 'things themselves'. But these 'things' are in their turn artefacts, 'figures of men and animals' – hence the triple telescoping represented by the

shadow effects, sometimes compared to the exegetists of the oriental shadow puppets.[17]

The epiphenomenon of sound reinforces the epiphenomenon of shadow in a scenario committed to obscuring the boundaries between the world of appearances and the real world. To Plato, shadow and sound are akin to the earliest kinds of make-believe (one optical, the other *auditive*) of reality. Consequently, even in a world of optical illusions, the shadow precedes the specular reflection.

At this stage of his philosophy, it is clearly Plato's intention to place the shadow *at the origins* of the epiphenomenal duplication, *before* the image in the mirror. Had Plato wanted to, he would probably have been more than capable of inventing a different allegorical mechanism of knowledge, for example a specular one. However, he does not want to, and on two occasions (the first in the foreword to the cave episode and the second at the end) he discloses the reasons behind his choice.

Let us begin with the one at the end. Having presented us with the scenario of the cave, Plato describes the prisoner leaving the cave. Once liberated, the former prisoner

> would need to grow accustomed to the light before he could see things in the world outside the cave. First he would find it easiest to look at shadows [*skias*], next at the reflections [*eidola*] of men and other objects in water, and later on at the objects themselves. After that he would find it easier to observe the heavenly bodies and the sky at night than by day, and to look at the light of the moon and stars, rather than at the sun and its light ... The thing he would be able to do last would be to look directly at the sun, and observe its nature without using reflections in water or any other medium (*phantasmata*), but just as it is.

In this extract (*The Republic*, 516a), the philosopher visualizes a païdetic itinerary[18] made up of five stages. At opposite ends of the initiation the shadow stage is the first and the sun stage is the last. Reality can be found somewhere in the middle.

At this point we need to examine Plato's terminology. Reflections in the water are referred to as *eidola*, whereas shadows (at the end of the extract) are referred to as *phantasmata*. The terminology is not without its ambiguities, however, since Plato himself, in another famous extract, prior

to embarking on a description of the cave, defined the visible world according to 'degrees of clarity and obscurity' where the terms are reversed:

> By 'images' [*eikona*] I mean first shadows [*skias*], then reflections in water [*phantasmata*] and other close-grained, polished surfaces, and all that sort of thing ...

We see in this extract (510a) how shadows are also placed in first position (*proton*) preceding specular reflections, but the latter are now referred to as *phantasmata*, a name used to refer to shadows in the passage where the prisoners leave the cave. This terminological ambiguity can probably be attributed to the fact that to Plato – apart from their 'degree of clarity and obscurity' – there is very little difference between shadows and specular reflections.

There is, however, a third component in the system of *eikona* that Plato rather sweepingly refers to as 'all that sort of thing'. What are these? The explanation is be found indirectly and a little further on in the tenth book of the same dialogue (596e), during the debate devoted to the place of art in the ideal city:

> '... take a mirror and turn it round in all directions; before long you will create sun and stars and earth, yourself and all other animals and plants, and all the other objects we mentioned just now.'
>
> 'Yes, but they would only be reflections,' he said, 'not real things.'
>
> 'Quite right,' I replied, 'and very much to the point. For a painter is a craftsman of just this kind, I think. Do you agree?'
>
> 'Yes.'
>
> 'You may perhaps object that the things he creates are not real ...'
>
> 'Yes,' he agreed.

The theme of this passage is the nothingness of the mimesis. The painted image, like the specular reflection, is pure appearance (*phainomenon*), devoid of reality (*aletheia*). It is highly likely that 'all that sort of thing' to which Plato alludes in Book VII of his dialogue is – following on from shadows and reflections – man's artistic achievements. However, in the mimesis passage just quoted, Plato does not refer to the shadow as the matrix of all optical illusion to be used

exclusively when comparing the painted image with the specular image. We would seem to be assisting, therefore, in the advancement if not the actual triumph of the mirror at the heart of the system of epiphenomenal representations.

This suspicion becomes a conviction when, in the dialogue written after *The Republic* – which returns to and develops the mimetic theme (I mean in the *The Sophist*) – Plato repeats almost word for word (the modifications are significant) a passage from *The Republic* (510a). (Re-)defining the image, Socrates states:

> Clearly we shall say we mean images in water or in mirrors, and again images made by the draughtsman or the sculptor, and any other things of that sort. (*The Sophist*, 239d)[19]

There is in *The Sophist* an elision of the deceptive projection that played such a crucial role in *The Republic*.[20] This can be attributed to the symmetry of reversal. Here it is the shadow in the representation that is marginalized, subordinated to painting and specular reflection, relegated to the quasi-anonymity of the other 'things' of 'that sort'.

It would appear, therefore, that we are witnessing a vacillation in Plato's philosophy (on the level of function and terminology) between the model of the shadow and that of the specular image. The shadow represents the stage that is furthest away from the truth. This is crucial to the allegory of the cave, since Plato needed something totally opposed to sunlight. Here and later, the shadow is charged with a fundamental negativity that, in the history of Western representation, was never to be abandoned altogether. To Plato, the shadow was not just an 'appearance', for it was an appearance induced by a censure of light.

In the mimetic theory, however, the phantasm of the shadow had a secondary role to play. It made way for the mirror image that, according to its 'degree of clarity and obscurity', was its superior. After Plato, the work of art was to yield to the constraints of the specular paradigm, and the projection of the shadow was relegated to a marginal role.[21] But this did not lead to the shadow being completely eliminated from the representation's arsenal: it became for all time the poor relation of all reflection, the forgotten origin of all representation.

It is important to remember that, despite the shadow/image

being replaced by the reflection/origin, as augured in the second part of *The Republic* and thoroughly established in *The Sophist*, the debate surrounding the *eidola* still involved them both, with the mirror in the foreground and the shadow with the other 'things'. Both are *phantasmata*, both are *eidola*. And both, together with all works of art, are questionable realities:

> 'Well, sir, what could we say an image was, if not another thing [*heteron toiouton*] of the same sort, copied from the real thing?'
> ' "Of the same sort"? Do you mean another real thing, or what does "of the same sort" signify?'
> 'Certainly not real, but like it.'
> 'Meaning by "real" a thing that really exists?'
> 'Yes.'
> 'And by "not real" the opposite of real?'
> 'Of course.'
> 'Then by what is "like" you mean what has not real existence, if you are going to call it "not real".'
> 'But it has some sort of existence.'
> 'Only not real existence, according to you.'
> 'No; except that it is really a likeness.'
> (*The Sophist*, 240 a–b)

The problematic of the image as presented in this central extract – an 'unreal but corresponding double'[22] has been virtually ignored and can only be understood in the context of the actual staging of this dialogue: the speaker is an Athenian (Theætetus), the listener is a stranger, or more exactly an Eleat. In terms of being and appearance, the Athenian defines for the non-Athenian: otherness and identity, the essence of the 'archaic *eidolon*' and the limitations of the production of images (*eidolopoïké*). To a certain extent he presents the latter as a productive activity of doubles, as an activity that follows the same dramatic art as that which appears, for example, in Pliny's fable of the birth of art. A minimum of imagination is required to see that Plato would have used the same terminology to expound on the story of Butades, which stems from the same archaic if not oriental mentality as the surrogate image. In both Pliny's *Natural History* and Plato's *The Sophist* we find ourselves at the boundary between the production of images and magic. Plato never actually states

that artistic representation stems from the myth of the shadow (to him, it is the specular reflection that is responsible for the mimetic status of painting), nor does he mention the creation of propitiatory doubles, but he does not give the impression that he is completely unaware of the tradition that underlies the Plinian fable. But, while the (oriental, indeed ancient Greek) tradition that culminated in Pliny synthesizes the concepts of the birth and status of the fantasy-likeness, of the adjacent-place of the real (such as *similitudo ex argila*, which gave the shadow a body), Plato endeavours to define the image as a purely apparent being. If, in the Plinian tradition, the image (shadow, painting, statue) is *the other of the same*, then in Plato the image (shadow, reflection, painting, statue) is the same in a copy state, *the same in a state of double*. And if, in the Plinian tradition, the image 'captures' the model by reduplicating it (such is the magic function of the shadow), in Plato it returns its likeness to it (such is the mimetic function of the mirror) by representing it.

Both *The Republic* and *The Sophist* uphold this distinction. The problem is broached in the former's first dialogue:

> 'Then consider – does the painter try to represent the bed or other object as it is, or as it appears? Does he represent it as it is [*alétheia*], or as it looks [*phantasmata*]?'
>
> 'As it looks.'
>
> 'The artist's representation [*mimetiké*] is therefore a long way removed from truth, and he is able to reproduce everything because he never penetrates beneath the superficial appearance [*eidolon*] of anything.' (*The Republic*, 598)

In the second, however, the distinction is established:

> 'The first kind of image, then, being like the original, may fairly be called a likeness [*eikon*] ... Since it seems to be a likeness, but is not really so, may we not call it a semblance [*phantasma*]? ... So the best name for the art which creates, not a likeness, but a semblance will be Semblance-making [*phantastiké*]?'
>
> 'Quite so.'
>
> 'These, then, are the two forms of image-making [*eidolopoïké*] I meant – the making of likenesses [*eikastiké*] and the making of semblances [*phantastiké*].' (*The Sophist*. 236a, c)

We might add that the making of likenesses represents the Platonic mimesis, whereas the making of semblances or simulacra pertains to archaic divination.[23]

There is a famous passage in *The Republic* that illustrates quite clearly the problems highlighted by this distinction. The extract is all the more important to us since it deals directly with the manipulation of the shadow in the pictorial representation. In the following extract the philosopher denounces the 'turmoil' that all representation produces in our souls:

> It is on this natural weakness [*pathéma*] of ours that the shadow painting [*skiagraphia*) and conjuror art [*thaumatopoia*] and their fellows rely when they deceive us with their tricks [*goéteia*].' (*The Republic*, 602d)

Repeatedly commented on,[24] the statement does, however, remain obscure. What did Plato have in mind when he compared the 'shadow painting' to 'magic'?

There are two ways of interpreting this extract, since the actual word used by Plato (*skiagraphia*) has at least two meanings.[25] The first and earliest of these is the one used by Athenagoras to recount the fable of the young Corinthian woman and her father. Here *skiagraphia* corresponds to the Latin expression used by Pliny, *umbra hominis lineis circumducta* ('tracing an outline around a man's shadow'). If this is how Plato is using the word it would indicate that he is isolating – at the centre of the possibilities of pictorial expression – the most ancient of these, the flat painting/shadow of the origins, by investing it with a quasi-magical significance. The tricks of *skiagraphia* could therefore be attributed to the image being conceived as a simulacrum.

The second, more 'modern' meaning of the word *skiagraphia* is that of 'perspective painting', or indeed *trompe-l'œil*.[26] The explanation behind the structure of this compound word (*skiagraphia*/scene painting) is that within this trick image, the projection of the cast shadows is based on a geometric logic that increases or even gives the representation an illusionist quality. In this case, the magic condemned by Plato would have nothing to do with the magic of semblances or of archaic *eidola*, but it would, on the other hand, touch on the deceptive nature of the mimetic illusion.

Since it is impossible to opt for one or the other of these interpretations, it might be better to determine the significance

of this very difficulty. It is my opinion that it stems from the fact that both 'simulacrum' and 'likeness' originate from 'magic', except that in the first case it is a magic of substitution, and in the second a magic of resemblance. Moreover, it implies that the 'magic of resemblance', induced by the mimesis, can (or even *must*) absorb the projection of the shadow, by transforming it from the support of a semblance into a feature of the resemblance itself.

SHADOW STAGE / MIRROR STAGE

'Why is there a shadow there?'
 (making a shadow with the hand)
GALL (five years old): *'Because there is a hand.'*
'And why is this shadow black?'
'Because . . ., because we have bones.'

Through studying children's responses to the origins of the shadow, Jean Piaget discovered, in 1927, the existence of four stages. Young Gall's reply, given above, demonstrates that around the age of five a child can already understand that the shadow is the shadow of an object (the hand) and that this is attributable to the hand's opaqueness (to the bones). But this argument is not satisfactory: in this first stage, the shadow is said to be the result of the collaboration or participation of two roots, one internal (the shadow *emanates* from the object, it *is* a part of the object), the other external (the shadow comes from the night, from a dark corner of the bedroom etc.). It is only around the age of six or seven that the shadow is seen to be the product of one single object. From that point it is regarded as a substance, emanating haphazardly from the object. However, from the third stage (around the age of eight), the child can even predict where a shadow will fall, going as far as to state that the shadow is produced where light is absent. But behind this outwardly correct reasoning we discover the 'substantialism' of the final stages: to the child, the shadow is still nothing but an emanation from the object, but it is an emanation that drives out the light and is therefore obliged to position itself on the side opposite the source of light. It is only around the age of nine that the child, at last, realizes that the shadow is not a substance behind the object, driven away by light. To the child the shadow simply becomes synonymous with the absence of light.[27]

There are several quite striking aspects to the actual conception of Piaget's experiment. I should like to quote two of these. The first would appear to be the relatively advanced age of the children questioned. Is there really no 'shadow stage' before the age of five? I feel that this question is all the more relevant since Jacques Lacan, in a study made twenty years after Piaget's, reminds us that children as young as six months can recognize themselves in the mirror. The often silent responses, provoked by the pleasure of this (re)cognition continue until around the age of eighteen months. It is what Lacan refers to as the famous 'mirror stage', by which he means a 'representative situation' in which 'the symbolic matrix' manifests itself and where 'the I is precipitated in a primordial form before becoming objectivized in the dialectic of identification with the other'.[28]

We might therefore be tempted to conclude that the child recognizes *his* image in the mirror before he queries the essence of shadows. But this (hasty) conclusion leads us to another problem, also raised by Piaget's experiment. During the experiment, the psychologist did not seem to show much interest in how the child reacted to being confronted by his own shadow. Only once does the question arise:

> Pointing to (five years old) Stei's shadow on the ground: 'Is there a shadow there?'
> 'Yes, the chair made it.'[29]

The reply is extraordinary by virtue of its limitations. The child does not even recognize that it is *his* shadow on the ground; he fails to respond to the question by transferring it to another object. Why is this?

It is my opinion that there are two complementary answers to this question. The first stems from the physical circumstances of the projection, the second involves the actual status of the 'shadow stage'. It is a pity that Piaget was not more explicit about how the interviews were staged. It is nevertheless possible to imagine that the child's failure to recognize himself in the shadow can be attributed to the fact that the shadow was stretched out on the ground, whereas the child was standing, or – which is even more likely – sitting on a chair. If he had been shown his shadow vertically projected onto the wall it is possible that he might have reacted quite differently. The fact that he instantly recognized the projection

of the chair (on which he was probably sitting), *and only of the chair*, can be attributed to an element that would seem to form the very essence of the 'shadow stage' as opposed to the 'mirror stage'. As Lacan has stated, the mirror stage involves primarily the identification of the *I*, whereas the shadow stage involves mainly the identification of the *other*. In light of this we can understand why Narcissus fell in love with his specular image and not with his shadow. And we also understand why, to Pliny, the object of the young woman's love is the shadow of the other (the lover). We are probably confronted by two scenarios different in essence, in origin and in the unfolding of the plot. They are in fact two contrasting modalities (though they sometimes interact) of the relationship between image and representation. For the time being I intend to do no more than make a brief summary of these interferences and modalities, since I shall have occasion to return to them throughout this book.

Once again, I suggest (re-)interpreting the following original text:

While he seeks to slake his thirst another thirst springs up, and while he drinks he is smitten by the sight of the beautiful form he sees. He loves an unsubstantial hope and thinks that substance which is only shadow. He looks in speechless wonder at himself and hangs there motionless in the same expression, like a statue carved from Parian marble. Prone on the ground, he gazes at his eyes, twin stars, and his locks, worthy of Bacchus, worthy of Apollo; on his smooth cheeks, his ivory neck, the glorious beauty of his face, the blush mingled with snowy white: all things, in short, he admires for which he is himself admired. Unwittingly he desires himself; he praises, and is himself what he praises; and while he seeks, is sought; equally he kindles love and burns with love. How often did he offer vain kisses on the elusive pool? How often did he plunge his arms into the water seeking to clasp the neck he sees there, but did not clasp himself in them! What he sees he knows not; but that which he sees he burns for, and the same delusion mocks and allures his eyes. O fondly foolish boy, why vainly seek to clasp a fleeting image? What you seek is nowhere; but turn yourself away, and the object of your love will be no more. That which you behold is but the

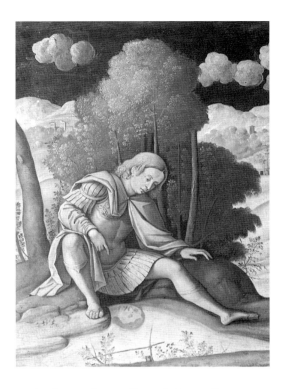

3 A detail from Girolamo Mocetto, *Narcissus at the Pool*, before 1531, tempera on wood. Musée Jacquemart-André, Paris.

shadow of a reflected form [*ista repercussa, quam cernis, imaginis umbra est*] and has no substance of its own [*nil habet ista sui*]. With you it comes, with you it stays [...].[30]

We need but to examine the lexis: without realizing it, the young man is enamoured of his own image, or to be more precise, with the form (i.e. of beauty) of his image (*imagine forma*). At the outset he contemplates it somewhat indecisively, as though it were a work of art.

Thunderstruck, stupefied, he resembles a statue and the reflected image resembles a painting. It is the author who confides that this image is not in fact an illusion without a body (*spes sine corpore*), a semblance, the shadow of an image (*imaginis umbra*), a nothing (*nil*). This does not mean that Narcissus falls in love with his 'shadow'. On the contrary: in the text the 'shadow' comes at the end of a list of terms that make reference to the indefinite image,[31] it barely precedes the 'no substance' (*nil*) to suggest therefore all that is unclear, obscure, unreal in the vision at the bottom of the water.

Over the next few centuries, artists who illustrated the myth

of Narcissus usually stressed the evanescent nature of the specular image (illus. 3), but avoided representing the 'shadow', which was in fact no more than a metaphor in Ovid's account. I know of only one exception to this, where the artist's skill is both exemplary and significant, an engraving Antonio Tempesta made for Ovid's *Metamorphoses* (illus. 4). It depicts a thirsty Narcissus bent over a well. We do not see his reflection, but imagine it to be that of an image of a face broken by ripples. What we do partially see, though, is the shadow cast by the young man at the edge of the well. But the shadow comes to an abrupt end at the actual spot where it should become an 'image'. Because this transition, this transformation (*ista repercussa, quam cernis, imaginis umbra est*) is almost impossible to portray, Tempesta tackled it by resorting to making one of its components elliptical. It is, however, important to note that this engraving illustrates the first part

4 Antonio Tempesta, *Narcissus at the Well*, engraving from an edition of Ovid's *Metamorphoses* of 1606. British Library, London.

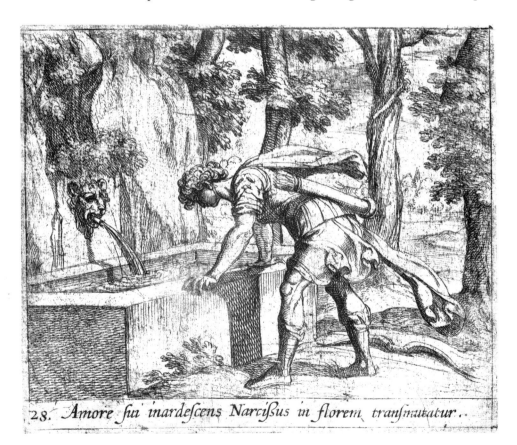

28. *Amore ſui inardeſcens Narciſßus in florem tranſmutatur.*

of the account, where Narcissus does not know that what he sees is himself (*quid uideat, nescit*). There is a margin of doubt in the somewhat unclear aspect of the shadow. What if this 'shadow' were in fact 'another'?

The drama of identification comes in the following lines:

'I am charmed, and I see; but what I see and what charms me I cannot find' – so serious is the lover's delusion – 'and, to make me grieve the more, no mighty ocean separates us, no long road, no mountain ranges, no city walls with close-shut gates; by a thin barrier of water we are kept apart. He himself is eager to be embraced. For, often as I stretch my lips towards the lucent wave, so often with upturned face he strives to lift his lips to mine. You would think he could be touched – so small a thing it is that separates our loving hearts. Whoever you are, come forth hither! Why, O peerless youth, do you elude me? or whither do you go when I strive to reach you? Surely my form and age are not such that you should shun them, and me too the nymphs have loved. Some ground for hope you offer with your friendly looks, and when I have stretched out my arms to you, you stretch yours too. When I have smiled, you smile back; and I have often seen tears, when I weep, on your cheeks. My becks you answer with your nod; and, as I suspect from the movement of your sweet lips, you answer my words as well, but words which do not reach my ears. – Oh, I am he [*Iste ego sum*]! I have felt it, and know my own image [*imago*]. I burn with love of my own self; I both kindle the flames and suffer them. What shall I do?' (*Metamorphoses*, III, 446–65)

The first part of the Narcissus story was static, the second active. The pleasure of sight (*et placet et uideo*) does not end in the pleasure of the embrace (*cupit ipse teneri*). Sight deceives, and the proof of reality, which should have come through touch, does not take place. In the attempted transgression described by Ovid – a veritable ballet for two – Narcissus still believes that the image is *another*. His vain attempts to transform *sight* into *embrace* ends in tragedy at the precise moment of ecstasy when the hero at last attains the 'mirror stage'. The image (*imago*) no longer deceives him, it is no longer a 'shadow', no longer *the other*, but himself: 'Oh, I am he!'/*Iste ego sum*.

Even so, it is interesting to see that the majority of medieval translations and interpretations of the myth of Narcissus perpetuated the semantic interaction between 'shadow' and 'reflected image'. The two expressions were for a long time interchangeable. In a poem by Bernard de Ventadour, to give but one example,[32] it is said that 'Narcissus saw his shadow, fell head over heels in love with it and died of this great passion' (*vi sa ombra e l'amet tot entier / e per fol' amor mori*). The assonance (*ombra/amor/mori*) was no doubt intentional, and transforms the lexical connection – image/shadow – into a poetic inspiration loaded with meaning.

From the point of view of the illustrations of Ovid's myth, however, the lexical merging of shadow and reflection is not very productive, since in the visual domain the two hypostases of the image are optically and ontologically different: the shadow represents the 'other' stage, while the mirror represents the 'same' stage. We have already had occasion to see that someone as astute as Tempesta (illus. 4) avoids representing the transition from one stage to the other. Given that there are so few experiments of this type, I feel it would be extremely useful to compare it with another, which is at the edge of the visual interpretation of the Narcissus myth (illus. 5).

The origins and deep-seated significance of one particular advertisement can be uncovered through a hermeneutic process that is no stranger to the interpretations of myths and witticisms. What we see in our example is a young man who has just got out of the shower and is now fighting his own shadow in order to get his hands on a bottle of aftershave. The scenario is diametrically opposed to the one presented in the second part (the active part) of Ovid's myth. The ballet of identification between the man and his image is no longer centred on love but on rivalry. In truth – and we are very soon aware of this – the struggle is not founded on a relationship of identity but on a relationship of otherness. The modern Narcissus (*the Egoist*) is jealous of his own shadow. The latter is in effect a gigantic 'other' who is about to deprive him of the object of desire and instrument of seduction that the aftershave represents. The graphic designer has emphasized the otherness of the shadow through the man's movements not being identical with those of his double. This is an extremely sophisticated illusion. The ground

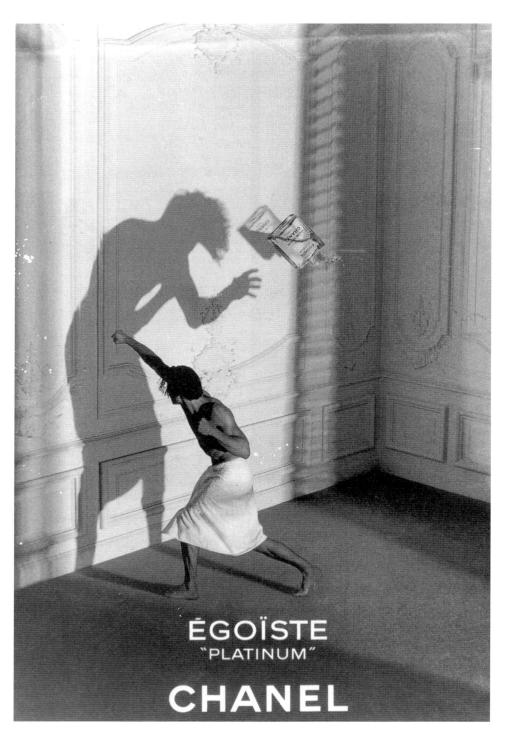

contact between the young man and the shadow suggests that they belong to one another, the – so very different – aggressive stance of their upper bodies, epitomizes (on a subliminal level) the notion of struggle with 'the Other'.

What we are presented with here is a corruption of the mythical scenario, whose origins are not difficult to recreate. Just prior to this episode, the young man was no doubt in a first-degree narcissistic situation. Barely out of the shower and standing in front of the mirror, he was about to use his favourite aftershave. The idea of confronting his double to gain possession of the fetish would not have had the same impact on the public if this double had been the 'same' (in this case the man's specular reflection). The graphic designer was obliged to transform his identity into an otherness. In order to achieve this he had to bring the young man out of the bathroom and transform the familiar reflection in the mirror into a menacing black projection. *The Egoist* protects his aftershave – the absolute exclusivity of the product is thus confirmed – against all 'Other', even his own shadow. Moreover: to prove his ability to manipulate images, the creator of the advertisement focuses the mind on the product's seductive quality, since this is the only thing in the whole production that is duplicated through the manipulation of a specular reflection rather than through the projection of a shadow. The bottle of aftershave (whose name appears twice in the image as though truly and accurately duplicated) is a desirable object in as much as the 'the reflection' presents it as having more consistency than the shadow and more reality than the mirror: in other words, it is presented as being 'the same'.

It is an almost pointless exercise to recall that such a manipulation is only possible within a culture that, on the one hand, turns manufactured goods into fetishes and, on the other, details its own visual mechanisms from the time of that great invention – the photographic image. But this is an aspect to which I shall have occasion to return.

In the history of Western representation, it was Plato's philosophy that dealt the first blow against the shadow stage, further illustrated, but in an anachronistic way, by the Plinian legends on the birth of painting and sculpture. Beginning with Plato, it was the mirror rather than the

projection of interposed bodies that was to become the vehicle of the mimesis. However, the projection was to continue to be central to a whole culture. Without the application of this principle, it would have been (and still would be) difficult to define Eastern representation. It would take another book, and probably a different author, to review this particular history.[33] My subject is more limited, and in fact sets out to trace the history of only a fragment of Western representation.

I have attempted to demonstrate that Western representation saw – in Plato (philosophically) and in Ovid (poetically) – the mirror stage[34] as a deviation/mutation of the shadow stage. However, it was not until the Renaissance that the first theory of art to claim the specular paradigm for itself was born.

In the founding book on Early Modern art, Leon Battista Alberti's *De Pictura* (1435), we read:

> Consequently I used to tell my friends that the inventor of painting, according to the poets, was Narcissus, who was turned into a flower; for, as painting is the flower of all the arts, so the tale of Narcissus fits our purpose perfectly. What is painting but the act of embracing by means of art the surface of the pool? Quintilian believed that the earliest painters used to draw around shadows made by the sun, and the art eventually grew by a process of additions.[35]

It is worth emphasizing that the first text on new painting makes a clear distinction between the 'mirror stage' and the 'shadow stage'. By citing Quintilian's version of the Butades fable, Alberti would give us to understand that to him, 'drawing around shadows made by the sun' was not yet 'true art' (Quintilian was also of this opinion): this would only grow 'by a process of additions'. A little further on he makes the break from ancient tradition even more radical:

> … we are not telling stories like Pliny. We are, however, building anew an art of painting [*artem novissime recenseamus /di nuovo fabrichiamo una arte*] about which nothing, as I see it, has been written in this age.[36]

The author of *De Pictura* is conscious of the fact that the new art of painting, which stems from Narcissus, is a 'personal' invention, but he also wants to demonstrate that it emerged from circles dominated by reflection and humanist debates. It

was probably born of careful readings, made by Alberti and his friends, of the first part of the Ovidian myth, where Narcissus gazes at the water as though it were a painting. From this interpretation comes a new conception of the pictorial image as the product of an erotic act[37] (as was the case with Pliny), but this act involves the same and not the other. In 'On Painting', the embracing of the mirror (amplector/abracciare) contrasts radically with the outlining of the shadow (circumscribere/circonscrivere). From the Renaissance on, Western painting was quite clearly to be the product of the love of the same.

It is interesting to note that when Giorgio Vasari decided to write his history of painting (published in 1550, with a second edition in 1568), he found the collision of the two paradigms disconcerting.[38] He tried to reconcile these two in a final but vain effort. Having read Pliny in haste (a reading however quite obviously made through Albertian eyes), he submitted the following scenario of origin:

> But according to Pliny this art was introduced into Egypt by Gyges of Lydia, who, on seeing his shadow cast by the fire, at once drew an outline of himself on the wall with a piece of coal. For some time after that it was the custom to draw in outline only, without any colouring.[39]

In one of the actual frescoes of his Florence house, Vasari provides us with the setting of this original act (illus. 6).[40] It is not difficult to recognize in this image a somewhat questionable alliance of the Albertian and Plinian myths. The main problem with Vasari's scenario lies in the virtual impossibility of imagining the creation of a self-portrait through the outlined shadow. The visible outcome of this, on the wall of the house in Florence, is a rather shapeless and incongruent stain. In the Plinian fable, the harnessing of the likeness through the outlined shadow was only made possible because model and artisan were two different people. The image/shadow was the likeness of *the other* (and not of the self), and this was solely manifested in the form of a *profile*. Indeed, this truth has been understood by all painters who wanted to depict Pliny's or Quintilian's fable, beginning with Murillo, the first modern artist, it appears, to have devoted a painting to this theme (illus. 7). On the other hand, the image/reflection, as illustrated in the Ovidian myth (illus. 3, 4) and

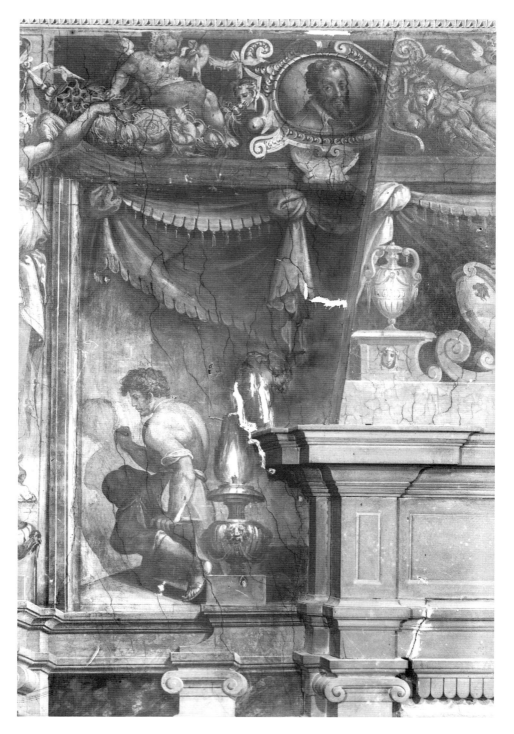

taken up by Alberti as a metaphor of painting, is, in principle, a frontal representation. The frontal relationship with the mirror is a relationship with the same, just as the relationship with the profile was a relationship with the other.[41]

Apart from this ambiguity, the image of the 'origins of art' formed by the first art historian (illus. 6) contains a moral: the art Vasari wants to use to make his history is the one that integrated the 'shadow stage' and the 'mirror stage'.

2 The Shadow of the Flesh

According to tradition, Murillo's painting depicting the origins of painting (illus. 7) would have been done when the Spanish artist was appointed *mayordomo* of the Seville Academy of Painting in 1660.[1] It was probably not an illustration of Pliny's nocturnal fable but of the Quintilian version mentioned in the *Institutio oratoria* (x, ii, 7): the characters – a group of men it would appear – are outdoors, just as the shadows are beginning to lengthen. The silhouettes of two of them are projected on an overgrown wall (an analeptical sign of dilapidation and neglect). The two profiles are created through an in-depth study – not mentioned in the ancient texts – of the cast shadow seen splitting in two, one part being darker than the other. It is unquestionably an anachronism since this procedure reflects knowledge acquired during Murillo's period rather than during the origins of painting. It is actually one of the dark shadow of one of the characters that is in the process of being delineated by the other's style.

But only half the canvas is taken up with the posing session. There is a group of four men on the other side, gazing at the image's original scenario of production. The youngest of these is describing what is happening on the right. It is not difficult to imagine what he is saying. All we need do is (re)read Quintilian to hear the young orator's voice:

> 'For what, I ask again, would have been the result if no one had done more than his predecessors? ... we would still be sailing on rafts and the art of painting would be restricted to tracing a line around a shadow thrown in the sunlight.'

If our supposition is correct, then it means that this painting – before illustrating the 'origins of painting' – was a gloss, a moving away from these very origins. Confirmation comes from the inscription inserted on the shield on the right-hand side: 'From the shadow/ originated/ the beauty you admire/ in the famous painting' (*Tubo de la sombra/ origen / la que admiras her/ mosura / en la celebre pintura*). The inscription

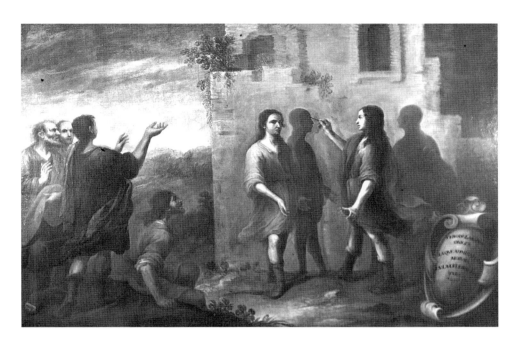

7 Bartolomé Esteban Murillo, *The Origin of Painting*, c. 1660–65, oil on canvas. Muzeul National da Arta, Bucharest.

completes, or rather draws conclusions from, the orator's discourse and the representation as a whole. It needs to be understood in the light of the antithesis between the two key words: shadow and beauty. This final note – like the moral of a fable – framed as though it were a memento for the young students of the Seville Academy, is a reminder that *the beauty* of the painting (what we most admire in it today and which makes it famous) has its roots in all that is humble and least attractive in a representation: a *shadow* and what is more, a shadow on a weed-covered wall. This manifesto–painting is a paradoxical object since it appears to be a living example of a painting performing a transcendence: the inscription speaks of the 'beauty' that the spectator ('you') can (now) admire in it. This materializes from the image we are looking at in a whole series of classical signs: the various attitudes of the characters, the contours of their bodies, the chromatic quality, split shadows, etc. Given that it is an emblematic painting from an academy of art, the work represents the superior stage of 'beauty' as conquered by art. We understand that beginning with the rudiments of art (the shadow) and ending with beauty, Murillo's academy guaranteed the assimilation of artistic knowledge.[2]

The transcendence thematized by Murillo's painting goes back a long way. It had already begun at the end of Pliny's first statement on the origins of art.[3] It started again with the birth of the Renaissance, although it did not figure very much in the painting of the Middle Ages. We would be quite justified in speculating over this absence.

'WHENCE THE GLOOMY SPOTS UPON THIS BODY?'

Ma ditemi: che son li segni bui / di questo corpo ...
(Dante, *Paradiso*, II, 49–50)

Although those who studied medieval optics were very interested in attending to the projection of the shadow,[4] it was virtually ignored by the artists of the period. This can be attributed to the (onto-)logical status of the medieval image,[5] since it was an entity that, in principle, did not wish to become a physical reality. This notion lasted, *grosso modo*, as late as Giotto, but it was not until the discovery of perspective that the shadow finally became an object of serious study for painters.

We need to make a brief examination of the modalities in this transition. It is in Dante that we first come across the premonitory change. Virtually all the characters in the *Commedia* are beings the author sees, but who in principle should remain invisible since they are without bodies. They are, as so often described by the author, *visible souls*, spectres, shadows. They appear to be bodies, *are* bodies though subtle and diaphanous.[6] It is difficult to know just how much Dante himself believed in the actuality of this phantom humanity he was so close to. In the second canto of *Purgatorio* (II, 74–7), a shadow approaches to embrace him affectionately and the poet tries to do the same: but his arms clasp nothing:

O shadows vain!
Except in outward semblance: thrice my hands
I clasped behind it, they as oft returned
Empty into my breast again.[7]

This is probably connected with the ancient concept of the shadow being the *psyche/eidolon*.[8]

A second and more modern view of the shadow appears in

the third canto of *Purgatorio* (III, 16–30). Their backs to the sun, Virgil and Dante are walking side by side. Each should, therefore, have had his shadow falling in front of him. But Dante is frightened when he realizes that Virgil does not have any:

> The sun that flared behind, with ruddy beam
> Before my form was broken; for in me
> His rays resistance met. I turned aside
> With fear of being left, when I beheld
> Only before myself the ground obscured.

Virgil explains the phenomenon to him. His own physical body (the body in which I cast a shade/*lo corpo dentro al quale io facea ombra*) is buried elsewhere. The diaphanous body, on the other hand, allows the rays of the sun to pass through and therefore no shadow is formed.[9]

In this crucial passage the author underlines – with all his innate clarity and poetic vigour – that the projected shadow is a fact of life: in the *Commedia* we learn that *only Dante has one*, because, like Virgil, the others *are* shadows. The discovery that the shadow is an indispensable quality of the body, the discovery, therefore, of the 'shadow of the flesh' (*l'ombra della carne*) as Dante calls it elsewhere (*Paradiso*, XIX, 62), was to have a profound impact on the early Renaissance. Here is an example. In 1436 Giovanni di Paolo painted, for a wealthy Sienese family, a polyptych that was unfortunately destroyed in a fire during the seventeenth century. However, parts of the predella survived, one of which was the most splendid of pictorial experiments: *The Flight into Egypt* (illus. 8). Over half the surface of this small painting is a landscape faithful to the Sienese tradition. The composition includes aspects of contemporary rural life. There is nothing new about this approach (Ambrogio Lorenzetti had already used this technique a century earlier). The innovative nature of the background, however, lies in the shadows cast by the objects, animals and people on which Giovanni di Paolo focuses with such evident delight, bringing into play all the *savoir-faire* of an artist living at the time when perspective was discovered.[10] He even remembers to insert in the upper left-hand corner the source of the whole lighting effects – the sun shining over the right-hand side of the painting.

The sun (painters are normally reluctant to include it in the

pictorial field) is there to stress the optical plausibility of the cast shadows. To the art historian it indicates a possible connection. Giovanni di Paolo had previously illustrated Dante's *Paradiso*,[11] where, in the second canto, Beatrice gives an extremely complex speech on optical knowledge (illus. 9). There would be no great advantage, at this point, in reviewing the whole of this part of the poem.[12] However, we should note that when she explains why there are spots or shadows on the moon (the gloomy spots upon this body / *li segni bui di questo corpo*), Beatrice (whom Giovanni di Paolo portrays flying in the left-hand side of the illustration) falls back on the theory of the cast shadow (which the painter illustrates at the centre of the image). The 'gloomy spots' are caused by the projected cone of the earth's shadow.

By repeating the same geometrized model of the sun in the Siena predella (even though he relegates it to a corner of the representation), the artist shifts the theoretical (and cosmic) context of Dante's geometric demonstration into that of a landscape that claims to be 'realistic'.

But what probably makes this experiment so momentous is that in the *Flight into Egypt* it overtly limits itself to the backdrop. Neither Virgin, Child nor ass has a shadow. This is all the more striking when we study the projection of the trees that almost touch Joseph's legs. It leads one to suspect, if not be convinced, that the artist used two very distinct pictorial forms. The foreground scene is faithful to the rules of a flat, two-dimensional world, typical of the medieval image; whereas the landscape is the product of a revitalized experience of the real. In the spirit of this Dante-like dualism, we could therefore claim that the foreground is peopled with 'shadow-images', whereas the middle distance is the area where bodies display their reality in the form of a cast shadow. But to what extent does this parallelism really work?

If we examine the foreground of Giovanni di Paolo's composition closely, we see that the two-dimensionality of the characters – their 'flatness' – is fairly relative. These characters do indeed form a continuous frieze that crosses the painting from left to right, and the area they occupy is ambiguous and barely defined. However, they are more than simple silhouettes projected onto a neutral screen. The artist has gone to great lengths to vary the attitude of the figures,

8 Giovanni di Paolo, *The Flight into Egypt*, 1436, tempera on wood. Pinacoteca Nazionale di Siena.

9 Giovanni di Paolo, illustration to Dante's *Paradiso*, canto II, *c*. 1450. British Library, London.

avoiding profiles that are too stereotyped, suggesting the existence of a physical body through the folds of the clothes. A closer examination still, reveals that despite the absence of a cast shadow, the characters are lit by the same light that comes in from the left to highlight a part of their bodies while the rest remains dark. There is shading, but only in the deeper folds of the clothes, the protrusions and hollows of the faces, and the dark areas delineating their bodies. It is undeniable, therefore, that shading has to some extent already been used to give these figures a physical body.

This should not, however, come as any great surprise since, starting with Giotto, shading was once again to be the focus of attention of Tuscan painters. Cennino Cennini reviews the situation in his *Libro dell' Arte* (while the earliest copy dates from 1437, it includes knowledge gained in the previous century):

And then take a style of silver, or brass, or anything else ... Then, using a model [*con esempio*], start to copy the easiest possible subjects, to get your hand in; and run the style over the little panel so lightly that you can hardly make out what you first start to do; strengthening your strokes little by little, going back many times to produce the shadows. And the darker you want to make the shadows in the accents, the more times you go back to them; and so, conversely go back over the reliefs only a few times. And let the helm and steersman of this power to see be the light of the sun, the light of your eye, and your own hand: for without these three things nothing can be done systematically.[13]

It is interesting to note that to Cennini, the action of shading is something that comes from the first rudiments of art. It is an element of *drawing* (therefore of the first phase in the creation of forms) before it becomes an element of colour. In this way he developed a somewhat belated medieval practice, which recognized two related acts in the realization of silhouette and shading.[14] If, for example, we were to read the Byzantine manual on painting (described in a later eighteenth-century version entitled *The Erminia of Painters*[15]), we would see how silhouette/shade in Eastern Europe was interpreted through the concept of form, based – to a certain extent – on the ancient Plinian tradition:

... smear some paper with uncooked *peziri* and leave if for one day in the shade to soak in. Then rub it well with bran to extract the oil thoroughly so that the colours take where you want them to, and the archetype is not damaged. Having attached the four corners of the original to the paper, make some black colour with a little egg, carefully trace the forms and then put in the shading.[16]

Cennini's approach is different from the Byzantine one in as much at it stemmed from the fact that the Trecento had already mastered a vision of the image as a copy of the real,[17] whereas with the Byzantines the image was no more than the product of another, already traced image. It is quite remarkable that despite this fundamental change of paradigm, Cennini still followed the ancient shade–silhouette tradition, although it must also be emphasized that his handbook, which presents a synthesis of the Trecento pictorial practice, contains at least three sections devoted to this question (chapters VIII, IX, X). Vital observations that appear further on in his work (chapters XXX, LXVII) should be added to these. This fact alone is sufficient to demonstrate that during the Trecento, shading had become central to the representation. Indeed, in the long chapter devoted to the creating of frescoes (LXVII), Cennini dwells on how the flesh of a youthful face should be painted as an essential part of the new Tuscan art (illus. 10):

And let us suppose that in a day you have just one head to do, a youthful saint's, like Our Most Holy Lady's. . . . Make a fine pointed brush out of flexible, thin bristles, to fit into the quill of a goose feather; and with this brush indicate the face which you wish to do, remembering to divide the face into three parts, that is, the forehead, the nose, and the chin counting the mouth. And with your brush almost dry, gradually apply this color, known in Florence as verdaccio, and in Siena as bazzèo. . . . Then take a little terre-verte in another dish, well thinned out; and with a bristle brush, half squeezed out between the thumb and forefinger of your left hand, start shading [*ombrare*] under the chin, and mostly on the side where the face is to be darkest [*scuro*]; and go on by shaping up the under side of the mouth; and the sides of the mouth; under the nose, and on the side under the eyebrows, especially in toward the nose; a little in the end of the eye

10 A detail from Giotto, *Adoration of the Magi*, 1304–6, fresco. Scrovegni Chapel, Padua.

toward the ear; and in this way you pick out the whole of the face and the hands, wherever flesh color [*incarnazione*] is to come.

Then take a pointed minever brush and crisp up neatly all the outlines [*rifermando bene ogni contorno*], nose, eyes, lips, and ears, with this verdaccio.

There are some masters who, at this point, when the face is in this stage, take a little lime white, thinned with water; and very systematically pick out the prominences [*sommità*] and reliefs [*rilievi*] of the countenance; then they put a little pink on the lips, and some 'little apples' on the cheeks. Next they go over it with a little wash of thin flesh colour [*incarnazion*]; and it is all painted ...

This quotation quite obviously proves that in Cennini's optics, producing a figure on a wall with the help of fresco colours takes on the attributes of creating a likeness, which can, with the help of more advanced techniques, give the illusion of

'flesh'. This is stated quite clearly in the first chapter of the handbook:

> [The] occupation known as painting, which calls for imagination, and skill of hand, in order to discover things not seen, hiding themselves under the shadow of natural objects [*sotto l'ombra di naturali*], and to fix them with the hand, presenting to plain sight what does not actually exist [*quello che non, è sia*].

The procedure addressed by Cennini deals with an important representational issue: *'how to do flesh?'*[18] He resolves it by varying his use of *verdaccio*, which, in different proportions, can be used for flesh, as well as for shading and silhouettes. Elsewhere in his handbook (chapter LXXXV), Cennini gives us a very concise recipe for this mysterious colour: 'make a verdaccio color, one part of black, the two parts of ocher'.

I think that the 'flesh colour'/'shade colour' ratio is not specified because of the atmosphere of secrecy that hung over artists' workshops to protect their individual techniques. Cennini implies this at the end of chapter LXVII, where, after having discussed another method of painting flesh, he explains his virtual silence on the subject, in words that are quite clear:

> But you [he is addressing the pupil] follow this method in everything which I shall teach you about painting: for Giotto, the great master, followed it. He had Taddeo Gaddi of Florence as his pupil for twenty-four years; and he was his godson. Taddeo had Agnolo, his son. Agnolo had me for twelve years: and so he started me [as a pupil] on this method . . .

It should be noted at this point that in the very chapter where he deals with the 'modern' problematic of depicting flesh and shade, Cennini felt obliged to highlight that a new tradition had been founded, which began with Giotto and which led to him along an almost geometrically accentuated line (twenty-four years/twelve years). This new problematic is not wholly divulged, though it does promise to initiate the reader–pupil in the secrets of this art in which 'I shall teach you [everything] about painting' (orally transmitted no doubt).

For the moment (and to close this section), let us see how Cennino Cennini returns (same chapter) to his blueprint of

principles and recommendations as to how an artist should organize his work in the studio, in order to produce flesh and shade. He enlarges on the important points already quoted without ever revealing the full extent of his knowledge:

> Then take three little dishes, which you divide into three sections of flesh color [*tre parti d'incarnazion*]; have the darkest half [*la più scura*] again as light as the pink color, and the other two, each one degree lighter. Now take the little dish of the lightest one; and with a very soft, rather blunt, bristle brush take some of this flesh color, squeezing the brush with your fingers; and shape up all the reliefs [*rilievi*] of this face. Then take the little dish of the intermediate flesh color, and proceed to pick out all the half tones [*i mezzi*] of the face, and of the hands and feet, and of the body when you are doing a nude. Then take the dish of the third flesh color, and start into the accents of the shadows [*nelle stremità dell'ombre*], always contriving that, in the accents, the terre-verte may not fail to tell. And go on blending [*va sfumando*] one flesh color into another in this way many times.... When you have applied your flesh colors, make another much lighter one, almost white; and go over the eyebrows with it, over the relief of the nose, over the top of the chin and of the eyelid. Then take a sharp minever brush; and do the whites of the eyes with pure white [*bianco puro*], and the tip of the nose, and a tiny bit on the side of the mouth; and touch in all such slight reliefs. Then take a little black [*un poco di negro*] in another little dish, and with the same brush mark out the outline of the eyes over the pupils of the eyes; and do the nostrils in the nose, and the openings in the ears. Then take a little dark sinoper [*sinopia*] in a little dish; mark out under the eyes, and around the nose, the eyebrows, the mouth; and do a little shading [*ombra un poco*] under the upper lip, for that wants to come out a little bit darker [*prendere un poco più scuretto*] than the under lip.... Then, by marking out with sinoper, shape up the outlines and the accents of the hair as you did the face as a whole.

I thought it fitting to quote the whole of this passage because it illustrates the codification of a new method of representation, and because the manner in which this new method is presented to us contains a very basic principle: when creating

relief, the lightest colours (the most diluted) are used for the prominences, while the darkest (the purest) are used for the hollows.[19] Shade-colour is in fact nothing other than flesh colour (*incarnazione*) in its least diluted and therefore purest form. A transcendence of this principle involves using pure white (*bianco puro*) for the clear 'tips' of the solid body and black for its 'holes'.

In chapter LXXXIII, where he deals with producing an *a secco* 'mantle for Our Lady with azurite, or any other drapery which you want to make solid blue', Cennini once again recommends the use of black for depth. He demonstrates that blue on its own – a sacred colour strictly codified and to be used for the Virgin's mantle – is not enough. If the artist wishes to outline the contours of the body it is enveloping, he goes on to say:

> Mix it up well. Apply three or four coats to the drapery, with a soft bristle brush. When you have got it well laid in, and after it is dry, take a little indigo and black, and proceed to shade the folds of the mantle as much as you can, going back into the shadows time and again, with just the tip of the brush. ... If you wish to shade the folds, take a little fine lac, and a little black, tempered with yolk of egg; and shade it as delicately and as neatly as you can, first with a little wash, and then with the point [of the brush] ...

Shading, as demonstrated in the *Libro dell' Arte*, is tenuously linked to solid bodies and relief. It is achieved through using the opposite extremes of the purest of flesh colours and black. However, the fact that Cennini had no interest in representing the cast shadow shows how limited his system was, for by ignoring it, he was without a doubt turning his back on the whole question of how bodies are positioned in space.[20] When an artist like Giovanni di Paolo attempts to represent shading and the cast shadow in one and the same painting (illus. 8), he does so through a 'Dante-like' splitting of the painting. This demonstrates the inability of the Sienese artist to opt for (unless it is an interaction) one of the two differing systems of representations, which he cannot (or will not) reconcile.

The advantage of having established – in what I shall term a programmatical way – the unity of the representation through the dual use of the shadow, goes back to Masaccio.

The fresco that depicts *St Peter Healing the Sick* (illus. 16) was painted by Masaccio in 1427–8. It was inspired by a passage in the Acts of the Apostles (5:12–15), and forms part of a cycle devoted to the Saint's life:

> And there were many signs and miracles done by the apostles before the people. They used to gather with one accord in Solomon's porch. No-one else dared to join them, although the people held them in high honour, and the number of those who believed in the Lord, both men and women, still increased; they even used to bring sick folk into the streets, and lay them down there on beds and pallets, in the hope that even the shadow of Peter, as he passed by, might fall upon one of them here and there, and so they would be healed of their infirmities.

In undertaking this theme, Masaccio was faced with an enormous narrative problem. The art of painting allows for one single action to be represented, not several. He therefore had to transform a text that does not recount *only one* event, but a chain of them with no precise temporality, into a living scene to be presented to the spectator's gaze. The depiction of complex narrative art was to be theorized a few years later by Alberti, as one of the major characteristics of new painting. Years later, when Vasari was writing Masaccio's biography, he acknowledged the pioneering role the young Florentine painter had played in the evolution of the *storia*, as well as the vital contribution he had made to defining a new pictorial style whose mastery of relief, perspective and foreshortening was outstanding.

All these innovations can be seen in a fresco in S Maria del Carmine in Florence. Working from the text and with the probable assistance of Biblical commentaries and theological advice, as was the custom at the time, Masaccio created a scene that contributes significantly to the episode in the Acts of the Apostles. We see Peter, John and an unidentified disciple walking down a street lined with sick people waiting to be healed. Indeed, the miracle seems to take place before our very eyes. Where the apostle has already passed, two men have stood up: one is leaning on his stick, another is thanking him, a third is kneeling, pleading for divine mercy, which

would seem to have touched him, for the shadow Peter casts on the ground has passed him and the sick man is in the process of standing. It is now the turn of a fourth and final person to experience the miraculous influence of the apostle's shadow. His expectant eyes are wide open, he is waiting for the moment when his strength will return so that he too can stand.[21]

The visualization of the account was heavily reliant on recent achievements in perspective. In representations depicting the same theme a century earlier, the cortège of Apostles moved from left to right, parallel with the surface of the image.[22] This was a 'primitive' way of conveying the notion of 'movement' that had, for example, appeared in the foreground of the Giovanni di Paolo composition (illus. 8) previously analysed. However, in Masaccio's, the figures move from the back of the scene and make their way to the foreground. They cross from the depths – created by the vanishing point of the perspective of the buildings that skirt the left-hand side – and their actual advance punctuates the three-dimensionality of the scene. The shadows Peter and John project are themselves the product of the perspective structure. They cover the centre of the foreground, the space left empty by the group on the left and the one on the right. Although the text mentions the miraculous effect of Peter's shadow only, Masaccio was determined to portray John's as well. The double, parallel shadows emphasize the depth of this perspective space.

The symbolism of the shadow in this story from Peter's life has been the object of several studies. The most recent ones agree that it relates to the ancient, magical notion that the shadow was an external manifestation of the soul.[23] If we examine the passage from the Acts of the Apostles more carefully, we see that the shadow's power contrasts with and neutralizes the 'impure spirits' with which the sick were possessed. Experts have already drawn attention to one of the most popular commentaries on the Bible in Masaccio's time, for it demonstrates how this motif was viewed when the Carmine frescoes were done: according to Nicolas de Lyra's commentaries,[24] the Apostles had the power to heal the sick either by touching (*per tactum manuum*) or by speaking to them (*per verbum*). Peter was the only one who had the power to heal with his shadow (*per umbram*), which was even more

exceptional (*quod est maius*). Healing words come from men who possess extraordinary power (*ex homine habens virtutem*), but the shadow is nothing more (*sed umbram nihil est ipsius*) than a lack of light due to the interposition of a body (*sed tantum privatio lucis ex interpositione corporis*). This declaration would seem to imply that the shadow had been subjected to a process of desacralization. However, this is only a superficial impression since, by defining the projection in scientific terms, the commentator's intention was to exalt the miraculous (indeed inexplicable) nature of its healing power.

As far as Masaccio is concerned, he emphasizes only the exceptional power of the shadow. Neither Peter nor John speak; they advance in silent solemnity. They neither touch nor bless, each of the apostles has his left hand wrapped in his cloak, and Peter's right hand hangs loose by his side. Masaccio's narrative clears up any ambiguity that might have been left by the text or its commentary. Through an extremely refined process he brings together the two origins (sacred and scientific) in this *mise-en-scène* of the shadow's power. However, this was unfortunately not always understood, and Vasari was the first to have misinterpreted it – an error that was to be perpetuated for centuries. When he describes the scene, Vasari in effect tells us that what we are seeing is St Peter 'healing the paralytics with his shadow as he moves forward accompanied by St John towards the Temple' (*nell' andare al tempio*).[25] However, this interpretation of the events is completely different from the one given by the painter (and/or his advisors), since in the Masaccio fresco, Peter and John are not 'on their way to' the temple, but have just left it. In the background of the composition, at the end of the street taken by the Apostles, we see a portico ('Solomon's Portico', mentioned in the Biblical text) which Masaccio has only suggested, constrained perhaps by the lack of information regarding this mythical edifice. The tower suggests that the Solomon's Temple depicted by Masaccio resembles a church with its *campanile*. The position of this component has direct repercussions on the message of the image. The solemnity of the Apostles can be attributed to the fact that they have just left a holy place, as can their miraculous power. The power Peter's shadow is endowed with is nothing more than an outward manifestation of a *virtus*, acquired when he was in the mysterious depths of the temple.

56

Used to deciphering symbols, the spectators of the Quattrocento would probably have had no difficulty understanding the message. Moreover, they would have been sensitive to the other symbols in the image, which indicated that this faculty actually came from the heavens: Masaccio was determined to represent the obligatory blue rectangle in his fresco, towards which the tower of the 'campanile' was pointing, like a veritable hyphen between the 'portico' and the 'beyond'.[26] Through details like these, the artist was endeavouring to give everything in the text (and commentary) a very precise meaning in order to avoid ambiguities. To me, it is a process of symbolization through which Masaccio established an 'intense' relationship between the healing shadow (in the foreground) and the temple (in the background), or, to be more exact, between 'exceptional power' and the 'church' and, furthermore, between the shadow's exceptional power and the heavens, considered to be its real origin.

This whole procedure does not prevent the painter from approaching the representation of body projections as the product of the law of optics. The daylight that floods the whole scene comes from the top right-hand corner, and the same physical law can be applied to other 'interposed bodies', such as the roofs of the houses for example, which cast dark shadows onto the walls. We might even speculate over whether Masaccio's representation of John's shadow cannot be attributed to a need for coherence in the illustration of the same physical law, rather than to an attempt to endow it with powers that do not appear in the texts.

The full extent of the coherence of Masaccio's approach is revealed the moment we analyse the pictorial modalities of the lighting. It might at first glance appear strange that in this complex composition Masaccio made the light enter from the right-hand side of the scene. We know that painters usually chose to have the light entering from the left, as it was less awkward when it came to creating the image (for the right hand holding the stylus or brush would come between the source of the light and the surface to be painted). Cennini advises this in his *Libro dell' Arte* (chapter VIII):

But arrange to have the light diffused when you are drawing; and have the sun fall on your left side.

We have seen that during the Quattrocento (and this was the case with Giovanni di Paolo (illus. 8), who experimented with the problems of lighting in the period of transition between the two paradigms of representation) it was even possible to integrate the image of the sun in the left-hand corner of a composition to emphasize the 'authentic' nature of the projection of cast shadows.

We should therefore question the deep-seated reasons that led Masaccio to brush aside the established practice of lighting. It does not take long to find the answer. The Brancacci Chapel in S Maria del Carmine only had one window that opened onto the apse. Daylight streamed in from the right-hand side, to shine on the healing scene. It would therefore have been out of the question to *envision* another source to the left of the image. What Masaccio in effect does is to *incorporate* into his composition the light that comes from outside (real light from a real window). Consequently, the real lighting – which in this instance comes from the right – becomes part of the creation of the form.[27]

Cennini (chapter IX) had already anticipated this kind of problem:

> If, by chance, when you are drawing or copying in chapels, or painting in other adverse situations, you happen not to be able to get the light [*la luce*] off your hand, or the way you want it, proceed to give the relief [*el rilievo*] to your figures, or rather, drawing, according to the arrangement of the windows which you find in these places, for they have to give you the lighting. And so, following the lighting, whichever side it comes from apply your relief [*rilievo*] and shadow [*scuro*], according to this system.

Masaccio might appear to have contributed nothing to a process that was already familiar to the Trecento. But this is not the case. The significant difference can be found in the fact that the 'system' Cennini mentions refers to shading only. To him, therefore, lighting from the outside must be taken into account in the creation of reliefs and solid bodies (*rilievo*). Cennini would never have had the idea of exploiting real light in order to throw a cast shadow beyond the fictional area of his compositions. Indeed, it was a notion completely alien to him, and which would have involved depicting the inter-

posed figure as an actual obstruction to the passage of real light rather than a fictional body created by the artist.

This is exactly what Masaccio does in the Carmine fresco. As recommended by Cennini, the natural light constructs the relief (the almost statuesque bodies of the apostles are enough for us to understand the way in which Masaccio developed this procedure), and, obstructed by the 'solidity' of the bodies and painted forms, generates the enormous cast shadows. The natural light (the daylight from the concrete window) thus penetrates deep into the image, giving it a double structure that belongs to two worlds at the same time: that of fiction and that of reality.

It is surprising that the very first cycle from this emerging new art – the Carmine frescoes – includes a scene that, on a thematic level, enables (as no other does) a new aesthetics based on the relationship between body, space, shadow and light.[28] Masaccio, no doubt, made use of the whole of the *St Peter Healing* theme. This outcome is in keeping with his new conception on art, which Vasari defined as follows:

> [Masaccio] reflected that, as painting is nothing more than an imitation of all natural living things, with similar design and colouring, so he who should follow Nature most closely would come nearest to perfection. [. . . he] introduced movement, vigour and life into the attitudes, giving the figures a certain appropriate and natural relief that no painter had ever succeeded in obtaining before. . . . His works possess harmony and sweetness, the flesh-colour of the heads and of his nudes blending with the tints of draperies, which he delighted to make in a few easy folds, with perfect nature and grace. This has proved most useful to artists and for it he deserves as much praise as if he had invented it. For the things made before his time may be termed paintings merely, and by comparison his creations are real, living and natural.[29]

We could take this extract to be a simple collection of commonplaces. But it is also possible to see it as the product of an in-depth analysis of the aims and methods of Masaccio's figuration. Within the context of our discussion, we should note that in effect Masaccio created solid bodies (Peter and John as well as houses, rooftops and balconies) that possessed a half-real quality, as though they had been objects obstruct-

ing a genuine source of light and projecting shadows within the area portrayed. As a result of this, real light is 'fictionalized', and the area of the fiction is transformed into an extension of real space. It is an almost pointless exercise to add that such a feat could only be realized through the change of the representational paradigm introduced by the Renaissance, which submitted every image as a specular reflection, as an extension of reality.

In the light of this, we might also have expected Alberti's treatise on new painting to contain – within the concept of the image as a mirror of the real – the entire theory of this new art of projecting shadows, as illustrated by Masaccio's fresco. However, this expectation is not fully realized since Alberti is much more concerned with the relationship between light and colour than with the creation of cast shadows.[30] When he does cover this last point, there is a preoccupation with its wider assimilation into a theory of specular reflection. Thus, when he first defines the shadow (*De Pictura*, I, 11), he does so in the simplest possible way: 'A shadow is formed when rays of light are intercepted'. What distinguishes Alberti's text, is that once this statement was written down, he stopped examining the shadow (what was happening behind the interposed body), and concentrated on what happened to sunlight when it was obstructed by a solid body:

> Rays that are intercepted are either reflected elsewhere or return upon themselves. They are reflected, for instance, when they rebound off the surface of water onto the ceiling.[31]

This is how the first definition of the shadow became transformed into a dissertation on reflection.

He returns, however, to the problem in his second book (II, 46–7), where he deals *in extenso* with the relationship between shadow and colour:

> I would consider of little or no virtue the painter who did not properly understand the effect every kind of light and shade has on all surfaces. . . . To avoid condemnation and earn praise, painters should first of all study carefully the lights and shades, and observe that the colour is more pronounced and brilliant on the surface on which the rays

of light strike, and that this same colour turns more dim where the fire of the light gradually grows less. It should also be observed how shadows always correspond on the side away from the light, so that in no body is a surface illuminated without your finding surfaces on its other side covered in shade. But as regards the representation of light with white and of shadow with black, I advise you to devote particular study to those surfaces that are clothed in light or shade. You can very well learn from Nature and from objects themselves. When you have thoroughly understood them, you may change the colour with a little white applied as sparingly as possible in the appropriate place within the outlines of the surface, and likewise add some black in the place opposite to it. With such balancing, as one might say, of black and white a surface rising in relief becomes still more evident. Go on making similar sparing additions until you feel you have arrived at what is required. A mirror will be an excellent guide to knowing this [*iudex optimus speculum / sarà buono giudice lo specchio*]. I do not know how it is that paintings that are without fault look beautiful in a mirror; and it is remarkable how every defect in a picture appears more unsightly in a mirror. So the things that are taken from Nature should be amended with the advice of the mirror [*speculi iudicio emendentur / si emendino collo specchio*].[32]

I think it would be difficult to find more lucid evidence (in this apparent lack of theoretical intent) regarding the control to which the mirror paradigm, from the moment of its birth, subjected new painting – including the use it was to make of light and shade. Beginning with Alberti, who, we should not forget, situated the actual birth of painting with Narcissus, the mirror as a way of controlling the mimetic image was to enter the work of the artist's workshop/studio and remain there for a long time. A few decades later, Leonardo da Vinci also explored the process in a well-known passage from his unfinished 'Treatise on Painting', where he actually explains what appeared in Alberti to be more of a conjecture ('I do not know how': *nescio quo pacto/né so come*):

When you want to see if your picture corresponds throughout with the objects you have drawn from nature, take a mirror and look in that at the reflection of the real

things, and compare the reflected image with your picture, and consider whether the subject of the two images duly corresponds in both, particularly studying the mirror. You should take the mirror for your guide – that is to say a flat mirror – because on its surface the objects appear in many respects as in a painting. Thus you see, a painting done on a flat surface displays objects which appear in relief, and the mirror – on its flat surface – does the same. The picture has one plane surface and the same with the mirror. The picture is intangible, in so far as that which appears round and prominent [*tondo e spiccato*] cannot be grasped in the hands; and it is the same with the mirror. And since you can see that the mirror, by means of outlines, shadows, and lights [*ombre e lumi*], makes objects appear in relief, you, who have in your colours far stronger lights and shades [*ombre e lumi*] than those in the mirror, can certainly, if you understand how to put them together well, make also your picture look like a natural scene reflected in a large mirror.[33]

I should point out immediately that, unlike the previously quoted passage from Alberti, Leonardo regarded the mirror to be more like a term of comparison. The correlation relies on the relationship of principle between the surface of the painting and the surface of the mirror. Each is two-dimensional and allows one to picture a three-dimensional reality thanks to the relationship between light and shade. In his heavily annotated papers, Leonardo returned more than once to these considerations.[34] One of the most notable contributions to issue from his reflections is that he was the first to offer a theory of the relationship (which Masaccio had already sensed) between cast shadow and perspective space:[35]

Shadow is the obstruction of light. Shadows appear to me to be of supreme importance in perspective, because without them opaque and solid bodies will be ill defined.[36]

In one of his manuscripts (illus. 11) he pictures a candle placed in the hole of a shelf throwing a spherical shadow onto a wall. The result is a projection that could be interpreted as being an emanation of the wall itself. Leonardo thus leads us to assume that the projection of the shadow and the perspective projection are identical processes.

11 Leonardo da Vinci, study of shadow projection, *c.* 1492. Bibliothèque de l'Institut de France, Paris.

12 Albrecht Dürer, study of shadow projection, from his *Underweysung der Messung?*, Nuremberg, 1525.

13 Leonardo da Vinci, study of shadow projection, *c.* 1492. Bibliothèque de l'Institut de France, Paris.

Gleicher weyß wie ich den cubus in ein abgestolen gemel gebracht hab/also mag man alle corpera die man in grund legen vnd auffiehen kan /durch solliche weg in ein gemel pringen.

willich vnderweyssen /wie man ein yetlich ding das man sihet /vnd mit fast wert sta durch rineffen vnd dardurch in ein gemel pringen mag.

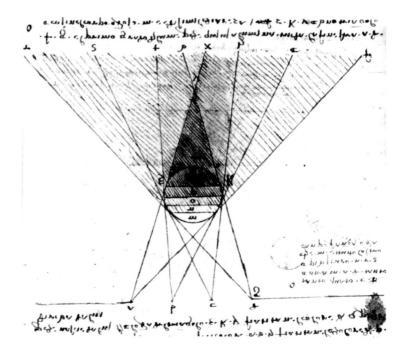

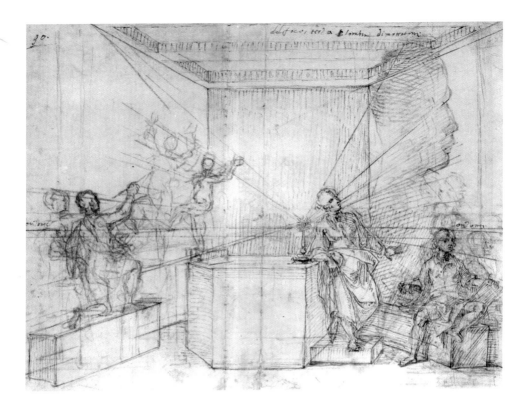

Another question that preoccupied him greatly was that of the shadow's contours. In a drawing in the *Codex Huyghens* (illus. 14), quite clearly influenced by Leonardo's teaching,[37] we are shown an experiment: a candle has been placed on a pedestal in the centre of the room and projects shadows on the wall that increase in proportion to distance. A painter (we can presume it is a studio/academy) outlines the shadow of a statuette on the wall. The experiment demonstrates that those in 'Leonardoesque' circles were familiar with the Plinian fable on the origin of painting. No one is sure what the drawing means since instead of being solid (as it was in the original fable), the delineation of the contour is ambiguous, unclear and composed of recurring, criss-crossing and overlapping lines.

Leonardo repeatedly returned to the theory of the ambiguity of the shadow's contour that is only alluded to in this drawing. For example, in the experiment described in 'manuscript A' which is held in the library of the Institut de

14 School of Leonardo da Vinci, study of shadow projection, after 1500. The Pierpont Morgan Library, New York.

France (illus. 13), he pictures a sphere illuminated by a window. He makes a distinction between the 'primary shadows' to be found *on* the sphere and the 'secondary shadows' projected by the sphere and *behind* it. At the heart of this conflict, Leonardo observed a gradation in the intensity of the shadow and insisted that it was impossible to actually determine the contour. As a result of this, he justified his famous *sfumato* – a new technique – destined to circumvent not only the contours of objects but also those of shadows.

Within this context, it is probably significant that another artist, Dürer, the product of a very different school of thought when it came to the creation of forms, would, on the other hand, have insisted on the edges of shadows being defined. He was presumably familiar with some of Leonardo's theories. However, he developed them by introducing a major innovation: he replaced the object of the experiment – the sphere – with a cube (illus. 12). Thus the contours of the shadow became sharper. As with the Italian master, it is a projection *grosso modo* defined by perspective. And yet more than one ambiguity has been detected in Dürer's engraving that illustrates the perspective of shadows.[38] One of these involves this particular example, where the source of light is the sun, although – given the abstract nature of the demonstration – it must have been no more than a dot. By doing this, I feel he was drawing attention to the fact that the rules illustrated here involve 'everything that is to be found under the sun'.

This, however, raises an important issue. If Leonardo and Dürer theorized – each in his own way – the projection of the shadow as a particular attribute of all three-dimensional representations, how can we explain that the practice of pictorial art was, after these theoretical adjustments had been made, so cautious, so avaricious even, when it came to representing the cast shadow in painting? It is not necessary to be a great connoisseur to recognize that there are very few concrete examples available in which all the theoretical achievements of the projection are brought into play. If artists had systematically and indiscriminately applied the laws that exist to form cast shadows, by depicting *all* the shadows of *all* the objects produced by the light, their paintings would have been a lot less attractive. That is why, from the time of the

Renaissance onwards, a veritable science of the shadow evolved that was soon to be integrated into the teaching of academies of art, while the practical application of its requirements was carefully controlled. To a certain extent, the need to respect the representation of shadows already existed with Leonardo, but it would not be conclusively validated until much later:

> The Painter is not at first satisfied with nature as he happens to see it, he knows that in relation to the use he wants to make of it, it is nearly always defective, and that in order to render it perfect, he must turn to his art which has taught him how best to select its visible assets. Light and shade are just as much a visible asset of nature as are the contours of the human body, its demeanour, the way the draperies hang and everything else that composing a painting entails. All these things necessitate a choice, and so do light (and shade).[39]

Or even more explicitly:

> He who invents objects is in charge of arranging them in such a way that they receive as much light and shade as he wants them to have in his painting.[40]

Artists had for quite a long time been applying this practical axiom, so decisively spelt out by Roger de Piles at the beginning of the eighteenth century. They had understood that a representation of cast shadows was evidence of a mimetic fidelity to nature, although it had above all to be meaningful, and therefore required a clear thematic justification. Without this thematic justification, the images would have been ludic, like the background strewn with cast shadows in Giovanni di Paolo's *Flight into Egypt* (illus. 8). It is a happy coincidence that the work which launched perspective painting – Masaccio's cycle for the Brancacci Chapel (illus. 16) – raised the question of representing the cast shadow on a formal as well as on a symbolic level. In the scene depicting *St Peter Healing*, the shadow was crucial in two ways: as a narrative agent and as a proof that the huge figures of the Apostles were 'really' obstructing a source of external light as though they had been made of flesh and bones.

In an attempt to summarize the conclusions reached so far we can say that the artists of the Trecento (as demonstrated in Cennini's handbook) considered shadows to be an essential element in the creation of figurative 'reliefs'. With Masaccio and thanks to Leonardo's and Dürer's theoretical achievements, the cast shadow became a prerogative of perspective painting, and evidence of the 'reality' of all bodies obstructing a source of light.

We could at this point, cite a whole series of examples from Italy as well as Northern Europe that demonstrate with what evident and masterly delight artists experimented with these new elements of the construction of forms. We could also cite numerous other examples, where artists were quite obviously influenced by dictates of a thematic order, justifying – if not suggesting – the figuration of the cast shadow. I shall now deal with a radical example – crucial to Western representational philosophy – of the figuration of the shadow.

In St Luke's Gospel (1:26–38), the story of the Incarnation is interpolated with a complex dialogue between the Angel and the Virgin. Gabriel's announcement ('Thou shalt conceive in thy womb, and shalt bear a son, and shalt call him Jesus') amazes Mary: 'How can that be, since I have no knowledge of man?' To which the angel answers: 'The Holy Spirit will come upon thee, and the power [dynamis / virtus] of the most High will overshadow thee [episkiazein / obumbrabit]. Thus this holy offspring of thine shall be known for the Son of God.'

There are few passages from the Gospels that have been commented on as much as this one. This can be attributed to the enigmatic nature of Gabriel's replies, which do not, however, seem to alarm the Virgin: 'And Mary said, Behold the handmaid of the Lord; let it be unto me according to thy word.'

Scholars who have deliberated over the meaning of 'the power of the most High will overshadow thee' (virtus altissimi obumbrabit tibi) have come up with several possible interpretations. One of these originates from the notion that the Greek word (episkiazein) used by Luke, and the later Latin version (obumbrare), only partially translate the now archaic meaning of the prosaic Eastern (Semitic) expression that inspired this extract. It refers to the shadow's magical faculty

in general, and in this instance to its fertilizing power in particular. We should not forget that a similar reference to the shadow's extraordinary power (in this case healing) also appeared in the story from the Acts of the Apostles, where the same word was used in the original Greek (*episkiazo*).[41] The magical power of the Most High would therefore have been responsible for making Mary pregnant. A second and more modest explanation also relies on the semantics of ancient languages, where 'to take someone in (under) your shadow' signified offering them your protection.[42] A third, and final, explanation is based on an interpretation of neo-Platonic origin (previously proposed by Theophylactus and Philo Judaeus of Alexandria): the verb *episkiazo* referred to an activity similar to that of making images. The angel was therefore saying that in the Virgin's womb God would form (that is to say would make a first sketched image of) the 'shadow' of himself: meaning Christ.[43]

It is interesting to note that the apocryphal versions that circulated throughout medieval Europe would sometimes endeavour to avoid all these problems of interpretation by resorting to a metaphoric and highly suggestive language:

Par le salu, que l'ange dist,
Par la destre oreille i entra
Jhesu, quant il s'i en ombra
Through the greeting spoken by the angel, Jesus entered the left ear, where he became a shadow.[44]

The image of the Verb 'becoming a shadow' in the Virgin could be applied to any of the three possible interpretations quoted above!

The iconography of the Annunciation had to take into account these constantly debated alternatives – hence the great diversity of solutions addressed by painters. But the polysemy of Luke's text remained an established and accepted truth. Jacobus de Voragine felt the need to add a few explanations in his book *The Golden Legend*, which, from the end of the thirteenth century became the artists' guidebook as to how to illustrate the Holy Story:

Then the angel informed her, and began to say how her virginity should be saved in the conceiving of the Son of God, and answered to her in this manner. The Holy Ghost

shall come in to thee, which shall make thee to conceive: the manner how thou shalt conceive thou shalt know better than I can say, for that shall be the work of the Holy Ghost, which of thy blood and of thy flesh shall form purely in the body of the child that thou shalt bear, and other work to this conception shalt thou not do. And *the virtue of God sovereign shall shadow thee* in such wise that thou shalt never feel in thee any burning ne covetise carnal, and shall purge thine heart from all desires temporal, and yet shall the Holy Ghost shadow thee with the mantel corporal, that the blessed Son of God shall be hid in thee and of thee for to cover the right excellent clarte of his divinity; so that by this ombre or shadow may be known and seen his dignity; like as Hugh of St Victor and St Bernard say. After, the angel said: And for as much as thou shalt conceive of the Holy Ghost and not of man, the child that shall be born of thee shall be called the Son of Man.[45]

I shall do no more than summarize the interpretations to be found in *The Golden Legend*. There are three: the *obumbrabit* is an allegory of the incarnation; the shadow is a symbol of the secret which hovers over the incarnation; metaphorically, the *obumbrabit* implies that the incarnation is a 'cold' conception, devoid of carnal knowledge.

It is obvious that the first interpretation, which appealed to the neo-Platonic metaphysical tradition of light, and which Jacobus de Voragine subscribed to, without, however, enforcing it absolutely, lent itself to the most sophisticated of the figurative illustrations. A brief overview of these is most enlightening.

In a small diptych illustrating the Annunciation, c. 1440, which is part of the Frick Collection in New York (illus. 17, 18), the Florentine painter Filippo Lippi depicted the angel Gabriel in the left-hand panel and the Virgin in the right-hand one. There was nothing new in the idea of creating what is effectively a spatial caesura between the two agents of the story. It stemmed from the necessity to demonstrate that the incarnation took place without there being any kind of contact between the messenger and the Virgin. Artists very often placed a pillar between the two characters that was both a sign of 'separation' and a long-standing codified symbol of Christ's incarnation.[46]

No-one knows what the Frick diptych was originally like, but it is presumed (also by the curators of the Frick) that the first frame probably contained a small interposed central column. Although the thematization of the dialogue between the two characters is helpful, a considerable effort is required on the part of today's spectator for the scene to have any kind of spatial unity. However, alongside the sign of continuity there are signs of a split; the most important has to do with the production of the shadows. Daylight streams in from the left, that is to say the side from which the angel enters and the large shadow of the celestial messenger is projected onto the ground. This shadow has more than one significance. It demonstrates that the angel is not an apparition but a physical entity. The fact that the shadow is there at all and that it is directed towards the Virgin Mary could have resulted in inopportune conclusions being drawn, particularly within the context of the famous phrase relating to its magical powers. This would account for Lippi's rather abrupt obstruction, which prevented it from entering the panel occupied by Mary. The area in front of the Virgin's feet is empty. However, a spectre rises on the wall behind her, to which she indirectly draws attention with a gesture that initially implies that she fully accepts her destiny. Though seeming inadvertently to draw attention to this shadow, Lippi integrates it into the story's temporality and well-structured symbolism. I do not think I am mistaken if I claim that this painting depicts the instant of *obumbrabit*. In answer to the Virgin's question 'How can that be?' (*Quomodo?*), Gabriel has just given his mysterious reply ('The Holy Spirit will come upon thee, and the power of the most High will overshadow thee'). And the Holy Spirit, in the form of a dove, is in fact already brushing against her lightly while the light from an invisible external source strikes the Virgin's body and projects her shadow onto the wall. What we see is a kind of movement, an inversion even: for although the angel's shadow is suddenly blocked, it is the Virgin's (illuminated) cast shadow that connects with the idea of the Lord's shadow being cast on or in her. The acceptance (the *fiat*) that marks the actual moment of the incarnation has already taken place: the Virgin has opened her mantle, her belly is exposed to the action of divine power, the dove brushes her lightly. Recent studies have drawn attention to the absence of any objects or emblems, such as the book, *prie-Dieu* or made-up bed –

traditional in Tuscan Annunciations. The unusual nature of the gestures of the two characters has also been subject to ample comment.[47] It is my opinion that by offering us a more circumscribed interpretation founded on the symbolism of the shadow, Lippi is moving away from traditional iconography. This cannot be understood unless it is seen as an integral part of the *mise-en-scène* of that critical moment of the Incarnation.

The full extent of Lippi's narrative and symbolic integration of the shadow can only be appreciated if we compare the Frick diptych to its likely sources of inspiration. It is highly probable – and this has been purported time and again – that the underlying impulse, as far as cast shadows were concerned, came from the early Netherlandish painters. Van Eyck and his contemporaries had popularized the depiction of the Annunciation on the outer panels of triptychs, using the grisaille technique. This method allowed for the creation of optical illusions, and conferred on non-religious paintings the status of images bordering on reality.[48] One of the elements of the plastic language used to accentuate the actual volume of these figurative objects was the cast shadow. We need do no more than look at one of these famous experiments, Jan van Eyck's triptych in Dresden (illus. 19), for example, to understand how sophisticated the deceitful game had become[49] – and which had impressed the Italian connoisseurs of the Quattrocento so much.[50]

The whole of van Eyck's representation is actually split: figures (the angel, the Virgin), emblem-objects (the fleur-de-lis) and symbols (the dove). Within this context it is almost impossible to decide with any accuracy whether the Virgin's shadow is the product of a more complex symbolism. In the absence of any 'definite' signs, this can neither be proved nor disproved. On the other hand, Lippi's symbolization is conspicuous. But if it is based on what he has learned from van Eyck, then it is so that he can apply it by integrating it into the story. If in van Eyck the statues' shadow is produced by their simulated volume, then in Lippi, who makes stone look like flesh once more, the shadow becomes the figurative manifestation of actual presence. The narrative's highly reflective style becomes even clearer when we compare it with other works of art produced during the fourth decade of the Quattrocento, which raise problems similar to those raised by the Frick diptych.

The large *pala* that adorns the altar of the church of S Lorenzo in Florence was painted by Lippi *c.* 1440 (illus. 15). Like the Frick diptych it illustrates the Annunciation. Since it is impossible to establish which was painted first,[51] we can do no more than underline differences in function and format: while the work in Florence is a church altarpiece, the Frick diptych was probably destined for private devotion. The method of presentation used in the altarpiece is extremely complex and highly evolved as far as the spatial unity of the elements in the previously mentioned diptych are concerned. We move through the imitation frame of the portico into an area whose perspective is unified by the perspective of the buildings and trees in the background. The dividing pillar, whose function it was to define the structure of the diptych,

15 Filippo Lippi, *Annunciation, c.* 1440, tempera on wood. S Lorenzo, Florence.

16 Masaccio, *St Peter Healing the Sick with his Shadow*, 1427–8, fresco.
Brancacci Chapel, S Maria del Carmine, Florence.

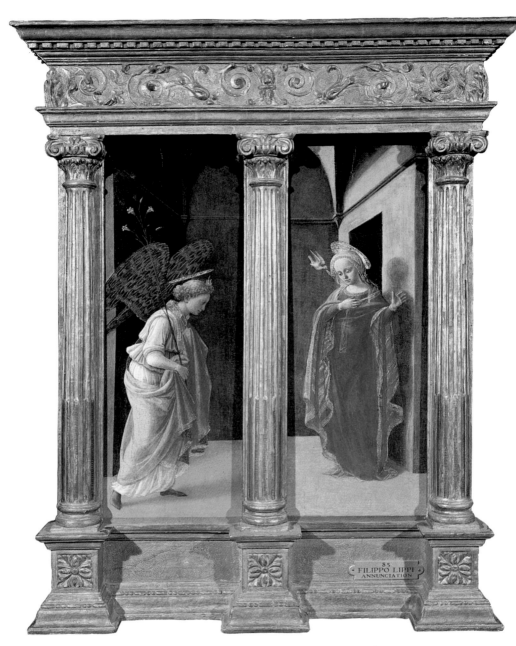

17 Filippo Lippi, *Annunciation*, c. 1440, tempera on wood, two panels.
Frick Collection, New York.

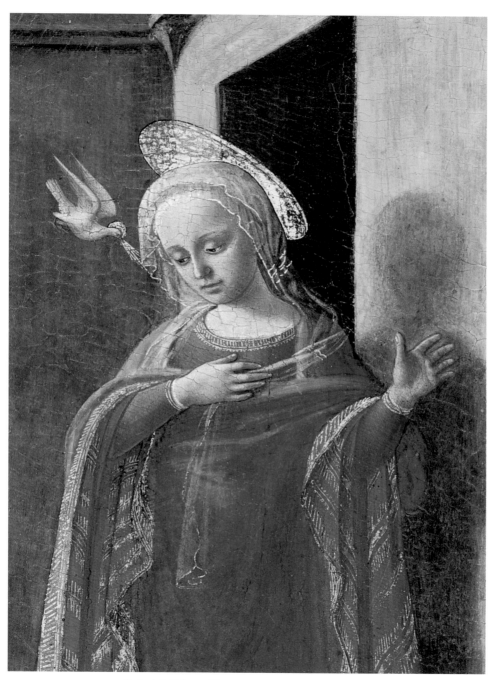

18 A detail from illus. 17.

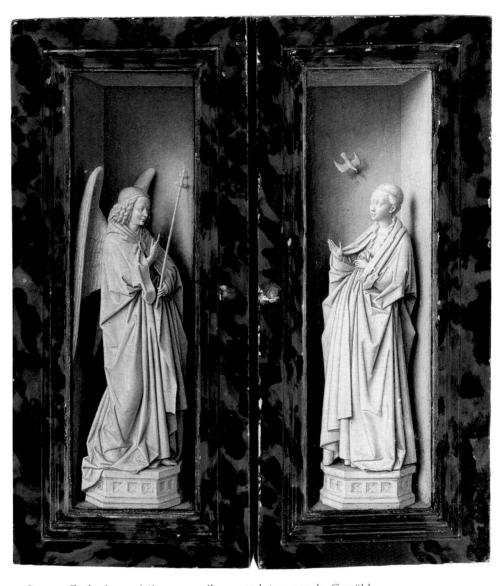

19 Jan van Eyck, *Annunciation*, 1437, oil on wood, two panels. Gemälde-
galerie Alte Meister, Dresden.

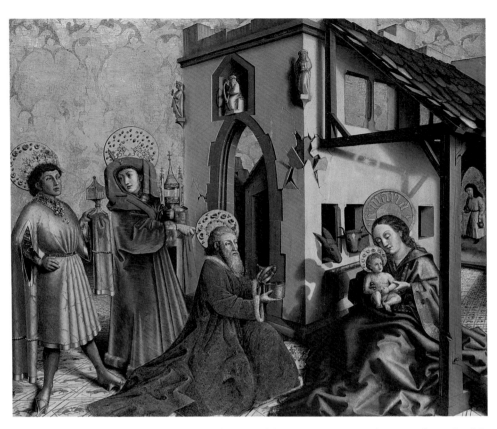

20 Konrad Witz, *Adoration of the Magi*, 1444, wing from a polyptych of *St Peter*, tempera on wood. Musée d'Art et d'Histoire, Geneva.

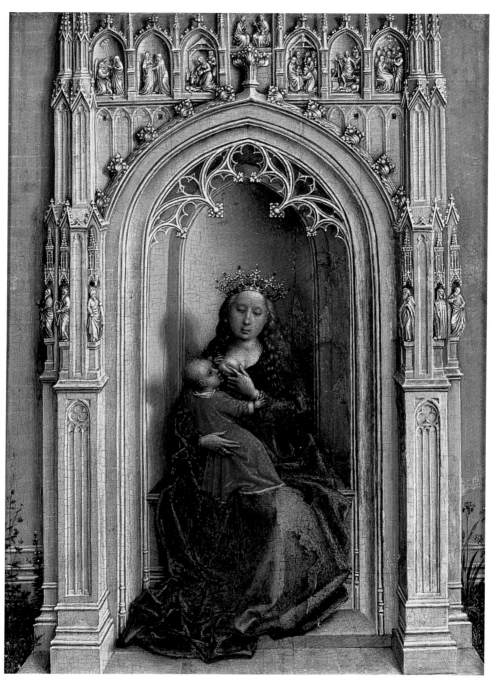

21 Rogier van der Weyden, *The Virgin and Child*, c. 1433, oil on wood.
Fundación Colección Thyssen-Bornemisza, Madrid.

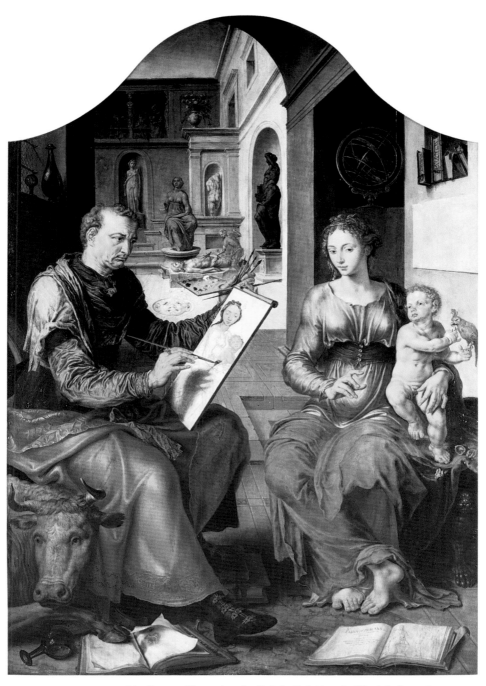

22 Martin van Heemskerck, *St Luke Painting the Virgin's Portrait*, *c.* 1553, tempera on wood. Musée des Beaux-Arts et d'Archéologie, Rennes.

23 Marie-Louise Elisabeth Vigée-Lebrun, *Self-portrait*, 1790, oil on canvas.
Uffizi, Florence.

has become a pilaster, located between fiction and reality. It transforms the 'diptych' – both as a representation as well as a panel-object – into a single scene, since it covers and hides the join between the two pieces of wood that act as the physical support of the image.[52] We might wonder in fact whether it still contains something of its original symbolic function. The question becomes more urgent when we realize that the angel in the image has crossed it and entered the area reserved for the Virgin.[53]

There are other narrative signs that reinforce the idea of transcendence. The first is probably the fragment of Gabriel's cloak that we can just see behind the pilaster. Another is the Virgin Mary's attitude, for she reacts to the angel's appearance with a gesture that expresses the 'profound consternation' (*conturbatio*) of which the exegetes speak.[54] Her reticence and fear are not only a reaction to the angel who is already kneeling quietly as a mark of respectful greeting, but also (or rather) to his shadow. If in the Frick diptych the dark stain projected by Gabriel was broken by the caesura of the two panels, in the S Lorenzo altarpiece it accompanies him on the journey he makes from left to right, transcending with him (before him even) the pilaster-column marking the boundary beyond which he should not pass.

In the diptych (illus. 17) Lippi accentuates the fact that the angel's shadow does not touch the Virgin and that the *obumbrabit* is the direct result of the light falling on Mary's body. In the altarpiece (illus. 15, 24) he exploits the same idea but through a more complex symbolic translation. Between the angel and the Virgin Mary, where the column representing the Incarnation usually stands, in a foreground that is ambiguous since it belongs as much to the image as to the spectator's 'real' space, Lippi has inserted a transparent vase of geometric as well as symbolic value. The Italian artist was probably once again inspired by Flemish paintings[55] where the vase symbolized Mary's purity. But the symbolic role Lippi bestows on this object is more complex, and its positioning at the boundary between two worlds, more expressive. The painter's intentions would have been obvious not only to anyone possessing great theological knowledge but also to the average onlooker/believer. Experts have pointed out that Italian hymns had for a long time conveyed the idea illustrated by Lippi and that contemporary theolo-

gical opinion had also written extensively on the theme of light penetrating the vase without destroying it.[56] The small shadow cast by the decanter in the S Lorenzo *Annunciation*, on the 'spot' where the incarnation takes place, is the metaphor of the latter. In relation to the Frick diptych, Lippi has performed an extrapolation, indeed a translation; for he has placed 'before the eyes' of the spectator (at the edge of the painting), what in the diptych was placed in the narrative.

This said, and out of respect for the process that engendered the painting, we should go no further in our analysis. Any attempt to describe the shadow (or its significance) more explicitly would be to misunderstand it, for Lippi's intention was that it should depict – not the fathomable, but its absolute opposite: the mystery. Although, in response to the demands of hermeneutics, we could say that to Lippi the shadow as a symbol, is *an interminably interpretable symbol*.

It is fortunate that during the fifteenth century the imagery of the shadow was able to offer us examples where a similar (but not identical) problematic unfolded on a level that is more easily understood. Let us take the example of Konrad Witz, an artist who originated from the south of Germany but who worked in what is now Switzerland.

Witz had assimilated the Flemish experiments with the projection of the shadow.[57] He proved to be remarkably enlightened on the subject and exploited his knowledge with extraordinary wit, which is probably why he loved commenting on the significance of his name (Konrad Witz / *Conradus Sapientis*). He was, among other things, a leading expert on shadows cast by objects outside the area of the painting, which gave him the opportunity to create humorous conversations between spectator and image. This unusual approach, whose experimental nature is intensified by his use of archaic gold backgrounds, warrants a special study, but one that would take us beyond the dictates of this work. I therefore propose to limit my analysis to just one of his pieces, the *Adoration of the Magi* of 1444, a panel from the altarpiece dedicated to St Peter (illus. 20). In depicting this scene, the artist has virtually abandoned the style of projection that typifies his work. There are in fact plenty of shadows, but almost all of them have been created by the light – falling from above right – being obstructed by objects and people in the area of the representation. The perspective lines of the shadows cast by the beams, the projection of the silhouettes of the Three Kings on the geometric tiling and the Flemish-inspired study of the relationship between statues, light and space are all admirable. But, by being placed at the very centre of the scene, the shadow that dominates the whole composition is the one cast by Christ and Mary on the wall of the Bethlehem stable.

We are also struck by the fact that the shadows' profiles do not correspond exactly to their models. A possible explanation for this might be that the heads of Mary and her Child were retouched afterwards. But would these adjustments have altered Jesus' attitude so radically? He, seated in his mother's arms, is looking outside the painting towards the luminous source, while his shadow, projected on the wall, seems to be looking at the kneeling King, and, moreover, seems to be conversing with him as He stretches out His hand to receive

the gift. What we have here is the shadow being integrated into the narrative, a process that will require further explanation. However, we cannot do this without first examining the whole scene carefully.

The text on which Witz's illustration is based comes from the Gospel according to St Matthew (2:9–11):

> They [the Kings] went on their journey; and all at once the star they had seen in the east was there, going before them, till at last it stood still over the place where the child was. They, when they saw the star, were glad beyond measure; and so, going into the dwelling, they found the child there, with his mother Mary, and fell down to worship him; and, opening their store of treasures, they offered him gifts, of gold and frankincense and myrrh.

It is not difficult to spot the differences between Witz's depiction of the scene and the original text. They are the product of a long and complex exegetic and iconographic tradition.[58] These are much more than simple anomalies, they are extra, innovative details of which the text does not speak. The most important of them, the shadows for example, stem exclusively from the 'mise-en-scène'. They could hardly have a meaning in the written account, but they are central to the pictorial version. The painting also introduces innovations of a more general nature, in the décor for example. The modest Bethlehem stable is in fact an elegant old building, fallen into ruin. While the roughly rendered walls of the house are in a state of decay, its entrance is adorned with statues, still visible signs of its former splendour. These factors are obvious allusions to a school of thought that believed that with the birth of Christ (or, to be more precise, the incarnation of the Verb) would come the fulfilment of Old Testament prophesies regarding the restoration of the Ancient Temple. Within the framework of this tradition, there is a theory Witz seems to have been familiar with, namely the one connecting the Bethlehem stable with the ruins of David's ancient palace.[59] As was also the case with the early Netherlandish painters, the three statues are not without significance. The Kings and prophets portrayed are those who had – one way or another – predicted the Incarnation. They and their particular message have already been identified by the experts.[60] However, the figurative modes through which this message is transmitted

have never been analysed. If we examine these statues carefully we note that they recall the Flemish tradition of cast shadows. But the artistry of the exercise does not fully explain why they are there. In my opinion it was Witz's intention to revive the *topos* of sacrifice and redemption that, in the Old Testament, were manifested *in umbra, in figura, in typo, in mysterio, in prefiguratione*, although, in actual fact, it was only in the incarnation that they manifested themselves *in veritate*.[61] 'Figures' and 'shadows' each watch the part of the scene unfolding before this portal: Solomon, portrayed on the left, had foretold (Psalms, 72:1–11) that all the Kings would make an offering and prostrate themselves before the Saviour. David had also confirmed that 'kings' shall 'bring presents unto thee' (Psalms, 68:29), while Isaiah had spoken the prophetic words according to which 'the ox knoweth his owner, and the ass his master's crib' (Isaiah, 1:3). The prophesies and homage paid by the Three Kings who carry out these prophesies are attributable first and foremost to the divine nature of the new-born Child. But by inserting the Child's shadow between Jesus and the Magi, Witz is exalting His human nature.

It is important to avoid disparaging over-simplifications. The shadow of Christ is that of the Verb made flesh. In the Epiphany scene, at the precise moment when Christ 'is shown' and 'shows himself', the shadow is there to prove that the actual presence of divinity has entered a body. In the complex theological climate that probably inspired the birth of this painting, the representation of Christ's shadow, which leads to him having the same density as his mother, was determined by the need for the reality of the incarnation to be visible. The wise and witty Witz would no doubt have loved playing around (maybe he did anyway) with the words *epiphaneia / ostensio evidentiae* and *skia* as contemporary intellectuals did when referring to the representation of divinity in its physical form.[62] He might have arrived at this complex *'mise-en-scène'* (and probably did) through the narrative evolution of an iconic idea already used by such early Flemish painters as Rogier van der Weyden.

In the small *Virgin and Child* (illus. 21), for example, Rogier also uses the cast shadow to signify 'real presence'.[63] It is also interesting to note that he resorted to using prophetic figures: here the prophets of the Incarnation are tiny statuettes in the

left-hand pillar of the niche, while in fake relief framed by Gothic arches above the niche we are reminded of the story of the Verb made flesh, from the Incarnation to the Resurrection.

If we now return to Konrad Witz's work we see how the scene has been composed in his own inimitable narrative style. His insistence on the 'angularity' of David's house is striking. It resembles an axis on which the symbols of the Redemption are arranged: the prophesy 'as shadows and figures' of the imminent Salvation, the destruction of the old world, the shadow of Christ. It is advisable to interpret this axis of figures and symbols in correlation with the one displayed on the horizontal of the narrative line. On the left, the kneeling King offers the child myrrh (it is the shadow that leans forward to accept the gift). On the right we see the crib, from which the Virgin has just taken the Child to present Him to the visitors. And it is to the crib that the second King is pointing, to the area in fact where the symbols link up, one after the other. Let us endeavour to decode them.

In all the traditions that deal with the Epiphany, myrrh always denotes the Child's tragic destiny – the fact that he will die to save humanity.[64] The crib in turn is a symbol of the altar, where the Eucharistic sacrifice takes place.[65] Another tradition, not overlooked by Witz, maintains that the wonderful star would not only have been there to guide the Magi to the place where the divine Child lay, but that it would also have announced his future crucifixion.[66] The fairly special place given the star by Witz – superimposed onto the cruciform projection of the framework – is tantamount to a premonition. Moreover, we should of course add the split introduced by the Child's shadow, which accentuates the real presence of the body in the sacrifice that will be required for Redemption.

We have reached a point where a conclusion is imperative. In order to do this we need one final example, which, because it is so unusual, is equivalent to a true reflection on the status of the representation of Christ. I am referring to a painting thought to be by Pier Maria Pennacchi (1464–1514/15) that is now in Parma's Galleria Nazionale (illus. 25).[67] The painter is a minor artist, familiar with the choices made by Venetian artists like Giovanni Bellini or by Antonello da Messina. The painting is an isolated work, whose original function and

25 Pier Maria Pennacchi, *The Redeemer Blessing*, c. 1500, oil on wood. Galleria Nazionale, Parma.

significance are unknown. The Redeemer is standing with a book in his left hand, while with his right he is in the act of blessing. It is without a doubt a representation that develops the ancient elements of the image of adoration as represented by the icon. Its innovative aspect resides in the presence of the shadow, produced by a projection that forces the actual geometric factors to give the painting its meaning. From the outset we are tempted to see signs of an imaged discourse on the double nature of Christ. However, it is important not to forget that which the doctrine of the icon has never ceased to repeat: that the painted image is *only* possible *thanks to* the Incarnation and that it *only* represents Christ Incarnate.

This Cinquecento painting is in effect a very enlightening anachronism. It is an icon of the Renaissance, that is to say of the era that created the image through the instruments of the triumphant mimesis. What we see is indeed 'the Christ', the verb incarnate. The book symbolizes the Logos, the shadow is confirmation of the flesh.

3 A Shadow on the Painting

We should remind ourselves of Cennini's advice in chapter VIII of the *Libro dell' Arte*:

> But arrange to have the light diffused when you are drawing; and have the sun fall on your left side.

The meaning of this dictate leaves us in no doubt: since the artist draws with his right hand, any light falling next to him would project the shadow of his hand onto the sheet of paper, thus obscuring his creation in a most irritating fashion. The significance of Cennini's words is even clearer when we read them in the context of the passage they close:

> ... run the style over the little panel so lightly that you can hardly make out what you first start to do; strengthening your strokes little by little, going back many times to produce the shadows. And the darker you want to make the shadows in the accents, the more times you go back to them; and so, conversely, go back over the reliefs only a few times. And let the helm and steersman of this power to see be the light of the sun, the light of your eye, and your own hand [*la man tua*]: for without these three things nothing can be done systematically. But arrange to have the light diffused when you are drawing; and have the sun fall on your left side.

He is obviously referring to a process that requires great skill, which the slightest impediment could upset. Soft light streaming from the left is a guarantee of success.

AUTOMIMESIS

If this was one of the criteria of the apprenticeship of drawing, we would be justified in wondering why a painter like the Dutchman Maerten van Heemskerck did not observe it. In the painting of *c*. 1550 that depicts *St Luke Painting the Virgin's Portrait* (illus. 22, 26) he seems to have completely ignored old Cennini's advice, for the painter's right hand casts a dark shadow onto the small board on which he is working on the

26 Detail of illus. 22.

early stages of a Virgin and Child. The projection is clear: we can see the fingers and tip of the brush perfectly.

The whole composition has the appearance of a paradox: in creating the image, hand and brush touch the projection of their own shadow when they are close to the surface of the representation. All these details are too obvious, too forceful, for them not to have well thought-out relevance.

This painting was produced after van Heemskerck had returned to the Netherlands after a long stay in Italy. It is really the work of a humanist painter, familiar with the whole new artistic concept that evolved in Italy in the mid-sixteenth century. Though he might not have had first-hand knowledge of Cennini's text (which is highly likely), he would nevertheless have been aware of the limitations and major obligations of studio life. This might even have been the principal theme of his painting,[1] for we know that St Luke the Evangelist was the patron of painters. In the first chapter of his *Libro dell' Arte* Cennini himself referred to Luke as the 'first Christian painter'. In van Heemskerck's painting Luke is portrayed as a humanist painter, surrounded by scientific books and objects. He is seated in the *cortile* of a Roman palace, where a sculptor is busy at work in the background. The area is furnished with antiques, and one of the statues could be regarded as a 'classical' model of the Virgin (who is actually posing in the foreground) or even an element of comparison (*paragone*) between painting and sculpture, between new art and classical art. In the middle distance, where the action takes place, there is an abundance of technical details: the artist's palette is displayed so that we can see the colours, and the upper half of the board on which the portrait of the Virgin and Child is being sketched is also visible: the daylight, which would have been much too strong for Cennini's taste, floods it. The state of the portrait indicates that the representation is still in its very early stages: the painter is working on the outline of the drawing and of the incarnate. The 'shadow of the hand' that runs over the 'shadow of the flesh' contains a serious and double transgression: first the 'shading' stage that is hindered by an external projection, and second (and most importantly) the actual theme of the painting. I am alluding to the fact that the Evangelist is creating an icon, an extraordinary image of the kind usually referred to as *acheiropoieton*, that is to say 'not

made by the hand of man'. To emphasize its 'non-human' quality, other painters have sometimes depicted an angel guiding the painter's hand. Van Heemskerck chose a very different route: his Luke is a man with a face that is so individualized that we may quite rightly presume that it is a self-portrait. He highlights what he should in fact have concealed: the painter's hand.[2]

The hand projected onto the surface of the representation indicates the impact of the creative moment on the nascent image. An icon 'not made by the hand of man' but portrayed at the very moment when the projection of the creative hand gets in the way is no doubt a paradox, of which van Heemskerck was probably more than aware. We would be justified in asking ourselves how this reversal took place.

I think the explanation is to be found in the new artistic sensibility that evolved in Italy at the time of the Renaissance. It would no doubt have been in Italy that van Heemskerck heard the famous adage according to which 'every painter paints himself' (*ogni dipintor dipinge sé*). Although we cannot go over it here, the notion that, one way or another, an artist figures in his work was developed as a theme.[3] As far as we are concerned we need do no more than remind ourselves that this same motif did appear indirectly in Alberti's narcissistic paradigm, and that it reappeared, though greatly altered, in Vasari's new myth of origins (illus. 6). At the time when Vasari's *Lives* was first published in 1550 it was thought that the first image had been the painter's shadow. It is difficult to envisage van Heemskerck's painting without placing it in the context of these modifications and without considering their implications. The artist's circumspection is commendable. His painting illustrates an ancient theme ('Luke painting the Virgin'), which explains why the automimetic projection never becomes more than a suggestion. Two important features announce the new consciousness of the self: Luke's head has the qualities of a 'self-portrait'; the hand that of an allusive signature, appended to an image that is, in principle, 'without an author'.

However, the shadow of the hand on the nascent painting is no more than a fleeting presence. It does not invite the spectator to imagine that the author's mark was actually recorded in the act of creation, no – it is more like the 'drift' of a transitory sign, like the fleeting presence of a shadow.

Boileau's beautiful aphorism dates from the seventeenth century:

It is shadow that gives painting its lustre (*Satire IX*)

When he wrote this, the author of *L'Art poétique* introduced the work of art to the principle of the unfinished. Only on a first level of interpretation does the adage credit with 'brilliance' what might otherwise be considered a fault.[4] Boileau reverses the metaphoric relationship (codified by tradition) between darkness and light by projecting onto the shadow its absolute opposite ('lustre'). He does this in order to establish the anamorphosis of an absent subject. It is up to the spectator therefore to cast the necessary 'shadow' on the painting, without which the work would have no 'lustre'. But the shadow-figure of a viewer necessary to instigate the image in the actual act of reception does no more than replace the original figure, whose place is at present vacant: the first 'shadow in the painting' was that of the creator himself.[5]

Through the history of Western representation, I now propose to establish the milestones in a study that set out to secure a theoretical place for the avatars of this motif. While its prologue was Maerten van Heemskerck's painting, its true beginnings were in the classical era. But it did not flourish until our century.

When in 1672 G. P. Bellori published his manifesto-discourse entitled 'The Idea of the Painter, Sculptor and Architect', first read to Rome's Academy of St Luke in 1664, he chose for the frontispiece an engraving by Charles Errand (illus. 27). In it we see a nearly naked woman whose eyes are raised to the sky. She holds a pair of dividers in her left hand and a brush in her right, with which she is brushing a barely sketched painting, where a few figures and trees are just about discernible. Her right hand casts a shadow on the painting.[6] In his text Bellori never actually explains the significance of this detail. In a language that marries Platonism and Aristotelianism,[7] the author does however specify that

> ... noble Painters and Sculptors, who imitate the First Labourer, also envision a model of superior beauty, and without taking their eyes off it they modify nature by adjusting colours and lines. This Idea, or Goddess of Painting and Sculpture ... materializes and enters the

27 Giovan Pietro
Bellori, engraved
by Charles Errand,
Idea, from Bellori's
Vite, Rome, 1672.

27 Giovan Pietro Bellori, engraved by Charles Errand, *Idea*, from Bellori's *Vite*, Rome, 1672.

marbles and canvases; originating in nature she transcends its origins to become the origin of art; measured by the dividers of reason she becomes the measure of the creative hand, and quickened by the imagination she brings images to life. The greatest philosophers have demonstrated that noteworthy causes are to be found in the souls of Artisans, where they remain for ever exquisite and absolutely perfect. The Idea of the Painter and of the Sculptor is this perfect and excellent model in the mind, that resembles the things we see because they visualize its visualized form.[8]

A close examination of this text goes a long way to explain the engraving. The naked woman is Idea herself (the assonance should be noted between *Idea/Dea* = *Idea/Goddess*). She appears in a space furnished with blocks of marble and canvases, symbols of empty matter with which Idea will have to merge. In this fairly basic setting, the first object of any significance is without a doubt the cube on the extreme left of the engraving. The word *IDEA* inscribed on one of its surfaces is neither the engraving's nor the discourse's sub-heading (which can be found outside the image in the introductory quotation). The aim of this work is to point out that sculptors must inscribe Idea in the block of marble. Leaning against the cube, the canvas/painting continues the discourse on Platonic aesthetics by increasing the number of details, as though the

prologue (in its 'lapidary' representation in the first corner of the image) were actually developing into a complete and finely balanced demonstration. The allegorical body of the naked goddess is a transitory figure: the eyes are riveted on the sky where the model of perfect beauty resides. This model (re)forms in the mind (in the 'intellect') beneath the regulatory sign of the dividers, and is transmitted (by the right hand) to the canvas. Here, two images are superimposed. These are images of projection: the barely discernible silhouettes on the surface of the painting and the shadow of the hand. The latter is the most 'Platonic' element of the whole engraving: it is the shadow of 'practice', that contrasts with the 'celestial model' (which is itself invisible, except to the ecstatic eyes of Idea). The hand draws attention to the fact that, for idea to become substance, 'practice' must intervene, but it also delineates the precise boundaries of practice:

> The wise men of Old formulated this Idea and goddess of Beauty by always looking at the most beautiful aspects of natural objects, for the other Idea that is primarily founded on practice is horrible and most vile, Plato wanted Idea to be a perfect understanding of the thing, grounded in Nature. Quintilian teaches us how all things that have been perfected by art and the human mind have been inspired by Nature herself, from whom true Idea is born. Consequently, those who do not know the truth, and who base their work entirely on practice, represent larvae rather than figures.[9]

Bellori's and Errand's engraving must be regarded as a criticism of 'bad practice', and as the culmination of a philosophy on the imbalance between 'intellect' and 'hand' that reached its climax with Michelangelo. In his poems the Florentine artist had indeed praised 'the hand that listens to the directives of reason' (*la man che ubidisce all'intelleto*) although this was no more than a way of exorcizing, on a practical level, a certain inability to 'achieve' the concept (the *concetto*) unanimously deplored by early commentators (Vasari, Varchi, etc.).

The full significance of Bellori's gloss on Plato's motif only comes to light when we compare it to other contemporary allegorical discourses on the same topic, and also when we trace its subsequent and various revivals and transformations.

That the deep-seated implications of the message in Errand's frontispiece engraving for Bellori's publication were understood – notably those of the shadow of the hand – is confirmed by its revival in a drawing by the Italian artist Ciro Ferri (illus. 28).[10] This drawing is a development of the Bellorian setting, concretized and transformed into the studio of an art school. Idea has taken her place at the centre of the studio, in front of a real easel and canvas. As in Errand's piece, the Goddess has no palette, even though she could have held one, her left hand being free. However, she does not, and this is probably because – in this theoretical illustration – Idea is dipping her brush, as it were, directly into the celestial model. Hence the lack of any visible signs on the surface of the canvas – only the shadow of the hand and arm – visibly strengthening Bellori's initial inspiration. There is an additional component that emphasizes the transitory, ephemeral quality of the scene: the *putto* holding an hour-glass and hovering over the hand as it works, marks the symbolic pause at the actual moment of practice.

But Bellori is not the only art historian to comment on the theme of the 'shadow in the painting'. Vicente Carducho, a Spaniard of Italian origin, also does this in the engraving (illus. 29) that comes at the end of his *Dialogos de la pintura* (Madrid, 1633). He uses the art of the emblem to achieve this. On an empty canvas a brush has been laid that casts its shadow onto it. A laurel crown, intertwined with a ribbon, encircles it. On the ribbon is a Latin inscription inspired by Aristotle, praising the transcendence of the 'tabula rasa' through the transforming of 'power' into 'action'. The emblem's significance is explained in the Spanish quatrain that tells us that only a brush guided by 'sovereign science' can perform this transformation. What is of interest here, particularly within the context of this discussion, is that on the board – which is still only a 'tabula rasa' – there is no line, no 'completed' image: only the shadow of the brush. This takes on or (for the moment at least) replaces the function of the line. It is, as it were, the 'line of the action', its image. What Carducho had succeeded in doing was to propose a metaphoric equivalence between 'shadow of the brush' and 'line'.

The idea probably came to him from the books on emblems that were circulating at the time. In one of these emblems

28 Ciro Ferri, *The Drawing School*, *c.* 1665–75, drawing on paper. Galleria degli Uffizi, Florence.

En la que tabla rasa tanto excede,
que uee todas las cosas en potencia.
solo elpincel consoberana ciencia.
reducir lapotencia al acto puede.

Nulla dies *abeat,quin* linea *ducta sit vsus*
Solus erit,magnos qui facit artifices.

29 Vicente Cardu-
cho, *Tabula Rasa*,
engraving at the
end of his *Dialogos
de la pintura*,
Madrid, 1633.

30 Gabriel Rollen-
hagen, *Nulla dies
sine linea*, emblem
from his *Nucleus
Emblematum*, Paris,
1611.

(illus. 30), the drawing of the line comes from the illustration that accompanies a Latin saying that, according to Pliny (*Natural History*, xxxv, 84), originated from the single-minded devotion of the legendary Apelles, who would never allow a day to pass without drawing a line (*nulla dies sine linea*). Unlike Carducho's version, the line – although faint and difficult to see – is visible. We can also see the hand as well as the pen, both of which cast a subtle shadow. It was from emblematic representations of this kind that Carducho isolated and developed the motif of the cast shadow, strengthening the quality of the drifting symbol of the creative act.

This symbolic investment of the shadow is confirmed by the use Vicente Carducho makes of it in his self-portrait (illus. 31).[11] It is meant as a (self-)tribute to a theoretical painter. The spectator can see Carducho in the act of writing his *Dialogos*, in which he describes his ideas on artistic representation and the 'perfect painter'. He has for a moment put to one side (the right) his palette and brushes (instruments of 'colour'), as well as the paper, T-square and penholder ('drawing' instruments). In the self-portrait the shadow of the pen is projected onto the sheet of paper (illus.

31 Vicente Car-
ducho, *Self-
portrait*, *c.* 1633, oil
on canvas. The
Stirling Maxwell
Collection, Pollok
House, Glasgow.

31) as it is in the final engraving of his book (illus. 29). On the
blank pages of the book (only the title has been written),
Carducho allows his own shadow to fall. We understand
from this that it is the 'author' who will transform the blank
sheet of paper into a page covered in signs; he will perform
the act of transforming the potential of the 'tabula rasa' into
completed forms of writing and drawing.

Viewed in this context, we can appreciate the full relevance
and originality of one of the most famous self-portraits of the
classical period, the one by Nicolas Poussin (illus. 32).

The story behind its creation is well known. On 7 April 1647
in Rome, the painter wrote to his friend and patron Chantelou
about a portrait, which the latter wanted for his collection. But
Poussin informed Chantelou that he would have to wait a
little longer since 'there is no one in Rome now who does a
good portrait'.[12] It was not until the following year that
Poussin decided, reluctantly, to paint the portrait himself:

> I would already have had my portrait done and sent over to
> you as requested. But it grieves me to spend ten pistoles for
> a head in the style of Milord Mignard who is the only
> person I know who does them well, although they are cold,
> powdered, rouged and quite lacking in talent and energy.[13]

This is an important announcement since it reveals the unusual nature of this *self-portrait*, which, according to Poussin, promises to be quite different from a *portrait*. By reversing the list of negative epithets used by Poussin to describe the decadent art of his era, we are actually observing his growing intention to carry out an extremely ambitious project: a 'living', 'accomplished', 'authentic', 'energetic' (self)-portrait. But the following year things suddenly seem to have become complicated. In a letter dated 20 June 1649 Poussin speaks of two self-portraits:

> I shall send you the one that turns out to be the best, but please say nothing about it so as not to cause jealousies.[14]

Finally, in 1650, the facts are revealed:

> I have finished the portrait of myself that you wanted ... Mr
> Pointel will have the one I promised him at the same time,
> you will not be jealous of it, for I have kept the promise I
> made you, having chosen the best and most faithful for you.
> ... I claim that this portrait will be for you a sign of the
> servitude I have vowed you, in as much as, for no one alive,
> shall I do what I have done for you in this matter.[15]

Is this a simple rhetorical formula or is it further proof of an
action placed at the frontier of painting?

Let us examine the painting (illus. 32) more closely. In the
foreground of the composition is a half-length portrait of
Poussin; he is gazing at the spectator. He is not holding a
brush but a book. This is important since – as we shall soon
see – the central theme of the work is the 'theory' of the
representation rather than the 'act'. Behind him are several
canvases. In this particular painting, the arts–literature
relationship, which appeared in one form or another in
almost all seventeenth-century portraits of artists, has been
specially set up. Poussin emerges from the succession of
canvases and places himself in the foreground, interposing
himself between the putative spectator and the art in the
'background'. The fragment of painting on the left is an
allegory that Bellori had already understood:

> in this painting we see the profile of a woman's head, on the
> diadem that adorns her forehead is an eye. It symbolizes
> Painting. Two hands embrace her. They represent the love
> of painting and friendship; to that the whole portrait is
> dedicated.[16]

The framed and prepared canvas, situated just behind the
half-length portrait of the painter, is where we discover what
is unusual about the work. In order to read/understand the
message inscribed on it, the reader/decipherer needs more
than just basic Latin. He must above all be an extremely good
interpreter. As recent hermeneutics have pointed out,[17] this
canvas without a painting speaks of the actual representation
through its words. What is this 'effigy of Nicolas Poussin,
painter from Les Andelys'? Is what we see *in front of* this
prepared canvas a 'likeness' (the word recurs obsessively

throughout Poussin's correspondence with his patron), which seems to emerge from the frame?

Chantelou was undoubtedly intelligent enough to discern and understand all the subtleties of his friend's approach, including the significance of the cast shadow that glides between the words, superimposed over the name POUSSIN, but leaving two other words – EFFIGIES and PICTOR – clearly visible. In short, he should have been able to understand that the singularity of this portrait (stressed by Poussin in his letters) lay in the fact that … it was not a portrait. Similarly, Montaigne's *Essays* (with which it has quite rightly been compared[18]), for example, are not an 'autobiography', but a discourse on the 'self'. Poussin's painting – the token of his friendship for Chantelou – is not a portrait, or a self-portrait, but a living discourse on the status of the representation.

A subsequent but no less effective source might be elucidating since it reveals how the relationship between 'Shadow' and 'Portrait' was viewed at the time. It is Chantelou himself, in his *Journal*, who recounts (on 19 August 1665) Bernini's opinion, according to which:

> if at night we place a candle behind a person in such a way that his shadow is projected on a wall, we can recognize who the person is from their shadow, since it is true to say that no one's head rests on his shoulders in the same way as does another's, and the same goes for all the rest; moreover the first thing that anyone producing a portrait must look at for the likeness, is the general of the person, before even considering the particular.[19]

What is striking about this passage is how close the method of doing a 'likeness' is to the original myth of the cast shadow.[20] The shadow reveals 'the general of the person' rather than the particular. The shadow corresponds to the original state. What is central to Poussin's *mise-en-scène* is that Poussin's name (POVSSINI) and Poussin's shadow both appear projected onto the blank canvas. The canvas is there not because the artist is in the process of painting something, but because of a compositional technique. Poussin's painting is not a scenario of production,[21] but of representation. Therefore, in this instance the 'shadow in the painting' has nothing to do with the act of painting (as was the case

with the other paintings analysed in this chapter) but with the status of likeness. It ends a discourse on the perfect mimesis, at the apogee of a tradition that had begun in the Quattrocento.

Within this context, it is interesting to note what little influence Poussin's actually inimitable experiment had on the artists of the following century. When they did display any interest in it, it was with the sole purpose of reformulating it within the framework of reflecting on the presence of the artist in his work.

Marie-Louise Elisabeth Vigée-Lebrun's self-portrait dating from 1790 (illus. 23)[22] is also connected with the convention of the shadow of the creative hand. The painting is composed in such a way that painter and shadow are presented together for the spectator to see. There is, nevertheless, a flagrant contradiction between Vigée-Lebrun's pose (her smiling face is full-face to the spectator) and the fact that her hand is busy, painting. 'Posing' and 'painting' are a priori two separate and

33 Sébastien Le Clerc II, *Painting*, 1734, oil on canvas. Schloß Waldegg, Solothurn, Switzerland.

irreconcilable activities. But with an intelligence so typical of her time, she has been able to conceal the irregularities of the dichotomy, by performing a double 'pose' in the actual composition: that of the face and that of the hand.

In 1734 Sébastien Le Clerc, the author of an allegorical cycle on the arts and sciences,[23] was faced with difficulties of a similar nature. There is, however, an additional element in his work, since like the Bellorian emblem, the personification of Painting is depicted at the moment of divine inspiration (illus. 33). A *putto* draws Painting's attention to the world of paradigms, that she, Painting, should then transpose to the canvas. However, the instrument that performs the transition from 'idea' to 'painting' – the right hand – remains half hidden behind her turning body. The shadow is projected onto the canvas, a feature no doubt inspired by Poussin. In this instance the shadow takes on the role of a 'paradigm of painting', although the hybrid nature of this solution heralds an undeniable crisis.

THE SHADOW OF THE GAZE

An impression … To me this is above all a landscape that disappears into the distance, a melancholic street corner, where the shadow of a tree we cannot see is projected.[24]

This is how Gaguère, a minor character in Emile Zola's *Oeuvre* (1886), describes his 'impressionist' dream. It is a poetic definition, whose description of what the image contains (the 'melancholic' setting and secluded tree) is more important than any information regarding style, construction or pictorial technique. And yet there is a point where 'content' and 'form' meet, namely in the motif of the shadow. However, the shadow (which we are given to understand makes the street more melancholic) is cast by no object in the image. It is an extension, a projection of something that is still 'outside-the-frame', in other words, in the real world.

The philosophy that allows this technique to work has been expounded many times over, as for example in the following text, where beginning with an analysis of a painting by Manet, the author, Mallarmé, establishes the actual milestones of a whole artistic movement:

The secret is to be found in an altogether new concept of

cutting the painting that gives the frame all the charm of a completely imaginary boundary ... Such is the painting, and the function of the frame is to isolate it, although I realize that this might run counter to preconceived ideas. For example, what is the point of portraying an arm, a hat, a river bank, if they belong to someone or something outside the painting? All you have to do is make sure that the spectator who is accustomed – in a crowd or in nature – to picking out the parts that please him, can reconnect with the whole, not have cause in the work of art to regret the loss of one of his customary pleasures, and, while remaining aware that it has become a painting, half believe that what he is seeing is the vision of a genuine scene.[25]

The truncated shadow of which Gaguère speaks would be incomprehensible if it were not viewed within the context of this new perception of the boundaries of the image and their function. Yet there are two reasons why the truncated shadow is more than the product of a revolutionary, new compositional method. The first is that in the painting it is not just a 'fragment' but a 'messenger' of reality. The second is more complex and involves one of the shadow's core components: in nature, the shadow corresponds to a very precise moment in the day. Consequently in the painting, the shadow establishes a unity between being and becoming.

We can trace the repercussions of this fictionalization of the truncated shadow by exploring a few examples. We shall begin with Renoir's *The Pont des Arts* of 1867–8 (illus. 34), for it is a painting that predates the actual birth of the term 'Impressionism' (1874) though typical already of the sensitivity displayed by young painters to certain aspects of the cityscape. Renoir chose one of the most spectacular views of Paris at the time of the Second Empire.[26] The right-hand half of the painting is the quai Malaquais, the left is the Seine. In the distance, beyond the Pont des Arts, stands the grey silhouette of Notre-Dame, like a final point marking the end of the perspective. Other buildings are instantly recognizable: the two theatres of the Châtelet on the left and the dome of the Institut de France on the right. A small crowd of people is walking along the river-bank flooded with light. Though the figures are made up of short, rapid brushstrokes, it is easy to see that they come from different social classes. The painter

34 Pierre Auguste Renoir, *The Pont des Arts, Paris, c.* 1867–8, oil on canvas. Norton Simon Museum, Pasadena, CA.

has envisioned an anonymous, mixed crowd typical of any modern city. Taken from the Pont du Carrousel, Renoir was determined to represent the view by depicting the bridge's shadow at the base of the scene. In this way, by integrating through projection a fragment of the context of the canvas's birth, he was able to capture for ever a precise moment in time, the afternoon when he painted it.

Baudelaire was to wonder:

> What is pure art in the modern concept of the term? It is to create an allusive magic that contains both the object and the subject, the world outside the artist and the artist himself.[27]

We can (indeed, must) picture Renoir leaning over the Pont du Carrousel gazing at the crowd, or seated at his easel capturing in the painting the drifting, transient image. Elusiveness appears twice in the painting: in the swarming of the people on the river-bank and in the shadows drifting over the bridge. The silhouettes projected at the base of the painting are barely delineated. It would demand too much ingenuity to determine whether one of them is the painter himself and whether the others are passers-by glancing absentmindedly over their shoulders. It was probably Renoir's intention that these shadows remain slightly sketchy

so that they would give the impression (the word is aptly chosen) of the momentary and the transitory. This done, he plunges deep into the aesthetics defined by Baudelaire a few years earlier, in *Le Peintre de la vie moderne*:

> To the consummate *flâneur*, the enthusiastic observer, there is nothing more exhilarating than to choose to live in amongst the people, the surge, the action, the elusive and the infinite. Not to be at home and yet to feel at home everywhere; to see the world, to be at the very centre of the world and yet remain hidden from it, these are some of the small pleasures enjoyed by those free, enthusiastic, objective spirits that language can but clumsily define. The observer is a *prince* who relishes being incognito wherever he goes. ... It is an insatiable *self* of the *non-self*, which at each moment portrays and expresses it in images more alive than life itself, perpetually mercurial and elusive.[28]

This quotation can be applied to an almost infinite number of Impressionist paintings since it describes the attitude typical of the 'modern painter' when confronted by reality and the image. However, it is particularly relevant in this case in as much as in *The Pont des Arts*, Renoir – unlike his contemporaries – produces a representation by projecting the transitory and impermanent figure of the observer. In short, Renoir quite easily could have cut the image in such a way that the lower half contained nothing that signified the intrusion of the outside world into the area of the painting. This would not have changed the painting very much. It would still have contained the observations of a '*flâneur*', of a painter who, particularly by following Baudelaire's advice to the letter, would have remained completely 'hidden'. The shadows in the foreground betray, though only partially, his presence and thematize the presence of the spectator, while keeping them both *incognito*.

In this case, however, the projection of the authorial *self* reaches proportions that transcend the boundaries of Baudelaire's founding aesthetics. Let us now examine one of the more extreme examples. It is not a painting but a photograph taken by Claude Monet towards the end of his life. It is a view taken from the 'Japanese bridge' of the famous ornamental 'lily pond' in the garden at Giverny (illus. 35). In the lower part of the photograph we see Monet's silhouette reflected on

the surface of the water. We know very little about the background to this image, but studies all acknowledge that it is a late self-portrait by the artist. This becomes even more significant when we take into account how few self-portraits Monet left and the veritable dearth of the mixed genre – the integrated self-portrait – in his work.

This photograph, in order to be understood, needs to be located within the aesthetic vision of Monet's later years. We should not forget that from 1893 he was relandscaping his garden at Giverny, which included digging the famous pond, and that in 1909 he held an exhibition with Durand-Ruel in which he showed 48 paintings, entitled *The Water Lilies: Landscapes of Water Series*.

How important this exhibition was to him is revealed in a letter written just before it opened:

> Know that I am absorbed by my work. These landscapes of water and reflections have become an obsession. It is beyond my powers as an old man, and yet I want to arrive at rendering what I feel. I have destroyed some ... Some I recommence ... and I hope that after so many efforts, something will come out.[29]

It is interesting to find that Monet refers to the water-lilies as 'landscapes of water and reflections', although he dropped the last word in the title he gave the series. I think this was part of his strategy, for he did not want the title to give away his new aesthetics (illus. 36). This was actually the product of a novel relationship between the observer and the object being observed, and between the frame and the representation. These canvases are not landscapes in the actual sense of the term, since they have neither horizon nor sky. The surface of the painting merges with the surface of the water, and the outside (tree, sky ...) is only in the image while it is being absorbed by the effect of the mirror. As for the observer, he is not *in front of* a landscape, but *leans* over the water-mirror turned thus into a 'painting'.

It is quite striking that once the exhibition opened, the critics – as revealed in the following extracts – were almost unanimous in acknowledging that this new process transcended Impressionism, thus establishing a new aesthetics:[30]

35 Claude Monet, *Monet's Shadow on the Lily Pond, c.* 1920, photograph.

36 Claude Monet, *Water-lilies*, 1906, oil on canvas. Art Institute of Chicago.

The Water Lilies are quite exactly, just as he indicates, landscapes of water; but that water contains the sky ... This mirror contains the sky, the clouds, the trees, all the verdure and the quivering of the leaves. Everything reflects itself in it, resumes itself in it, dissolves itself in it.[31]

Or:

There is no more painting here: the water itself, that which reflects itself there, and an emotion in front of the water.[32]

Let us return to the photograph (illus. 35). It can be seen as the symbolic creation of an artistic confession. It is possible – and this has been done already – to discover in this approach traces of the Narcissus myth,[33] as well as an ultimate gloss on Alberti's variation of the relationship between the origins of painting and its automimesis. But we should take into account the somewhat intuitive rather than deliberate nature of Monet's philosophy and, more particularly, what is essentially a choice destined to reverse rather than elaborate the myth of origins: it is his shadow and not his specular image that floats on the reflective surface of the water.

We may remember that in the first poetic rendition of the Narcissus myth, Ovid proposed different degrees of reflection, the least clear of which – the shadow – came last, just before the disappearance of 'nothing'. If, in this symbolic photograph, Monet chose to be reflected in the form of a shadow on the surface of the water (which is not different from the surface of the representation in general), it was, I feel, not because he wanted to suggest that he loved himself but because he wanted to show his devotion to his symbolic world. The modern medium of photography allowed him to express what was intrinsic to his final paintings: the shadow of the gaze, the instigator of painting. Unlike the Western mimetic tradition, Monet's shadow heralds the (modern) primacy of the *gaze* on the *hand*. And unlike modern experiments based on the origins (I am thinking particularly of Renoir, who had already brought the shadow into the image to be the cipher of an anonymous presence), Monet's *own* shadow is etched on the surface of the representation like a figurative and paradoxical feature of a dual symbol of presence/transience.

This is why his confession-photograph, as small as a haiku,

can be regarded as an important turning-point in the history of self-reflective imagery. It suggests that the narcissistic paradigm of Western mimesis be replaced by the oriental eulogy on the transience of the shadow.[34] This is indeed what Monet was suggesting when he chose where to position himself to create his final and unorthodox self-portrait: the Japanese Bridge. It is from this vantage-point that Monet contemplates the water mirror, to pursue – to quote one of his closest friends – 'his dream of form and colour almost to the point of annihilating his own individuality in the eternal nirvana of things that are both and at the same time changeable and immutable'.[35]

PRELIMINARY OBSERVATIONS ON THE SHADOW AND ITS REPRODUCIBILITY DURING THE PHOTOGRAPHIC ERA

It might just be a coincidence that Monet's photographic self-portrait is undated, or it could be a prerequisite of a symbolic order, since the artist's silhouette on the surface of the water is above all a manifestation of the silent and timeless presence of one who 'plunges' into an image in order to lose himself in it. Despite this, the photo is 'dateable', firstly because it is the product of a 'modern' representational technique and second because it illustrates a phase in Monet's artistic agenda that began with the early experiments involving the *Water Lilies* (around 1904-05) and ended with the artist's death in 1926. The confession-photograph (illus. 35) is the image of Monet's *Weltanschauung* between these two dates.

It is highly unlikely that Monet would ever have had the idea (or the audacity) to create a painting that contained the self-reflective features of this photograph.

What the painter accomplished (an authorial projection through the cast shadow) was also undertaken by contemporary photographers and regarded to be one of the major experiments of this new representational technique.

It is not the design of this book, nor is it within its scope, to re-open the debate surrounding the endless discussions between photography and painting that so fundamentally marked nineteenth- and twentieth-century art.[36] However, I do feel we should pause, albeit briefly, to consider the different ways the all-encompassing camera-shots were manifested in photographic art.

The earliest known photograph to contain the shadow of a tripod actually dates from 1908 (Lewis Hine, *Newsboy, Indianapolis*). It is a tentative start that interprets classical pictorial experimentations with the self-defining reflection by updating them.[37] It was not long before shadow projections were being subjected to somewhat more substantial experiments. The most important of these was probably Alfred Stieglitz's *Shadows on the Lake* of 1916 (illus. 37). We need to examine it briefly, given that it is not only contemporaneous with Monet's confession-image (illus. 35), but because its purpose is strikingly similar. The latter, though, is purely a thematic coincidence: the shadows are projected onto the surface of the water and the new imaging technique captures their instantaneity. With Monet as with Stieglitz, the status of the water changes from being a reflective surface to being an area of projection. Yet there are conspicuous differences. Monet's shadow is a 'discreet' presence at the base of the image, while Stieglitz's virtually covers the whole of it. Monet's shadow reproduces his head and distinctive hat while Stieglitz has two shadows, neither of which has any distinguishing features. Unlike Monet's shadow, however, his do move, and the motion suggests the existence of a 'mirror effect' and of a dynamic dialogue between the exotopic characters and their endotopic double. Finally, whereas Stieglitz allowed himself to become fascinated by the 'texture' of the watery surface, by its excellence as an abstract backdrop, from which he made the two shadows loom like gigantic figures, the gaze of the behatted man in Monet's work produces an image that can still be classed as a painting–image. If, in the final analysis, photography was an *allegory of painting* to Monet, then to Stieglitz, the photograph entitled *Shadows on the Lake* was an *allegory of photography*.

The most effective way to evaluate this experiment is to reflect on the history of its genesis. Thanks to Stieglitz's own writings we know for a fact that in the original the silhouettes of both men were placed the other way around.[38] Once the shot has been taken, the photographer decided to rotate it by 180 degrees, and left very precise instructions as to how it should always be exhibited in this position. The reversal had two complementary outcomes. The first was a materialization – for by rotating the photo Stieglitz reinstated the figurative nature of an almost abstract pattern of blotches. This

procedure is reminiscent of an unusual inversion Kandinsky made one evening a few years earlier, when he 'invented' abstract art after seeing one of his figurative paintings reversed.[39] The second outcome involves the interaction between the shadow stage and the mirror stage. The two silhouettes appear to occupy what is today the viewer's space. As a consequence they take on the role of circumspect judges – a role they did not have initially. In short, their function has become analogous with Monet's in his self-portrait/photo.

But what neither Monet nor Stieglitz was able to achieve (and probably did not even want to) was to give their projections the likeness demanded by the traditional definition of the portrait (and self-portrait). Likeness is, of course, a criterion regulated by the specular reflection and not by the

cast shadow. Monet and Stieglitz transformed the specular reflection into a silhouette, thus blurring the boundaries that separate the reflective surface from the projection screen. The process is typical of the new situation in which Western mimesis found itself once photography had been invented.[40]

During the first half of the nineteenth century this new method of capturing a luminous impression was referred to as a 'portable mirror'.[41] It was only later – when Monet and Stieglitz were submitting their experiments – that American pragmatism arrived on the scene to confer on the photographic image in addition to its mimetic value (as an *icon*) the value of *index*, token of physical connection. The index has the same characteristics as both shadow and photograph in so far as it

> refers back to its object not so much because it is similar or analogous to it nor because it is associated with the general characteristics that this object happens to possess, but because it is dynamically (and spatially) connected with both the individual object on the one hand and on the other with the senses or memory of the person to which it serves as sign of the other.[42]

Although under a different name, the index quality of the shadow had already been recognized quite some before. Pliny saw it as a trace-imprint of the person, and in the seventeenth century it was acknowledged that it revealed 'the general of the person' though not his 'particular likeness'.

Before the photographic self-projection can be thought of as an iconic likeness, as well as an index, it must forsake the mimesis of the shadow and return to that of the mirror, or – but this becomes a somewhat borderline case – it must search out the index's likeness. This can only take place on one condition (crucial because of its theoretical and historical implications): in order to approach the 'likeness', the representation of the shadow must take on the symbolic form of the profile. This was in fact the only message that the myth of the origins of art was understood to convey, because it maintained that only in the profile of the outlined shadow could mimesis *and* index (likeness *and* physical connection) coexist.

But does the possibility of creating the self-portrait of a shadow exist at all? As we saw, Vasari's solution (illus. 6) was

full of contradictions. The major problem with indicative automimesis is that the profile is always the profile of the *other*. Its representation can only result from an interaction. And in effect, having broached the history of the photographic self-portrait,[43] we see that research carried out in the 1920s and 1930s also took this same route. André Kertész's self-portrait of 1927 (illus. 38) occupies a special position. There are only two ways of producing this kind of (self-)representation: either through the extremely complicated use of several mirrors (that is to say by imperceptibly combining shadow stage and mirror stage), or through a schize (through a literal or metaphorical split between creator and model).

It was during the same period that, despite its complexity, the symbolic form of the profile's shadow became a form of self-representation. After the initial trials (Edvard Munch's, for example), it suddenly got established. The artist responsible for this feat was none other than Pablo Picasso.

In the painting entitled *Silhouette with Young Girl Crouching* (illus. 39), he appears in the shape of a black shadow that covers the whole of the right-hand section of the image. There is no doubting that this is Picasso's profile, as its 'particular likeness' proves. Its relation to the image as a whole is less clear. There are no direct indications – as there are in Kertész's photo – pertaining to the creation of a scenario of production, and, more significantly, Picasso's profile is not the central focus of the image. On the contrary, it looks more like an insertion, a lateral projection into a space inhabited by figures created on a very different scale. This disproportion between profile and figures is the direct result of the contrast generated by the black threadlike silhouette in the left-hand side of the painting. A genuine physical bond exists between these two extremes. One of the arms of the person on the left protrudes from the frame that encases the upper part of his body, stretching out like a wandering line across the area of the image, to merge finally with its other extremity, the outlined contour of the shadow. Therefore, if this painting contains clues to its scenario of production, they are – compared to what is revealed in Kertész's photograph – as it were, reversed: it is not 'Picasso' in the form of a shadow who is creating the images that populated the painting, on the contrary, it is he who is actually being created in the form of a shadow by his images. A second interpretation thus

38 André Kertész, *Self-portrait*, 1927, gelatin silver photograph. J. Paul Getty Museum, Los Angeles.

becomes possible. This is to a certain extent connected with photographic experimentation in the way it exposes its theoretical components. The frame that encases the silhouette on the left is that of a mirror, and the figure reflected therein – reduced to the status of a diagram – is Picasso himself, at work. His hand that 'emerges' from the mirror is creating the painting in the centre (in this case the *Young Girl Crouching*) as well as the author's second likeness, the one that looks like an outlined shadow. Picasso has therefore undeniably established several links with the tradition of self-reflection. The first of these has had repercussions on more recent experiments with the self-portrait in profile (illus. 38). It

39 Pablo Picasso,
*Silhouette with a
Young Girl Crouch-
ing*, dated 6 July
1940, oil on
canvas. Private
collection.

proclaimed, in other words, and within the self-reflective
painting, the otherness of the shadow (and of the profile) as
opposed to the identity of the specular reflection. A second
link involves the transformation of the one into the other, for
what Picasso is in effect proposing through the motif of the
threadlike hand 'emerging' from the mirror to 'capture' the
shadow is the transformation of identity into otherness, a
transformation that occurs before the spectator's eyes. By
following the line–hand's circuit, we shall never know where
the reflection ends or where the shadow begins. We shall
never know whether, once past the frame of the mirror, this
line–hand has not already become a *shadow*; and last of all,
we shall never know whether the large black blotch in the
right-hand corner of the canvas is not a shadow projected
through a short-circuiting of the representation – by the

person who is in the mirror – or whether it emanates from the creative hand itself.

Picasso's scenario is diametrically opposed to the scenario of self-projection with which we are more familiar. His painting could actually be regarded as an attempt to redefine the whole tradition of the shadow of the hand, which in classical aesthetics (illus. 22, 26, 27) was like a spoor of the author in his work, whereas in this instance it symbolizes the ultimate erasing of the boundaries between painter and painting.

The shadow of the author is born of his creations and is confronted by them. Picasso's whole painting is in actual fact constructed around the idea of its creator being inserted into the world of framed forms. At the very centre and in the form of an inserted image, we recognize one of the works he painted that same year. It has been placed eye level with the shadow and is conversing with it. Once again there is a difference in scale between 'shadow' and 'painting' that does not prevent the boundaries between them from becoming blurred, or their forms from mingling. Other frames are scattered around the painting. They overlap and interweave, and the result is a complex creation, a radically reformulated outcome of a typically classical representation. In short, it is as though Poussin's *Self-portrait* of 1650 (illus. 32) had been subjected to a redefinition, resulting in its balance being upset and its components mixed up. Of all the reversals executed by the modern reformulation of this classical theme, it is the role of the shadow that is the most vital to us. Poussin saw it as a metaphor of the person (that is why the name was part of the structure). To Picasso it was, above all, the point of contact between creator and creation. This evolution is a radical outcome of the reversal of aesthetics brought about by photographic techniques.

We have already seen how authorial projection through the cast shadow was part of the very fabric of the self-reflective discourse in photography (illus. 38). If Picasso and the other 'Cubists' embraced it in their experiments they did so in direct response to the mimetic rivalry brought about by photographic representations. The discovery and use of the profile to define forms does indeed follow this route. We should not forget that Picasso regarded Cubism as the product of a formal construction that began from several vantage-points,

from an 'imitation of the material form of objects, seen face on, in profile, from above'.[44] In this context, the view of the profile becomes one of the 'aspects' of the real that, through synthesis, facilitates the dismantling of classical representation. What is of even greater interest to us is that within the 'elastic iconicity' of Cubism,[45] Picasso instinctively equates shadow and profile. This is extraordinarily clear in a whole series of works taken from different periods.[46] We need do no more than approach one of these to see what the process involves.

The *Sad Young Girl* of 1939 is the product of three vantage-points (illus. 40). The chair on which she sits is seen from above, the oval of her face is viewed from the front, but her nose and her other facial features are seen in profile. This last view (which is shaded) is folded back onto the frontal view (which is highlighted) to give the impression that the face has projected its own shadow onto itself. This procedure is without precedent in the whole history of Western figurative painting. With it, Picasso marks the end of the old tradition that saw the shadow as the indispensable companion of the 'incarnate'. To him, the shadow was not just a way of 'making' solid bodies, it was a way of un-making them.

We can see how, from the end of the 1920s, Picasso imbued the metapictorial reflection with this concept. The most interesting example in this respect is *Painter and Model* (illus. 41).[47] The chromatism of the canvas is absolutely purified and dominated by the relationship between black and white. A disconcerting interaction, reminiscent of a photographic negative, would seem to have inspired the artist. We see the artist seated in front of his easel. He presents us with a white profile, but his eyes are seen face on. The dark colours coagulate, forming deep black geometric areas. Part of the head and body, but especially the palette projected onto the canvas he is working on, are also black. The left-hand boundaries of the canvas are quite well defined, but those on the right are ambiguous. In fact, it is difficult to establish with any precision where the canvas finishes and where the person of the artist begins. It is also a little difficult to determine whether, as a result of an anamorphous game, the artist has been engulfed by his canvas. What is certain is that he is already there. Paradoxically, the canvas does not show the image of the model but a profile that duplicates the left-

40 Pablo Picasso, *Sad Young Girl*, dated 10 June 1939, oil on canvas. Private collection.

41 Pablo Picasso, *Painter and Model*, 1928, oil on canvas. Museum of Modern Art, New York.

hand edge, as though it were being introduced by the unusual effects of projection. But this is only a superficial impression since the contour is obviously a sketch that is being made as we watch. It is also – and this is important – the most organic, the most mimetic form of the geometricized universe.

As far as 'likeness' is concerned, there is no problem recognizing Picasso in the profile he used to sign several of his canvases. Although it is like the negative of the one analysed earlier (illus. 39), they share the same origins, for – in the final analysis – all these paintings are radical variations on the ancient theme that 'all painters paint themselves'.

The relationship between model and painter was, as we know, an obsession of Picasso's. In *Painter and Model* (illus. 41) the model was removed from the canvas to be replaced by the self-projection of the author. During the 1950s it was to reappear in several of his works, two of which are particularly significant – the canvases Picasso painted on the same day (29 December 1953) at Vallauris. In Christian Zervos's *catalogue raisonné* they are entitled *The Shadow on the Woman* (illus. 92) and *The Shadow* (illus. 93).[48] The brevity of these titles points to two distinct moments in a metapictorial narrative. In the first painting (illus. 92) we are dealing with a case of voyeurism, similar to those already addressed by nineteenth-century artists such as Degas, one of Picasso's favourite masters. The second work shows how the voyeuristic setting is transformed through the contemplation of a painting. Let us analyse this transition.

In *The Shadow on the Woman* (illus. 92) a spectre appears to be leaving the spectator's area in order to enter the image. It forms a large, threatening vertical that is superimposed onto a reclining figure. Through the spectre's unseen eyes the viewer violates the privacy of sleep, transforming the interior of the room into a highly sexualized scenario. A sudden glow, a change in the chromatic status of the human form, is produced where the shadow touches the naked body. It is interesting to note that it is not the intruder's eye that makes the woman's flesh blush but the superimposition of the shadow (vertical and masculine) on the body (horizontal and feminine). Paradoxically, it is the breasts, abdomen and pubis that are illuminated. The painting thereby presents Western pictorial tradition with a new conception of the 'nude' as a pictorial genre. What Picasso is accentuating in this painting

that constitutes the first act of a two-part narrative, is that the
'nude' (as defined by Western tradition) is the product of a
projection, of a violent and radical voyeuristic action.

Picasso's approach has actually brought together more than
one tradition. Two of these fit quite happily together: the one
that regards the shadow as a sign of the painter and the one
that discovers in the shadow the embodiment of the spectator.
In reality the two positions correspond, and do no more than
recapture, at a higher level of symbolization, the pioneering
state of modern Western painting. All we need do is examine
Dürer's didactic engraving made for his painting manual in
1538 to realize that perspective representation as a medium
was in fact a highly sophisticated voyeuristic device (illus. 42).
We must, however, take two important facts into considera-
tion. The first is that to Dürer, if not to the whole of classical
doctrine on representation, the organ of the eye had become a
fetish because of its ability to create projections. Through its
lower regions it transmits its commands directly to the hand,
bypassing the rest of the body. The second is that classical
aesthetics allowed, above all, the object being observed to be
projected onto a representational surface. In short, with Dürer,
it is the naked, sleeping (therefore passive) woman who,
foreshortened and in perspective, will 'leave' her place to
cross – in the form of an image – the *velum* that separates her
from the artist in order to project herself onto the sheet of
paper stretched out in front of the painter.

Once again, it is Picasso who reversed the classical
situation. By resorting to the shadow he was able to produce
an inverted projection of Dürer's. Normally it is the voyeur
who transcends the boundaries of an invisible frame. This
violation not only involves the eye as a fetish but the whole of

the body. The entire painting (illus. 92) is constructed along the lines of what photographers call a 'double exposure'. It is manifested through the glow emitted by the woman's body, as though – like the ancient myth of the shadow – it possessed the magical powers of the *incarnation*, the ability to impregnate metaphorically, an act in that the artist is God and the model his very humble servant. Needless to say, this investing of the shadow with magical powers in Picasso's discourse only involves the problematic of the representation.[49] Therefore any lateral undertones are purely metaphorical.

The second painting in this mini-series (illus. 93) clarifies the situation. However, to be understood it has to be seen within the context of the first work (illus. 92). Its title, *The Shadow on the Woman*, illustrates the theme of desire as the infrastructure of the representation. In this painting the 'nude' is a 'naked woman' (which we might have guessed from the title). In the context of a representation based on desire, which is what Western representation is (at least since Dürer's time), this quietly sleeping 'naked woman' might have been the model for a possible future painting. This painting is now on the easel, in the second canvas of the series (illus. 93). It follows on from the voyeuristic scene of the first act, and is therefore the end result of desire having been transmuted into a framed shape. If red was central to the first composition, the second denotes a radical 'cooling off' period, and so the dominant colour is blue. The attitude of the voyeuristic shadow, on the surface identical in both scenes, has actually been subjected to significant modifications: it is now smaller, less menacing and its body is no longer in contact with that of the 'nude'.

If the title of the first painting is *The Shadow on the Woman*, the real title of the second should be *The Shadow on the Painting*.

4 Around 'The Uncanny'

In his *Teutsche Academie* (1675), Joachim von Sandrart defends
the entire Western view of a history of art founded on Italian
pre-eminence. This, however, does not prevent him from
devoting a major chapter to the art of distant lands. He
considers that the most subtle are the Chinese, though he is
glaringly aloof when he deals with them:

> Everything they portray is blatantly over simplified for they
> only reproduce contours which have no shadows. They do
> not create volume [*rondieren nichts*] and depict objects by
> simply applying layers of colour. They do not know how to
> represent objects in relief, or how to represent spatial depth
> [*ob es vor- oder hinter sich zu treiben*], neither are they mindful
> to concentrate on the need to follow naturalness [*die
> Natürlichkeiten*], that is to say they ignore all the aspects
> which European painters devote themselves to. They know
> absolutely nothing about all these things, and their images
> only represent profiles. Frontal representations are foreign
> to them.[1]

Though significant, Sandrart's description is false. In his eyes,
Chinese art is 'foreign' and 'distant' *par excellence*. In relation
to Western painting it is the 'other art'. If we read the extract
carefully, we see that this art is 'different' because it is
ignorant of European norms: at the time, Chinese painting
was still the product of an archaic representational formula
(contour–surface–profile). The Chinese image did not depict
space, relief or shadow because it was still ... a shadow. We
would be correct in assuming that Sandrart was projecting the
Plinian myth of origins onto Eastern painting. He seems to be
saying that Oriental art perpetuated the shadow stage. It is
difficult to know just how far the tradition of 'Chinese
shadows' – which at that time was just being discovered in
Europe[2] – contributed to the development of this opinion.

Though not explicitly stated, the quotation would seem to be a direct reference to it.

At the beginning of his treatise Sandrart dwells on the classical myth of the origin of painting. To illustrate it he even used an engraving (reproduced here in the slightly modified version made by his son Johann Jacob: illus. 43),[3] where in the two different images he developed the texts of Pliny and Quintilian. In the lower image we see Butades' daughter outlining her lover's profile on the wall by the light of a lantern, while in the upper we see a shepherd delineating with a stick the contour of his shadow in the sand. What is the significance of this split?

One reason is given by the author himself: he writes that according to the two legends, shadow-painting would have been engendered either by sunlight (Quintilian) or by firelight (Pliny).[4] It is an important distinction and involves a typically seventeenth-century artistic situation, where 'diurnal' and 'nocturnal' painting co-existed although they sometimes jostled for first position.[5] However, Sandrart does not restrict himself to a faithful illustration of Quintilian's text, for example like the one Murillo felt obliged to produce for his programme–painting (illus. 7). What Sandrart does is to expand an idea that we shall endeavour to reconstruct. Just like Vasari's fresco in his Florence house (illus. 6), the pastoral scene in Sandrart's engraving contains a fundamental ambiguity that stems from his attempt to reconcile Alberti's myth of Narcissus with that of Pliny's. At the same time (and this is where Sandrart is so radically different from Vasari), the story of the shepherd (illus. 43) is not there so that one ancient myth may be replaced with another, as Murillo did, with the one based on Quintilian (illus. 7). Sandrart proposes a new version that is capable of transforming an *historical scenario* into a *natural scenario*. What the shepherd is actually doing symbolizes the discovering of art in the inmost depths of 'natural life', in the same way that the Plinian fable projected it into the inmost depths of history. If we add to this the description of Chinese art cited earlier, we conclude that Sandrart considered the art of the shadow to be distanced geographically, historically and culturally.

Reading between the lines, one can discover the final reason for this split. Although he might not have admitted it as such, in Sandrart's eyes the appearance of the shepherd had the

43 Johann Jacob von Sandrart, *The Invention of Painting*, engraving for Joachim von Sandrart's *Academia nobilissimae artis pictoriae*, Nuremberg, 1683.

advantage of sweeping aside the feminine nature of Pliny's scenario of origin. The story of the shepherd is diametrically opposed to the story of Butades' daughter, not only because of the diurnal/nocturnal contrast, but also because of the masculine/feminine contrast. Sandrart was not the only one who endeavoured to give the scenario of origin male characteristics, and it is extraordinary just how often this process is accompanied by the change in the source of light. An example:

> To return to Painting, there is yet another origin. According to classical Writers there was once a young man who was inspired by love to do the first drawing. He was about to be separated from his mistress; when, noticing the shadow that the rising sun cast on the wall, he made her move closer to this wall, and with charcoal traced the profile of his beloved's face.[6]

Let us examine the way in which Johann Jacob Sandrart's engraving (illus. 43) endeavoured to recount this 'macho' message. In the 'solar' scene it is men who question themselves on light and shadow and who end up creating the first drawing, while the women sit with the animals and quietly spin wool. Note how this engraving also attempts to Orientalize the story, for it introduces elements that are not mentioned in the text, such as the camel and the palm-tree. In this way the scenario of origin is projected not only into a distant primitive nature but also into that of a fictitious Orient.

On the other hand, the two images do avoid making too clear a distinction between the effects of nocturnal light and those of the diurnal light, even though the process entails a noticeable hiatus in relation to the discourse on the theory of art. Using the assertions of ancient philosophers, Alberti in the fifteenth century had already recorded his thoughts on this difference:

> Some lights are from the stars, as from the sun, from the moon, and that other beautiful star Venus. Other lights are from fires, but among these there are many differences. The light from the stars makes the shadow equal to the body, but fire makes it greater.[7]

From Leonardo and Dürer onwards (illus. 11, 12, 13, 14), the concept becomes even clearer: all shadows are the product of

a distortion that follows the laws of perspective. In the wake of this evolution,[8] and during Sandrart's lifetime, popular opinion was that

> Different lights cast different shadows; for if the object which illuminates is greater than that which is illuminated, the shadow will be smaller than the object; if they are equal, the shadow will be equal to the illuminated object; but if the light is smaller than the object, the shadow will always become greater.[9]

The German scholar was well aware of this. In Butades' house (illus. 43), a lantern held by a *putto* illuminates the scene. The shadows on the left-hand wall are more or less in proportion with those of the body. However, in the image that depicts the shepherd, the shadow is reduced to a simple black stain. In neither case does the geometric accuracy of the projection seem to have been the author's prime focus. His drawing was not that complicated: he wanted to demonstrate that the shepherd, Butades' daughter (and, we should add, the Chinaman) were practising a primitive art. The expressive value of the sources of light orchestrated in this way does not belong to this distant bygone art, it belongs to the tradition that was to evolve from him and in reaction to him. While the shepherd, Butades' daughter (and the Chinaman) saw art as a shadow, European art was to endow the shadow – within the representation – with meaning.

I have so far concentrated on examining the different significances that Western tradition accords the shadow. My initial conclusion was that the shadow appeared in European painting as an affirmation of body, volume and flesh. Among the many forms this manifestation can assume, I focused on two specific examples: the one that authenticated the incarnation and the one that portrayed the presence of the author. I should now like to address the significances accorded the cast shadow once the otherness of the myth of origin had been acknowledged.

THE OUTCOME OF DEMONIZATION

The most significant consequence of using a smaller source of light is that the projection is magnified. In the Codex Huyghens drawing that illustrates the teachings of a

Leonardoesque academy (illus. 14), a candle set in the centre of the room casts an enormous profile of the person against a wall. An engraving by Agostino Veneziano made in 1531 (illus. 44), depicting the Roman Academy of Baccio Bandinelli, confirms that the practice of drawing by candle-light was not uncommon. Several students seated around a table are busy copying statuettes that either are or look ancient. There are other statuettes on a shelf at the back of the room whose silhouettes are projected against the wall. The shadows on the right-hand wall are those of the objects and the people in the room. And yet, the students of the Bandinelli Academy seem to be concentrating exclusively on the art objects to be found on the table. No one is watching what is happening on the walls. In Bandinelli's drawing (British Museum, London) on which Agostino Veneziano based his, the shadows are not so obvious. Yet their role in the engraving is significant despite the fact that the members of this 'drawing academy' are ignoring them. We can hazard a guess as to what they are doing by referring to other sources, such as Ridolfi's life of Tintoretto, for example, where the author refers to small wax or plaster models that facilitated the study of the effects of artificial light on solid bodies.[10] Moreover, the Codex Huyghens drawing (illus. 14), while deferring the value of the model that casts the large shadow on the right, leaves us in no doubt as to how the statuettes and their projections on the left-hand wall were used. Even though no one is looking at the shadows in Veneziano's engraving (illus. 44), they are important from an expressive point of view. The ones we see on the back wall reproduce and enlarge the silhouettes of the small statues by giving their gestures a rhetorical function. It is almost as though the likenesses were being activated, so that they could talk to one another. A certain amount of obvious manipulation was required to achieve this effect: the raised arm of the medial shadow does not correspond to that of the statuette, but to the engraver's ludic purposes. On the right there is further evidence of the artist's intervention. The shadow of one of the characters is so distorted that it looks rather like the silhouette of a court jester. Today it would be difficult to determine who this person was or what the exact purpose of the exercise was, but what is significant is that Agostino Veneziano was determined to avoid the same thing

44 Agostino Veneziano, *The Academy of Baccio Bandinelli*, 1531, engraving. Metropolitan Museum of Art, New York.

happening with the neighbouring person (Baccio Bandinelli himself), since he has inserted a figure between him and the wall so as to prevent the likelihood of ambiguity.

It was suggested in a recent publication that the study of distortions produced by shadows would have been an important catalyst in the elongating of forms, so typical of Mannerism.[11] The hypothesis is sound and interesting. Yet it does no more than explain how the (hypothetical) 'shadow' becomes a 'figure'. However, developments that came after the experiments involving nocturnal lighting show that these were in fact carried out within the framework of a study on the expressive value of the shadow as such. It was in the seventeenth century and north of the Alps that this research was not only put into practice but also theorized.

The Dutch painter Samuel van Hoogstraten, a student of

Rembrandt, published a text in 1675 in which he set out his aesthetic creed: 'the perfect painting is a mirror of nature'.[12] This did not prevent him from devoting a major chapter to the representation of the shadow, which is illustrated with a very valuable engraving (illus. 45).[13] It illustrates that the study of cast shadows was not only a question of perspective projection but also the product of an empirical manipulation of light and volume. What we see is an experiment in a studio being carried out by apprentice painters. A minute source of light has been set up at ground level, in the left-hand corner. People taking on a variety of attitudes have been positioned at varying distances between the source of light and the wall, on which they cast their awe-inspiring shadows. It is a veritable shadow and light display, which results in two very different – in size and significance – scenes being created. On the left-hand wall we see two flying putti and three dancing figures. Because the people and objects who generate this projection are quite near the wall, even though their shadows are slightly

45 Samuel van Hoogstraten, 'The Shadow Dance', engraving for his *Inleyding tot de Hooge Schoole der Schilderkonst*, Rotterdam, 1675.

bigger than they are, they are in no way frightening. This is not the case with the shadows being projected onto the back wall. The most impressive feature of the scene is that the enormity of the shadows goes hand in hand with their demonization. We get the impression that it was Hoogstraten's intention to illustrate two contrasting symbolic scenes on the two walls: Heaven and Hell. It is in this second representation that the expressive power of the cast shadow is exploited to the full. It is interesting to note how the projection – through being distorted and magnified – transforms the real bodies into hybrid beings with tails and horns.

This is a feature that deserves our full and undivided attention. A few years earlier (1656), in his book *Ars Magna Lucis et Umbrae*, the Jesuit Athanasius Kircher had described a 'parastatic' (having the quality of presenting something before the mind) device that combined the principle of the Egyptian obelisk (the sundial) with that of the magic lantern (illus. 46). The main experiment (*representatio ludicra*) described by Kircher produced a diabolic silhouette that, through the effects of projection, appeared to have come straight from Hell (*Doemonum spectra ab inferis revocata*).[14] I think it must be presumed that the experiment illustrated by Samuel van Hoogstraten (illus. 45) in which, among other things, he uses the same type of sundial as Kircher, is a revival and an adaptation of the device described in the *Ars Magna Lucis et Umbrae*. One could probably study the actual ways in which

46 Athanasius Kircher, *Parastatic Machine*, engraving for *Ars Magna Lucis et Umbrae*, Rome, 1656. Bayerische Staatsbibliothek, Munich.

the revival (and transformation) was effected, but this would be a pointless exercise. In my opinion it is more important to reflect on the significance of the demonization of the shadow, in Kircher and (more especially) in van Hoogstraten.

The roots of this phenomenon lurk in the depths of the collective unconscious. They have been studied time and again by anthropologists and psychologists.[15] Within the framework of our research the problem becomes a particularly thorny issue, since the myth of origin harks back to a shadow that is in no way demonic. So how can we explain the negativity with which the shadow is so often invested in Western painting?

The simplest solution lies in the status of otherness with which representations of the cast shadow are endowed. This notion was intrinsic to the myth that, as we have seen, also involved the creation of a double. The relinquishing of this particular aspect by Western philosophy on the image can be attributed to a radical change of paradigm, which relegated the shadow–representation to the mythical time of origins or to the equally mythical space of distant lands. As a result, Western art ceased to be the 'painting of a shadow' and became painting that used the shadow as one of the many figurative or symbolic instruments. From the time of the Renaissance therefore, the representation of the shadow was to follow the principles of perspective projection. It would be controlled and orchestrated on different levels (which sometimes interfered with one another): the creation of solid bodies, the symbolization of 'real presence', the thematization of the authorial act Finally, it would be capable of illustrating, at the very heart of the representation, the negative moment and the otherness of this moment. In this final example, the notion of the double re-emerges to be transformed into another. And from that moment on we would be able to refer to the impact of the 'uncanny' for the definition of which we have to turn to Freud:

> When we proceed to review the things, persons, impressions, events and situations which are able to arouse in us a feeling of the uncanny in a particularly forcible and definite form, the first requirement is obviously to select a suitable example to start on. Jentsch [in an article of 1906] has taken as a very good instance 'doubts whether an apparently

animate being is really alive; or conversely, whether a lifeless object might not be in fact animate'; and he refers in this connection to the impression made by waxwork figures, ingeniously constructed dolls and automata.... When all is said and done, the quality of uncanniness can only come from the fact of the 'double' being a creation dating back to a very early mental stage, long since surmounted – a stage, incidentally, at which it wore a more friendly aspect. The 'double' has become a thing of terror, just as, after the collapse of their religion, the gods turned into demons.[16]

In this section I propose to deal with the shadow as an expression of autonomous power. I shall do this by drawing examples from different epochs and by referring to different figurative techniques. However, before we move on, it would be beneficial to remain with van Hoogstraten, since he illustrated the problem in such an astonishing way. At the time the method of projection directly involved the status of the representation. It might be useful at this point to reread the famous description of Alcandre's cave in Corneille's *L'Illusion comique* (1635):

> This wizard who all nature can command
> Has chosen as his palace this dark cave
> The night has spread over these bare, wild haunts
> Raises its veil but to an unreal day,
> And tolerates, of its uncertain rays,
> Only what dealings with the shades will bear.[17]

This sinister place was quite rightly considered to be a metaphor for the theatre.[18] But it could also have been the setting for a representation, for example the one in van Hoogstraten's engraving (illus. 45). It might also explain the rhetoric of a fictional place, such as the one, to give another example drawn from the figurative arts, which dominates the cave in Jacques de Gheyn II's *Three Witches Looking for Buried Treasure* of 1604 (illus. 47). What we are in effect seeing is a typical 'accursed cave'. The foreground is littered with objects needed for the casting of spells: pots of fat, a skull, a shrivelled frog and a broom; the gaping corpse of a man on which the witches are obviously experimenting lies in the centre; on the left there is the skeleton of an animal; a lantern hangs from the

vault above, and on the ground a cauldron rests on a tripod. Other 'regular visitors', typical of this kind of scene, complete the picture: bats, cats and mice. Each of the three witches is engrossed in a different activity: the one on the left reads from some old book, the one seated in the centre holds a smoking candle, while her companion points with her right hand to where the treasure is presumably buried.[19] What we are presented with here is the image of a fictitious underworld, the product of the seventeenth century's macabre imagination where – and this is important – 'shafts of false light' and 'the trade in shadows' are an integral part of the heart of the plot. Indeed the most important detail in this drawing, and that which gives it the lugubrious intensity de Gheyn was after, is the fantastic and gigantic silhouette projected by one of the witches against the wall of the cave. The super-human size of this shadow is a metaphor for occult powers, which allows the build-up of evil to materialize.

The distortion and magnification of the shadow, to which we shall have occasion to return, is in the figurative arts one of the techniques most frequently used to underscore a person's negative side. I should like to examine another example – just

47 Jacques de Gheyn II, *Three Witches Looking for Buried Treasure*, 1604, pen and ink with grey-brown wash. Ashmolean Museum, Oxford.

as radical because of when and why it was produced – for it demonstrates how a slightly modified Plinian fable can itself induce the effect of the 'uncanny'. I am referring to a painting of 1982 by Komar & Melamid entitled *Origin of Socialist Realism* (illus. 48). It is blatantly obvious that the discourse in this canvas is an ironic gloss on the myth of origins.[20] At the foot of the neo-classical décor, so typical of Stalinist architecture, the father of the people is clearly enjoying having his portrait painted by a half-naked woman, the personification of, or maybe the adoring muse of, 'Socialist Realism'. We know for a fact that the aesthetics of Socialist Realism encouraged the belief that the image should be an uncompromising and faithful copy of reality. Any deviation from this would have been tantamount to committing a serious offence, liable to a very heavy penalty. This is no doubt why the authors of this canvas were careful not to 'deform' the projection. Stalin's shadow is 'uncompromising' and 'faithful' as demanded by his artistic programme. But what is also obvious is that in creating this painting in 1982, Komar & Melamid were obliged to distance themselves from Stalin's past and from the new generation of Soviet artists heralding Perestroïka. They uncover the 'primitive' side of the Socialist Realism programme and show that the person who was behind it is the man portrayed, and suggest that the programme only ever generated one 'shadow': that of Stalin himself. They also demonstrate that the dictator's shadow, in other words his negative personality, is brought out by this same creative process. Stalin's profile is neither deformed nor distorted, although it is 'uncanny' (*unheimlich*). This impression is supported by a whole series of ancillary codified components. A closer examination will lead the viewer to the astonishing conclusion that the 'muse' is drawing this famous head with her left hand. This must have some deep-seated significance and cannot be brushed off as a simple flaw in the composition. This impression is further reinforced when we compare the canvas to what was its probable model (illus. 49).

The Soviet artists were actually inspired, though their version is laden with irony, by pictorial variations of the Butades fable bequeathed us by the first half of the nineteenth century. Eduard Daege's *The Invention of Painting* (1832) has become the *Origin of Socialist Realism* (illus. 48) with a minimum of modifications. An architectural frame peculiar to the

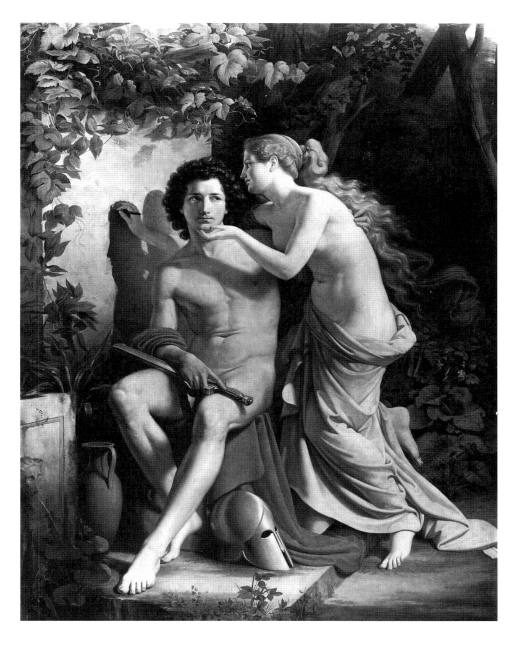

48 Vasily Komar and Alexander Melamid, *The Origin of Socialist Realism* (from the 'Nostalgic Socialist Realism' series), 1982–3, oil on canvas. Private collection.

49 Eduard Daege, *The Invention of Painting*, 1832, oil on canvas. National-Galerie, Berlin.

triumphalist style, popular with dictatorships, replaces the natural frame; artificial lighting replaces natural lighting; the huge body wearing his 'Generalissimo' uniform replaces the young naked Greek hero. Painting as an act of love is still there, but it is the product of a shift in meaning, the product of a Freudian *Verschiebung* that completely changes its significance: love has become adulation. This shift in meaning is reinforced by the left/right reversal of *The Invention of Painting* to become the *Origin of Socialist Realism*. The structure of the Russian painters' gloss is like a play on words which has to be interpreted in two different but complementary ways. The first resorts to the coded language used by artists from the former Soviet block: to paint, draw or write with the left hand indicated that they did not believe the finished work had any aesthetic value, it was either expedient to do it or else they were coerced into doing it. The origin of the second implication is more literary or intellectual and also involves the language of Soviet intellectuals: the left (*sinistra*) hand is not only the one which practises 'left-wing' art, it is also the one that unveils the real nature of things: in this case the shady, sinister side of the outlined shadow.

STORIES OF SHADOWS (FLIGHT, PURSUIT AND EXPECTATION)

Freud demonstrated that the duplication of the self was an essential ingredient in the production of the effect of 'the uncanny'. Otto Rank maintained that, primitively speaking, the double was an insurance against the destruction of the self, an 'energetic refutation of the rule of death'.[21] In chapter One I sought to demonstrate that it was within the actual context of a metaphysic of re-duplication that the Plinian fable is unveiled in all its ramifications. Once the reversal which produces the demonization of the shadow has been performed, Western representation exploits it to the full in order to portray the negative. At the end of this journey – and this is where Komar & Melamid's canvas (illus. 48) is pivotal – the 'demonization' of the shadow and the 'immortalization' it performs meet.

If we examine seventeenth-century language, a time when the fundamental theoretical elements of Western art were

being evolved, we see that one of the meanings given to the word 'shadow' by the first French-language dictionary was:

> SHADOW, thinks he is an imaginary enemy. Shall we still fight our *shadow*? In other words, our suspicions and our thoughts.[22]

What this definition describes is an internalization of the shadow as a personal projection and as an 'obscure' area of the soul, where inner negativity is born. The actual portrayal of this particular 'imaginary enemy' can be found in books on emblems. This is no coincidence since the shadow is, in a way, the emblem of negative reduplication.

In one of these images (illus. 50), we see a man armed with a sword ready to attack his own shadow which lies on the ground in front of him. The gesture is simple but meaningful. The difference in attitude between shadow and owner is particularly significant: the aggressive stance of the one is transformed in the other into a frightened and defensive one. What we have here is a manipulated projection whose expressive value had already been recognized in academies of art a century earlier (illus. 44). As usual, the text accompanying the emblem facilitates our understanding of the image (illus. 50). This is essentially what it says:

> Armed with a sword, his chest still heaving from the crime he has committed, the man wants to continue on his way. Occasionally he stops to stare in fear at his own shadow. He strikes it and orders it to go away. But when he sees the

50 Johannes Sambucus, *Guilty Conscience*, engraving for his *Emblemata*, Antwerp, 1564.

139

identical wounds, he shouts 'Here is the one who betrayed my crime!' Oh, how many times have murderers made of their remorse insane illusions, and fate armed them against themselves.[23]

The text explains the strange behaviour of turning against one's own shadow. The basic requirements can be found in a specific development, located within the sphere of the metaphysic of the double having been metaphorically misunderstood. The man thinks the shadow (his other) witnessed his transgression. He wants to silence it, but once he has done so he realizes that the other is 'himself'. The reader also realizes that the emblem offers him the key to a psychodrama and that the homicidal struggle with the shadow ends in suicide. This conflict is at this point a blueprint that will thrive as part of our European culture. It was predominately a favourite theme of romantic fiction, which has endured until now.[24] We have already encountered one example selected from contemporary imagery (illus. 5). I do not intend, however, to repeat my entire commentary, but I would like to remind the reader that when I analysed this advertisement I did draw attention to the fact that it was based on the reversal of the narcissistic situation. It is necessary to reiterate this observation when considering the Sambucus emblem (illus. 50), especially since it is precisely in this act of reversal that the unique and great contradiction between *imago* and *subscriptio* resides.

Indeed, we see the man in the image on the attack and the shadow cringing in fear, although the text speaks of a battle of equals that results in 'identical wounds' (*mutua vulnera*), presaging suicide. What the text describes is impossible to depict as an image. Surrender is attributable to the metaphoric nature of the shadow's reaction, a metaphor that cannot be visually represented. The text is an illusion, and the use it makes of the verb 'see' (*mutua vulnera vidit*) only goes to emphasize this. We must stress that this tension exists even in an era so different as our own. In the advertisement analysed earlier (illus. 5), the psychodramatic nature of the action is greatly reduced. The 'Egoist' will not lose his life if he is deprived of his bottle of aftershave. The motivations of the plot are different and the shadow manipulated in a way that would not have been possible in Sambucus' time. We have the

impression that the protagonist is strong enough and capable
of direct intervention. And yet it is not a fair battle. Even if the
object of the dispute – the bottle – is just for a moment in
danger, there is never any doubt as to who the victor will be.

 One final example reinforces the notion that the theme of
combat reverses the narcissistic situation and demonizes the
otherness of the shadow. Let us examine the vignette on the
back of Morris & Goscinny's comic strip, whose hero is the
cowboy Lucky Luke (illus. 51). The image is emblematic: it
brings to the reader's mind – once he has finished reading the
book and closed it – the action that defines this character as a
'man who pulls the trigger faster than his shadow'. This final
emblem is all the more significant since Lucky Luke never kills
anyone. In this ideal world only the foolish kill, the bullets do
no more than innocently convey the superiority of our hero.
The emblem, on the other hand, combines humour and the
depths of the human psyche. It distinctly praises the rapid
reactions that typify the psychic universe of the hero and
his admirers. Before Lucky Luke's black double has time to
draw his gun, the cowboy's bullets are through him, leaving a
small white hole above his navel. Hence, wound/symbol of
birth becomes wound/symbol of death. The bullets' bright

trajectories run parallel to – but are like the 'negative' of – the black lines on the ground. Finally, through this network of lines that link hero to silhouette, the symbols are reversed: Lucky Luke's tuft of hair indicates nonchalance, while his double's indicates fear. The hero's hat marks the speed of the action, while that of the shadow marks his surprise.

I do not suppose that Lucky Luke had read Sambucus' *Emblemata*, Ovid's *Metamorphoses* or Furetière's *Dictionnaire universel*. If he had, he would probably have realized that his homicidal feelings for his shadow (the action is repeated at the end of every adventure) were simply the product of a warped love, the sign of a guilty conscience and, finally, that this second-rate black silhouette he periodically uses for target practice was nothing more than the manifestation of an 'imaginary enemy'. But this string of thoughts would probably have slowed the brave cowboy's reactions, and – who knows? – given his shadow the kind of advantage that would have forced the loveable hero to forsake the sunny world of the comic strip for ever.

The pure spontaneity of the reflex action is nothing more than a particular circumstance at the heart of the great theme of the meeting with the other. The second significant manifestation of this meeting – in dreams about shadows – and which follows on from attack, is that of flight. The painting of 1872 by the American William Rimmer, entitled *Flight and Pursuit* (illus. 52), illustrates this better than any other example. It is an enigmatic setting. There is a man running through a palace. The architecture is mixed and borders on fantasy. The mixture of Oriental ingredients with the classical language of form, the rich but unintelligible decoration of the walls, the endless interaction of parallel corridors heightens the hallucinatory nature of the scene. The crude light from an opening outside the image casts long shadows on the ground and acts as an agent within this mysterious tale. The most important shadow is the one on the right. It is the projection of a person or persons (still outside our field of vision) into the area of the representation. They are highly energized shadows, not only because of their ability to enter the image but also because they correspond to the shadow of the running man on the left, who is attempting to leave the area of the image. We enter and exit the painting with the same impetuosity. The story that instigates the

52 William
Rimmer, *Flight and
Pursuit*, 1872, oil
on canvas.
Museum of Fine
Arts, Boston.

painting literally *intersects* it, and is both linear and circular.
The circularity (which magnifies its dream-like quality) is the
end result of having questioned the beginning, development
and denouement of the action. Is the man fleeing an invisible
enemy? But why is he fleeing since he is not only strong but
armed? Maybe he is the pursuant, and the one he is pursuing
has already left our visual field, having taken the staircase on
the left (where we see the shadow of the one who is hot on his
heels). Is the shadow that exits not the punctual rhyme of the
shadow that enters? Where, when and how will this story end,
of which all we see is a swift and fascinating sequence?

Issues concerning the beginning and end of the story were
deliberately clouded by Rimmer through a process of
psychology of form, which influences the spectator on a
subliminal level. For centuries the narrative development of
the figurative account relied on a convention born of the
mechanics of textual reading, which demanded that the
beginning of a story be situated on the left of the visual field
and that the end to be situated on the right. Rimmer
substituted the left to right reading with a right to left
reading. Consequently the beginning usurps the end, and the

143

end the beginning. The story's potential circularity is echoed by an awareness of reduplication: in the middle distance, at the very heart of the image, a spectre crosses the space. It is like a distant reflection of the man in the foreground. He too is running, his body is also bent forward, and the same leg – the right – is raised. He is an ambiguous being, virtually transparent despite being wrapped in a sheet; and despite being virtually transparent, he is casting a shadow on the ground.

In cases such as these the title usually comes to the rescue, but not here. The two words *Flight* and *Pursuit* do no more than reinforce the fact that the image must be understood in the light of their being conceptually equal. *Flight and Pursuit/ Pursuit and Flight* – where does the one begin and the other end? As the title confirms, the painting turns a general situation into an ambivalent one. There have been numerous attempts to specify its contents,[25] but these have only resulted in the principle being misunderstood, for everything leads us to believe that it was Rimmer's intention to create a story that functioned through its enigmatic form. For this reason Rimmer's painting is like a pioneering experiment that contains all the elements of a formal chronicle of the shadow that we were not to encounter for another few decades.

It is undeniable that the most complex and mysterious narrative characteristics to be conferred on the shadow are to be found in the metaphysical paintings of Giorgio de Chirico. The painter referred on more than one occasion to his passion for 'geometric and precise shadows',[26] meaning the shadows cast by the enormous colonnades of the neo-classical buildings that form the backdrop to the majority of the paintings he did between 1910 and 1919, as well as the huge human shadows inhabiting them:

> There is nothing like the enigma of the *Arcade* – invented by the Romans. A street, an arch: The sun looks different when it bathes a Roman wall in light. In all there is something more mysteriously plaintive than in French architecture. And less ferocious too. The Roman arcade is a fatality. Its voice speaks in enigmas filled with a strangely Roman poetry; shadows on old walls and a curious music, profoundly blue . . .[27]

Or:

> There are many more enigmas in the shadow of a man who walks in the sun than in all religions of the past, present and future.[28]

These reflections, which date from 1913, could be used by way of an introduction to several of De Chirico's metaphysical paintings, the one entitled *Melancholy and Mystery of a Street* for example (illus. 53). A strong Mediterranean sun divides the area into two contrasting zones: one is in deep shade, the other in full sunlight. It is a clear split, as is the corpus of the forms. 'Light and shade, lines and angles, and the whole mystery of volume begins to speak', the writer was to state elsewhere.[29] But this attempt at a confession was never to become a full declaration. The questions raised by the painting are more important than the facts. Metaphorically (or maybe metaphysically) speaking, we are at the crossroads where everything could happen or nothing would be gained in advance. The trajectory that crosses the image from left to right is the thematization of a future meeting. The two agents are only partially represented: one of them (a young girl) has just entered; the other, on the opposite side of the painting, only exists through the projection of the shadow. We have no way of establishing with any certainty to whom this shadow belongs. However, it is plainly aggressive and threatening by nature. Only the painter's statements or a familiarity with other contemporary works allow us to recognize that it is the inert shadow of a statue. The unenlightened viewer is unable to differentiate between anticipation and impending danger. All he can do is picture himself crossing the empty space between the two agents. The story emerges where the dominant theme is one of silent tension accompanied by objects that we recognize to be the subconscious symbols of a dream: on the one hand the hoop, on the other the vertical stick. Everything takes place on the level of a conflict of shadows: the young girl looks as though she were made of the same substance as the silhouette lying in wait for her round the corner of the street. She is an active element (accentuated by the raised foot; her hair and dress float in the breeze), whereas the silhouette is watchful, passive.

Rudolf Arnheim left us his famous description of this painting, which has the added benefit of revealing how De

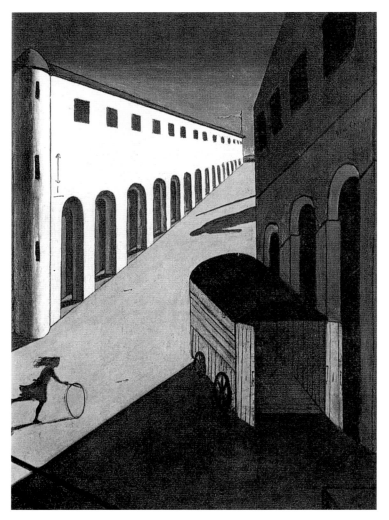

Chirico achieved the effect of 'the uncanny' by skilfully manipulating the spatial incongruities:

> At first glance the scene looks solid enough, and yet we feel that the unconcerned girl with the hoop is endangered by a world about to crack along invisible seams or to drift apart in incoherent pieces. Again a roughly isometric solid, the wagon, denounces the convergences of the buildings as actual distortions. Furthermore, the perspectives of the two colonnades negate each other. If the one to the left, which defines the horizon as lying high up, is taken at the basis of

the spatial organization, the one to the right pierces the ground. Under the opposite condition the horizon lies invisibly somewhere below the centre of the picture, and the rising street with the bright colonnade is only a treacherous mirage guiding the child to a plunge into nothingness.[30]

We would probably be misguided if we took the illogicalities of this painting to be the product of an inability to master the laws and conventions of perspective. On the contrary, everything points to the fact that De Chirico, far from being ignorant of these, was actually manipulating them. A few years later, in a work entitled *We, the Metaphysicians* (1919), he was to disclose the deep-seated motives that drove him:

> We, the painters, we are not the first to have had the idea of abandoning the logical meaning of art ... Art has been liberated by modern philosophers and poets ... Schopenhauer and Nietzsche were the first to demonstrate the significance of the non-sense of life. They also demonstrated how this non-sense can be transposed in art...[31]

On the basis of this declaration we can attempt to penetrate the artist's secret laboratory to explore the ways in which he actually achieved this transposition of historical and cultural pessimism. What we find is that his technique involved the nihilistic interpretation of the ancient code of the representation, assimilated while he was at the Munich Academy of Fine Art. It would be useful at this point to dip into classical manuals on perspective (illus. 55), in order to understand how the painter, equipped with a nihilistic bias, found himself able to uncover the absurd in plates where the scientific coherence of the projection is devoid of content and life. The reading of certain texts – the one below, for example, taken from Gerard de Lairesse's *Grand Livre des peintres* (1707) – can shed further light on this matter:

> It is uncontroversial that cast shadows in an area filled with sunlight and which enhance the beauty of a painting, must not only have the requisite length, breadth, strength and hardness, but must moreover be given the forms of the objects they project, such as that of a pillar, an obelisk, a square stylobate etc. The cast shadow of a statue whether erected on the ground or a pedestal, must be so well defined

that if this statue is placed behind an object thus preventing it from being seen, we can still divine from the shadow the attitude of the statue: for this is one of the principal means at our disposal to indicate that a painting is lit by the sun. There are painters who imagine that this need not be too precise, that all they have to do is trace an arbitrary line on the ground, unconcerned as to whether the shadow resembles a pillar or a man. . . . When a statue or even some other object is concealed behind another, it is just as important to be able to distinguish in the cast shadow the shape of the object or the attitude of the statue...

Painters who know how to make intelligent use of sunlight have an advantage that others do not have; for they are not obliged to paint trees, hills and factories in their work in order to form a great mass of shadow here or there on the ground with a view to highlighting objects in the foreground and making those in the distance disappear. All they have to do is place their shadows where they feel it is appropriate to do so, and for which there is always a logical reason.[32]

De Chirico's method is written in the margins of what the manual advocates. If we compare his painting (illus. 53) to the plates that illustrate the ancient books (illus. 54, 55), we see how virtually all the elements of his language already exist in these manuals; what the artist did was to link them. We find the same relationship between *Melancholy and Mystery of a Street* and Lairesse's *Grand Livre des peintres* as there is between a 'method of learning English without a teacher' and Ionesco's *Bald Primadonna*. There are 'logical reasons' behind De Chirico's shadows that he achieves by translating the manual and its illustrations into 'metaphysical' painting. In other words, he gives a 'meaning' to the forms in the manual (for they have none), but this 'meaning' is nothing more than the emptiness of their own enigma. The logical representation of the shadow in painting, as a sub-problem of the perspective projection, is therefore endowed with mysterious undertones that place the 'uncanny' effect of De Chirico's paintings, where the dominant theme is that of deliberately deriding the Western representational code.

The revival of an element elaborated in the seventeenth century, the resorting to the hyperbolization of the shadow

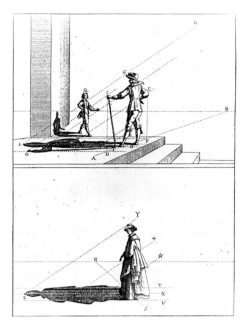

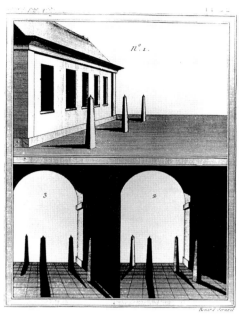

54 Jean Dubreuil, *Study of Shadows,* engravings for *La Perspective pratique,* Paris, 1651.

55 Gérard de Lairesse, *Study of Shadows,* engravings for *Le Grand Livre des peintres,* Paris, 1787.

(illus. 44, 45, 46, 47) troubled the still waters of Pittura Metafisica. It was to triumph, however, in the new medium of the cinema. If we run through the titles of some of the most remarkable films of our time, we become aware of a thematic obsession: Max Mack's *The Other* (*Das Andere*) of 1913; Ernst Lubitsch's *The Doll* (*Die Puppe*) of 1919; F.-W. Murnau's *Phantom* (*Phantom*) of 1922; Arthur Robison's *Warning Shadows* (*Schatten*) of 1923 (the French title is *Montreur d'Ombres,* 'shadow-master'); Paul Leni's *Waxworks* (*Das Wachsfiguren-kabinett*) of 1924. By examining some of the most famous shots to be found in Expressionist films, we discover the definitive characteristics of the aesthetics of the shadow. But before doing this, I feel that an explanation is in order. To discourse on a cinematic frame as though it were an isolated image (comparable to ancient paintings, drawings or engravings) is not, from a theoretical point of view, a recognized procedure. However, German Expressionist cinema is, for several reasons, an exception. Wiene and Murnau, who created the films from which I have extracted my two frames (illus. 56, 57), are among those directors who openly acknowledged their debt to the paintings of the past. Experts and historians of the cinema emphasize that these directors developed

149

a rhetoric of the cinematic image based on synecdoche. Consequently, each image, each frame is conceived in such a way that it relates – either through analogy or contrast – to the film as a whole, and that the film in turn hinges on the notion of or desire for a 'transversal contemplation' captured with each lengthy shot.[33] Therefore, to analyse only one frame is, in this case, not a heresy but an obligatory hermeneutic procedure. This would also explain why the frames from German Expressionist films are so easily reproduced in books without their impact being lost.

Hence the famous 'painting' from *The Cabinet of Doctor Caligari* (1920) by Robert Wiene and Willy Hameister (illus. 56). In it we see the Doctor on the left and the gigantic projection of his shadow on the right. Larger than the person, its dimensions are significant. It is the externalization of the person's inner self. It is as though the camera had first of all been able to plunge *into* the person's mind through the shadow, so that it could then project the man's inner self onto the wall (onto a second screen therefore, placed *en abyme* to the first). The shadow, an external image, reveals what is taking place *inside* the character, what the person *is*. Let us examine the contrast between Caligari's stance, arms protecting his chest, the (partly) clenched left fist and the shadow on the right. The shadow is simultaneously presented as an emanation, a distortion and a projection onto the inner screen of his psyche. Through the distortions, the projection opens up the configuration: the profile looks vaguely anthropoidic, the fist unclenches to reveal shrivelled fingers. The emphasis placed on the hand as an instrument of action thematizes the idea – presented in a similar way by de Gheyn (illus. 47) in an example we are already familiar with – that the shadow in this instance can be (and is) an active instrument, an instrument of evil.

But there is an underlying ambiguity in this image (indeed in the whole of the film): it incarnates a madman's fantasies, a man who is the narrator of the whole story (Francis). What we are seeing are 'projections', and they must be understood as such. And it is precisely because of this interaction that time and again it has been possible to point out that the narrator is like the director's double, and the projection of the shadows is like the film's double in so far as it is a figurative technique. And as far as this frame (illus. 56) is concerned, the meta-

56 A still from Robert Wiene and Willy Hameister's 1920 film *The Cabinet of Dr Caligari.*

57 A still from Friedrich Murnau's 1922 film *Nosferatu, a Symphony of Horror.*

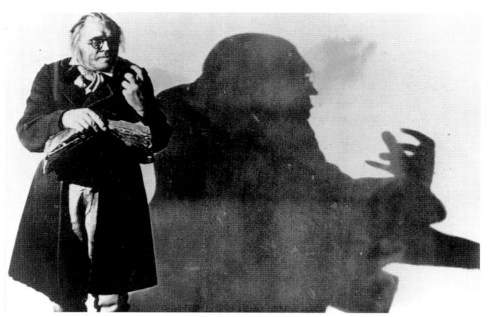

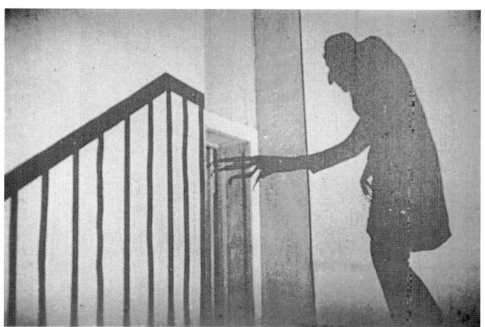

poetic message of the shadow is unequivocal: it is a metaphor, or more precisely, a hyperbole of the key medium of Expressionist cinema: the 'close up'. The shadow thereby challenges the very nature of cinematic production and the mechanics of its appeal.[34]

The impact of this kind of analysis is probably greater in Murnau's *Nosferatu* of 1922 (illus. 57). In this film the function of the shadow is more subtle. Is the famous silhouette that is about to climb the stairs the vampire himself, or his shadow? The distortions to which his arms and hands have been subjected (and which follow the same principle of distortion as those previously produced by artists such as van Hoogstraten and de Gheyn) might lead us to believe that the second alternative is the correct one. But both Murnau and the viewer know that, according to an ancient tradition, a vampire has no shadow. The only conclusion we can reach, therefore, is that it falls under the category of the meta-discourse: this silhouette is Nosferatu 'himself', 'a tentacular polyp, translucent, without substance, a virtual phantom'. He inhabits a subterranean world of doors, corridors and stairs, a world structured along the lines of the Freudian unconscious. Seen in this light, the function of the director is in effect that of a 'shadow-master'. He portrays the dark contents of the mind and turns them into a story that is, to all appearances, an aesthetics that accentuates the analogy between 'shadow' and 'cinematic image'. The proof that this meta-aesthetical interpretation is formulated in the story is only given to the viewer at the end of the film, at the very moment when the first rays of light to fall on Bremen annihilate Nosferatu, and when the lights are turned on in the projection room and the screen is once again white.

5 Man and his Doubles

Meines Herzens Bild zu finden
Bei den Schatten oder Hier.
(Hölderlin, *Diotima*)

ENLIGHTENMENT AND THE SHADOW

To the *philosophes* of the Enlightenment, myths were nothing but fairy-tales. The one claiming to shed light on the dawn of painting was no exception:

> The imagination is well practised in seeking the origin of Painting; and it is based on this, that poets have written the most charming of fairy-tales. If we are to believe them, then it was a shepherdess who, wanting to have the portrait of her lover, first drew a line with her crook around the shadow that the young man's face cast on the wall.[1]

This comment in the *Encyclopédie* casually amalgamates the sources in a venture destined to blur the issue rather than clarify it. It seems to highlight an uncertainty that was already apparent in Pliny the Elder: *picturae initiis incerta*! This is one of the reasons why the allusion to be found in the first chapter of Rousseau's *Essai sur l'origin des langues* (1781) conceals a particularly important problem. As regards the 'historical' debate surrounding the invention of art, the author opts for a more theoretical approach:

> It is said that love was the inventor of drawing. He might also unfortunately have invented speech; dissatisfied with it, love spurns it, for there are more active ways of expressing oneself. She who so lovingly traced the shadow of her Lover had such things to impart! What sounds did she use to achieve these movements with her stick?[2]

This was the first time the Plinian fable had been explicitly regarded as a myth of love. Moreover, it was also the first time

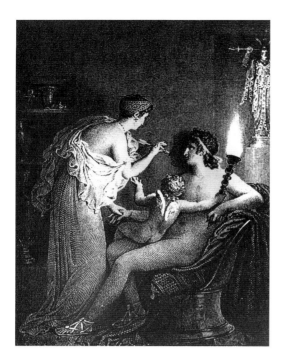

58 Anne-Louis
Girodet-Trioson,
*The Origin of
Drawing*, engrav-
ing from *Œuvres
posthumes*, Paris,
1829.

that the outlined shadow was considered to be, not a primitive
mode of pictorial expression, but a primitive language
through which love expresses itself.[3]

This is how, within the dream of origins that haunted the
eighteenth century, the fable of Butades became one of the
major themes of painting.[4] Something of Rousseau's spirit still
survived at the beginning of the nineteenth century, in the
way the Plinian iconography was addressed. In the engraving
that illustrates Anne-Louis Girodet-Trioson's *Œuvres post-
humes* (illus. 58), it is the god of Love himself who illuminates
the scene with a torch and who guides the hand of the
Corinthian girl while she traces her lover's profile with an
arrow probably taken from Cupid's quiver. The scene is like
an unbroken circuit: beneath the vigilant gaze of the statue of
Minerva, goddess of Wisdom, the hands of the two lovers and
those of Love form a continuous chain that leads from the
torchlight to the black portrait which stands out on the wall.
This complicated body language is also a transformed, exalted
'language of love'. Seated between the two lovers, the small
god of Love covers the young man's unseemly nakedness, but
– because of his position and through his symbols (wings,

torch) – there is an echo of flight and passion. Censure and sublimation – the real themes of the engraving – end up on the path mapped out by Rousseau: Girodet is probably aware that, in love, 'there are more active ways of expressing oneself' than through the actual art of drawing, but he elects to portray the love scene as a 'transfer of power', or, as he calls it in a poem appended to the engraving, a 'heavenly transport', steering its erotic energy (which to Girodet was basically masculine) towards the (feminine) creation of a surrogate image:

> And still to this sketch she brought her vows
> In silent adoration, and the faithful image
> Accepted the troth she plighted the model.[5]

At the time when Girodet was producing his poem and engraving, it was already accepted that the drawing of the outlined shadow was a primitive language of love. We find an excellent example of this in the first conference paper given to the Royal Academy of London (1801) by the Swiss artist Johann Heinrich Füssli:

> Greek art had her infancy, but the Graces rocked the cradle, and Love taught her to speak. If ever legend deserved our belief, the amorous tale of the Corinthian maid, who traced the shade of her departing lover by the secret lamp, appeals to our sympathy, to grant it; and leads us at the same time to some observations on the first mechanical essays of Painting, and that *linear method* which, though passed nearly unnoticed by Winkelmann, seems to have continued as the basis of execution, even when the instrument for which it was chiefly adapted had long been laid aside. [...] The first essays of the art were *skiagrams*, simple outlines of a shade, similar to those which have been introduced to vulgar use by the students and parasites of Physiognomy, under the name of Silhouettes.[6]

Füssli's observations connect early pictorial language to the fashion during the second half of the eighteenth century for cut-outs, which originated from a pun pertaining to Louis XV's Minister of Finance, Etienne de Silhouette. It spread through the whole of Europe and was cherished by the upper classes as one of their most popular party games. Füssli's allusion is not without its ambiguities. Although he acknow-

59 Thomas Hollo-
way et al., *Machine
for Drawing Silhou-
ettes*, engraving for
Lavater's *Essays on
Physiognomy*,
London, 1792.

ledges that it is a legacy from Pliny's fable, he also seems to
view the technique with obvious disdain, even though, a few
years earlier, he had contributed to its popularity by helping
to illustrate the English version of *Essays on Physiognomy*
(London, 1792) written by his compatriot Johann Caspar
Lavater.

Lavater's book describes a new device for the creation of
silhouettes (illus. 59). The illustration relating to this 'machine'
is much clearer in the English version than in the first German
edition (Leipzig and Winterthur, 1776). If we compare the
engraving in the *Essays on Physiognomy* with any contempor-
ary representation of the Butades fable (illus. 58), we see that
the Plinian scenario of origins has been transformed into an
actual posing session that aims to reproduce the profile
through mechanical means. The allegorical décor has dis-
appeared and the sexual roles reversed. The model – a woman
– is seated on a special chair, which incorporates a screen
mounted on an easel. On the other side of the screen stands
the person who is capturing the contour of the model's profile
projected by the candle burning nearby. For the method to
succeed, the model must remain absolutely still and very close
to the screen. As we can see, the process was devised in order

to capture as faithfully as possible the profile's negative image. That is probably why it has often been regarded as one of the direct predecessors of photography.

We can only understand the functioning, or more particularly the function, of the 'machine for drawing silhouettes' when we place it within the framework of Lavater's discourse on physiognomy, which we must now examine, beginning with his definition of the shadow-image:

> Shades are the weakest, most vapid, but, at the same time, when the light is at the proper distance, and falls properly on the countenance to take the profile accurately, the truest representation that can be given of man. – The weakest, for it is not positive, it is only something negative, only the boundary line of half the countenance. The truest, because it is the immediate expression of nature, such as not the ablest painter is capable of drawing, by hand, after nature.
>
> What can be less the image of a living man than a shade? Yet how full of speech! Little gold, but the purest.[7]

To Lavater, the outlined profile of the shadow is the minimal image of man, his *Urbild*. And thanks to this quality it can also become the favoured object of an hermeneutic of human nature.

Through the ancient tradition of physiognomic studies, Lavater believed that a person's face bore the marks of his soul. He deviated from that tradition because he considered the outlined profile to be important:

> I have collected more physiognomical knowledge from shades alone than from every other kind of portrait, have improved physiognomical sensation more by the sight of them, than by the contemplation of ever mutable nature.
>
> Shades collect the distracted attention, confine it to an outline, and thus render the observation more simple, easy, and precise. The observation, consequently the comparison.
>
> Physiognomy has no greater, more incontrovertible certainty of the truth of its object than that imparted by shade.[8]

With this assertion the author of *Essays on Physiognomy* makes an important conceptual leap. In fact, according to him, it is not – as was accepted by tradition – the human face that is the reflection of the soul, but the shadow of this face. This makes a

60 Anonymous engraving, *The Soul of Man*, for Jan Comenius, *Orbis Sensualium Pictus*, Nuremberg, 1629.

fundamental difference, since it exploits – probably subconsciously – another ancient tradition: the one which recognized man's soul in his shadow, and a shadow in his soul (illus. 60). The implications of this deviation are manifold. To analyse the shadow is tantamount to a *sui generis* psychoanalysis. To Lavater, the outlined profile is a hieroglyph that has to be deciphered. This work is regarded as a veritable hermeneutic that has all the hallmarks of a translation from one language into the other:

> The true physiognomist unites to the clearest and profoundest understanding the most lively, strong, comprehensive imagination, and a fine and rapid wit. Imagination is necessary to impress the traits with exactness, so that they may be renewed at pleasure; and to range the pictures in the mind as perfectly as if they still were visible, and with all possible order.
>
> Wit is indispensable to the physiognomist, that he may easily perceive the resemblances that exist between objects. Thus, for example, he sees a head or forehead possessed of certain characteristic marks. These marks present themselves to his imagination, and wit discovers to what they are similar. Hence greater precision, certainty, and expression are imparted to his images. He must have the capacity of uniting the approximation of each trait, that he remarks; and, by the aid of wit, to define the degrees of this approximation. . . . Wit alone creates the physiognomical language; a language, at present, so unspeakably poor. . . . All that language can express, the physiognomist must be able to express. He must be the creator of a new language,

which must be equally precise and alluring, natural and intelligible.[9]

We may therefore be justified in referring to the formation of a Lavaterian 'shadow-analysis' that was to become the focus of attack from enlightened circles heralded by George Lichtenberg:

> Nobody would laugh more than I, at the arrogance of that physiognomist who should pretend to read in the countenance the most secret thoughts and motions of the soul ...[10]

Despite all the criticism aimed at Lavater's method, it was widely practised around 1800 and situated somewhere between entertainment and scientific experimentation. As a method it regarded the shadow as a personal emanation more capable than the individual concerned of supplying us with authentic information on the person's inner self. Physiognomy does not interpret a person's 'expression' (the model must remain absolutely still, immobile) but his 'traits'. Unlike expression (*der Ausdruck*), which reflects the soul's temporary state, traits (*die Züge*) relate to its deep structure.[11] It is for this reason that the captured shadow is more precious to the physiognomist than the actual living face in front of him. What the person conceals, the shadow reveals. This is one of the reasons why it was so popular as a party game: all those who took part did so with a mixture of apprehension and anticipation: apprehension because they were worried they would reveal some terrible disorder of the soul; anticipation because they hoped they would reveal for all to see, inestimable, hidden qualities.

We would be mistaken if we believed that reading the four volumes of the *Essays on Physiognomy* would give us the key to deciphering the human profile. Lavater was in effect constantly revising the essays. They are a collection of repeated attempts to codify a language, although the author never succeeded in establishing its grammar. And despite Lavater's efforts to interpret the line that runs from the brow to the chin (illus. 61), these remained experimental and intuitive. That is why our own investigations will involve the origin and structure of Lavater's hermeneutic rather than its practical conclusions, since these belong in the realms of

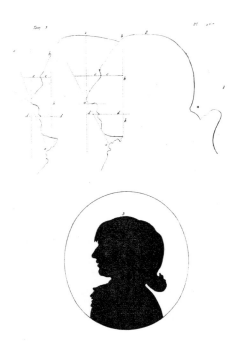

61 Johann Caspar Lavater, *Physiognomical Study*, Leipzig and Winterthur, 1776.

fantasy. Our task is not to judge whether the process is sound or absurd, but to reflect on the fundamental fact that Lavater's hermeneutic aims to understand man as a moral being, through his shadow. The symbolic significance of the method can only be understood if we bear in mind that, for Lavater, the study of physiognomy was the result of a religious vocation that led him to train to be a Protestant pastor. Goethe, who was initially involved in the development of this physiognomic interpretation, admitted quite openly when speaking with Eckermann: 'Lavater's method entails morals, religion.'[12]

This is why Lavater maintained that the practice of physiognomic deciphering was an act of love, committed to searching out the divine in a human being. The full title of the work is more like a warning against possible slander: *Physiognomical fragments for the advancement of man's knowledge and his love for his fellow men* (*Physiognomische Fragmente zur Beförderung der Menschenkenntnis und Menschenliebe*).

The aim of Lavater's 'shadow-analysis' is that it should be a new 'cure for the soul' (*Seelensorge*). It sets off with a notion of man that takes his divine origins into account. Man was made

in God's image and likeness. But sin drove him to lose his divine likeness. His relationship with the divinity was overshadowed by flesh.[13] Taking this kind of reasoning into account, we might wonder whether Lavater's claim that it was his search for the divine in man that led him to practise physiognomy was made in good faith. Or to be more precise, it raises the following question: are we really likely to encounter God in a *man's shadow*? We have every reason to believe the contrary. What Lavater was actually looking for was not the positive, divine side of man, but the negative, sinful side. This is a serious contention and needs to be justified.

Let us therefore examine once more the significance the outlined profile assumed with Lavater. It only had a synechdocal value (*pars pro toto*) and was based on the notion that the human shadow is a meaningful image:

> I am of the opinion that a man seen in silhouette from all angles – from head to foot, from the front, from the back, in profile, in half-profile, three quarters, would allow fundamentally new discoveries to be made on the omni-significant nature of the human body.[14]

What is quite implicit here is the notion that in the projection of the shadow, man is above all 'himself'. The importance bestowed on the profile resides in the fact that it is considered to be a direct externalization of the soul; its actual composition. The nose in particular, with its more or less pronounced protuberance, is one of the most remarkable creations of internal forces: it is, Lavater believed, 'the buttress of the brain' (*Wiederlage des Gehirns*).[15] The parallel – outlined profile/human soul – is, in Lavater's opinion, so perfect that the expressions are interchangeable and often indiscriminately used. The outlined profile *is* the external soul, and physiognomy is an exercise capable of moving from the profile up to the psychic energies it is composed of:

> Physiognomy, in the narrow sense of the word, is an interpretation of the forces, or the science which studies the signs of the forces ...[16]

But the most important question remains unanswered. If Lavater's physiognomy is based exclusively on the interpretation of the *line of the profile*, then why do the illustrations show

the whole of the man's head in the shape of a large dark stain rather than as a linear outline? The dilemma had cropped up earlier when, assisted by his friend Zimmermann, Lavater was finalizing the technicalities for the first edition of his *Essays*. Initially he was undecided but he finally opted to have shadows rather than empty contours. It was Zimmermann who decided that 'images of shadows should be dark' (*Schwarz sollen Schattenbilder sein*). Lavater appeared at first to be somewhat reticent, or to be more exact, cautious: 'the silhouettes must be precise; we must distance ourselves from the black arts' (*Die Silhouetten sollen genau sein, können nicht Schwarzkunst sein*). He came up with the compromise solution of the grey shadow, only to abandon it at the last minute.[17] The first volume of the 1775 edition of *Essays on Physiognomy* was illustrated in the main with black outlined shadows, as were the three following volumes. But his initial reservations and final choice together demonstrate that the shadow-image, far from being devoid of symbolic implications, was so imbued with them that Lavater himself was worried that they were being over emphasized.

His indecision over the colour of the physiognomical profile that marked the birth of the fame Lavater's illustrations was about to gain are perhaps difficult to understand, save in the context of the rhetoric of colour that distinguished the final quarter of the eighteenth century. When, in 1778, Alexander Cozens wanted to portray 'simple beauty' (illus. 62), he chose a purely linear profile of a face, which resulted in the white background becoming integrated into the drawing's symbolism. He was aware, however, that his image was the product of a purely 'statistical', intellectual process.[18] Cozens would probably never have dared depict his *simple beauty* as a black shadow, because at the time black was strictly codified as a key-colour within the framework of another aesthetic category, the Sublime. Edmund Burke claimed that 'darkness is one of the sources of the sublime', which, we should not forget, is a source of 'aesthetic displeasure', combining admiration and fear, even terror. In one of the most important chapters of his treatise, devoted to the 'power of black', Burke compares the perceptive power of black to the shock of a fall.[19]

The 'danger of the precipice' that Burke discovered in the attractiveness of black is in no way alien to Lavater, who was

62 Alexander Cozens, *Simple Beauty*, engraving for his *Principles of Beauty, Relative to the Human Head*, London, 1777–8.

quick to perceive the quasi-magical undertones that the manipulation of shadows contained:

> I teach no black art; no nostrum, the secret of which I might have concealed...[20]

This statement is probably circumstantial. We know that Lavater elaborated a complete set of secret rules (*Geheimregeln*) so that the whole of the shadow could be read, though it was 'not destined for the impure hands of the Public'.[21] We also know that there were strange events in his personal life and immediate environment: these were not without their neuroses, suicides and exorcisms. But since this is the stuff of biographies,[22] we need only establish that, according to all probability, the short-lived success enjoyed by Lavater's physiognomy was largely due to the fact that it was another form of divination. While some of his contemporaries went in for palmistry, read the lines of the brow or coffee grounds,[23] Lavater read ... the shadow.

Paradoxically, the process is a follow-up to investigations into myths undertaken in the spirit of the Enlightenment. The momentous event that took place while Lavater was developing his method of examining the contours of shadows in order to understand the human soul, and which indirectly explains it, was what could be referred to as 'the death of the Devil'.[24] And 1776 was an important year in the history of demonology, for there appeared in Berlin an anonymous work entitled *Ueber die Non-Existenz des Teufels* (*On the non-existence of the Devil*). It was soon discovered that the author was Pastor Christian Wilhelm Kindleben.[25] The author stated

with unprecedented clarity that it was his opinion that the Devil only existed in the minds of theologians and in the hearts of evil men: 'Do not seek the Devil outside, do not seek him in the Bible, he is in your heart' (*den Teufel nicht ausserhalb, suche ihn nicht in der Bibel; er ist in deinem Herzen*).[26] A significant step had been taken: the Devil makes way for Evil and becomes a psycho-philosophical principle that dwells in the heart of man.[27]

Lavater's shadow is therefore quite literally a shadow engendered by the Enlightenment. It is not a substitute for the Devil, but a physical manifestation of him.

In the light of these assertions, let us return to Lavater's 'machine for drawing silhouettes' (illus. 59). It is possible that the lady in the chair might not have sat down had she known that the man behind the screen was engaged in a practice that verged on the unlawful. He was attempting to capture an image of her soul, as a first step in a hermeneutic process. It is interesting to note how Lavater's 'machine' incorporates ideas inspired by the Plinian fable with an instrument traditionally used in Christianity (but abolished by Protestants) for the 'therapy of the soul': the confessional.

The scene could *grosso modo* be regarded as a translation into visual terms of a confession. The verbalization of the inner life (common during confession) is replaced by the internal being projected to the external with the help of the shadow. Through the projection screen the physiognomist watches the proffered image in much the same way that the priest listens to the anonymous voice which comes to him filtered, and without body, from the other side of the grille. Just like the confessor, the physiognomist has access to the secrets of the soul, and just like him he is more likely to discover the fallen man than the one created 'in God's image'. Lavater had this kind of process in mind when he described the physiognomist as a 'Christian seer':

> He (the good physiognomist) must possess the character of those Apostles and early Christians who possessed the gift of recognizing spirits and reading the thoughts of the soul.[28]

Except that Lavater did not read the souls of men, he read their shadows. To him the shadow was the imaginary area where the soul revealed itself to be full of sin. That is why the physiognomical hermeneutic can be regarded as an exercise

through which the shadow-soul is questioned and interpreted. To a certain extent it can also be seen as an act of love, but on one condition only: that we take into account a basic pessimism as regards human nature. This was not a feature of Lavater's philosophy alone, the pessimism was inherent to the Enlightenment. Diderot had something to say on this subject:

> In the whole world there is not a single perfectly formed, perfectly healthy man to be found. The human species is just a mass of more or less deformed and sick individuals.[29]

We should not be too surprised therefore that Lavater went so far as to subject an image – which at the time was considered to be perfect – to a physiognomical analysis: the *Apollo Belvedere* (illus. 63). He does so with full knowledge of the facts since he quotes the enthusiastic appraisal of the statue made by J. J. Winckelmann in his history of ancient art of 1764, *Geschichte der Kunst des Altertums*:

> Observe in spirit the kingdom of ethereal beauties and endeavour to guess the creator of this celestial nature and to fill your spirit with beauties which transcend nature. For nothing here is mortal and nothing has human means. No vein warms nor nerve animates this body. No, it was a celestial body which, flowing like a gentle stream, filled the whole contour of this figure.[30]

63 Johann Caspar Lavater, *Physiognomical Study of the Apollo Belvedere.*

Lavater half listens to Winckelmann's appeal. It is a double illustration. The first contour, filled with the white of the page, is reminiscent of Cozens's illustration of 'simple beauty' (illus. 62). The second reduces Apollo's head to an outlined shadow – not a very orthodox way to treat an immortal god. The beginning of the analysis is fairly positive, the conclusion borders on catastrophe:

> Twice have I drawn this head of Apollo based on the shadow then reduced it and I think I have been able to bring to it something which confirms Winckelmann's feeling. One never tires of contemplating these contours. Really, we can say nothing about them, we tremble and anything we say is intolerable. Nevertheless, from the confused mass we can highlight:
> The sublimity of the forehead, how the forehead relates to the face as a whole; the curve of the brow in relation to the lower part of the face; the way the chin curves into the neck.
> I believe that if the contour of the nose were a perfectly straight line, this profile would give the impression of even greater *noble power*, even greater *divine power*. The nose being completely concave to the contour of the profile is always indicative of a certain weakness.[31]

The effect of this final observation of Lavater's can be compared to the collapse of the entire structure that supports the moral values founded on the kind of aesthetic values Winckelmann had tried to construct around his fetish image. Everything hinges on Apollo's nose, whose weak character is *unveiled* by the shadow.

Let us examine Lavater's approach more closely. It is based on reductions that fit one inside the other. The statue is reduced to the head, the head to its shadow, the shadow of the head to the line of the nose. The problematic line demistifies a body (that of Apollo's) considered to be a model of perfection. The polemic is directly targeted against Winckelmann's text and the use he made of the notion of contour. In effect, to the art historian the contour (*die Umschreibung*) was a *significant line* since it was imbued (*ergossen*) with a divine spirit (*himmlischer Geist*). But if the divine spirit was, to Winck-elmann, manifested through the contour of the body (*die Umschreibung der Figur*), to Lavater, who unscrupulously eliminated the body from the value system, another contour

– that of the nose – cancelled out the very existence of a divine power (*göttliche Stärke*), which could have been one of the founding principles of this 'god' (of light), now reduced to a 'shadow'.

The process is symbolic and we must continue to examine it. Apollo is not just any god, he is the god of Light. Lavater's reduction places shadow in direct antithesis to light, thus directly targeting the Pantheon of the Ancients. It was not for another a year that the key to the problem raised by the 'shadow-analysis' of the *Apollo Belvedere* was finally found. It was in the second volume of his *Essays* (in 1776) that Lavater unveiled his prototype of physiognomical perfection (illus. 64). A glance at these illustrations, where he displays (in an overtly stereotypical manner) six profiles of Christ, instantly reveals the line of the nose whose absence in the *Apollo Belvedere* was so deplored by Lavater. The same glance will reveal that what differentiates the six silhouettes of Christ from the other plates in the book, is that they are all – could this have been otherwise? – what we could paradoxically term 'profiles of shadows without shadows'.

NOBODY ON GOLDEN GROUND

Let us imagine what the Devil who, as though to prove that he was not quite dead, appeared in one of the vignettes of

65 Johann Caspar Lavater, *Satyr in front of Silhouettes*, 1776, engraving.

66 George Cruikshank, 'The Man in Grey Seizes Peter Schlemihl's Shadow', engraving for Adelbert von Chamisso's *Peter Schlemihl*, London, 1827.

Lavater's second volume of *Essays on Physiognomy* might have been thinking as he looked at the painted silhouettes in front of him (illus. 65). Perhaps he would have repeated the words of Lavater himself:

> What is less the image of an individual of flesh and bones than his simple silhouette? And yet, what does it not say? There is little gold there, but the purest![32]

These words – we continue exercising our imaginations – could also have been spoken by the 'man in grey' who bought Peter Schlemihl's shadow in 1814 (illus. 66).

The story is well known. Schlemihl, a poor boy looking for work, happens upon a society of millionaires. Having been spurned because of his poverty, he is approached by a strange individual dressed in grey, who entertains the fashionable set by extracting the most unexpected objects from his pocket. He has a proposition to make which Schlemihl accepts: in exchange for his shadow he will give him a magic purse, which, whatever happens, will always be full of gold. And so Schlemihl is suddenly incredibly wealthy, but also incredibly unhappy, for, seeing him deprived of his shadow, people are suspicious of and repulsed by him. The man in grey then proposes a second exchange: Schlemihl can keep the purse and have his shadow back, but on his death he must give the man in grey his soul. The young man resists the temptation, drives the Devil away and throws the magic purse into an abyss. He has saved his soul but not recovered his shadow. As fate would have it, he becomes the owner of Seven League Boots and is able to travel the world. From that moment on he lives in absolute isolation and through his passion for botany regains his former tranquility and happiness.

The author, Adelbert von Chamisso, assures us that it is a 'wonderful history', a point about which we are left in little doubt. When it was published in France in 1839, he added a 'scholarly preface, where the inquisitive will learn what the shadow is':

> A solid body can never be lit by a luminous body, and any area deprived of light and situated on the side of the unlit part is what we call 'shadow'. And so, strictly speaking, the shadow is a solid whose shape is dependent on that of the luminous body, on that of the solid body, as well as on the

latter's position in relation to the distance from the luminous body. Seen on a surface situated behind the solid body which produces it, the shadow is but a part of this surface in the solid which represents the shadow.

The naïvely scientific tone of this explanation has a very precise objective with a moral root, which materializes as a result of an apparent semantic leap:

> While the science of finance teaches us the importance of money, the science of the shadow is not widely recognized. With no thought for the solid, my foolhardy friend lusted after money, the value of which he knew. He wants us to benefit from a lesson which cost him dear, and his experience shouts out: think of the solid.[33]

This surprising, and somewhat suspect, admonition on the part of the author prompted the many interpretations to which the famous tale has been subjected over the years. Rather than dealing with these,[34] I have chosen to discuss a problem of principle, which in this instance is the *interpretable* nature of the barter of the shadow. The exchange that precipitates the story is by nature paradoxical. The shadow is the very prototype of the irremovable sign. It is undetachable from, coexistent and simultaneous with the object it duplicates. To suggest (and to perform) such an exchange, we must accept that it is 'exchangeable' and that it has an exchange value. We must therefore accept its reification.

It is this particular aspect that the episode of the exchange emphasizes. The mysterious purchaser parades before the eyes of the company (and of the reader) a whole range of objects that gradually increase in size and value. From his pocket he takes English plaster, a telescope, a carpet, a tent with poles together with cordage and ironwork and, finally, three saddled horses ... This is, of course, a prologue to the key moment, that of the reification of the shadow which has all the characteristics of an investiture performed by the man in grey:

> During the short time that I had the happiness to find myself near you, I have, sir, many times – allow me to say it to you – really contemplated with inexpressible admiration the beautiful, beautiful shadow which, as it were, with a

certain noble disdain, and without yourself remarking it, you cast from you in the sunshine. The noble shadow at your feet there. Pardon me the bold supposition, but, possibly you might not be indisposed to make this shadow over to me.[35]

The man in grey's discourse marks the transition through which the shadow of 'nothing' becomes 'something'. We observe how the shadow gradually moves from being nothing to being endowed with an exchange value. The strange person does not use the powerful language of business (*buying and selling*), but speaks euphemistically of 'making the shadow over to him' (*überlassen*). It is up to Schlemihl himself to take the necessary step, even though this appears in the form of a question:

> What was I to make of this singular proposition to sell my own shadow?

Once the question has been verbalized the shadow becomes part of the system of objects that can enter or leave the man in grey's pocket:

> I have many things in my pocket which, sir, might not appear worthless to you, and for this inestimable shadow I hold the very highest price too small.

The shadow has been subjected to two operations: first of all it has been reified (the man in grey picks it up off the grass, folds it up and puts it in his pocket), and second, it has been invested with an inestimable value, a limitless value that materializes in the shape of the bottomless purse. The shadow thereby becomes a superlative symbolic possession. This is where the man in grey meets Lavater. This meeting is also symbolic; so it would be pointless, on a factual level, to search for Lavater's 'influence' on Chamisso. Their paths cross on a symbolic level because – to the man in grey as much as to the physiognomist – the shadow is priceless only as a substitute for the soul. For the one as much as for the other, it is through the shadow that a being is determined, where his identity is defined. To sell your shadow therefore, is the same as losing your identity: one moment you are 'somebody', the next you are 'nobody'.

Chamisso's philosophy is perhaps easier to understand if

we bear in mind that *Peter Schlemihl* was published soon after the play *Jemand und Niemand* ('Somebody and Nobody') had been completed. In it Achim von Arnim gives an updated version of an old English tale, which recounts the adventures of *Nobody*.[36] The whole of the first part of Chamisso's novel can be regarded as a kind of linguistic game, centred on the efforts of the shadowless person to overcome his condition as a 'Niemand' (*Nobody*) and to become a 'Jemand' (*Somebody*).[37]

Bearing this in mind, let us examine what Schlemihl does once he has sold his shadow and returned to the solitude of his hotel room:

> I drew the unlucky purse from my bosom and with a kind of desperation which, like a rushing conflagration, grew in me with self-increasing growth, I extracted gold, and gold, and gold, and even more gold, and strewed it on the floor, and strode amongst it, and made it ring again, and feeding my poor heart on the splendour and the sound, flung continually more metal to metal, till in my weariness I sank down on the rich heap, and rioting thereon, rolled and revelled amongst it. So passed the day, the evening. I opened not my door; night and day found me lying on my gold, and then sleep overcame me.

This powerful scene, while appearing to take place in absolute privacy, actually involves several agents: soul, shadow, self, gold. If Schlemihl takes the purse 'from his bosom' (*aus meiner Brust*) only to throw it to the ground, the gesture is doubly significant. It indicates the sudden loss of the money's intrinsic value, and it highlights its value as a surrogate. The ground is where his estranged shadow should have been. But even when it is scattered on the ground, gold is gold, and the body that covers it at the end, as though to leave its impression on it, is, in the absence of the shadow, the body of 'no-body'.

THE STORY OF PETER SCHLEMIHL AS SEEN THROUGH SOME OF THE ILLUSTRATIONS

The majority of commentators have quite rightly seen in the novel of the man who lost his shadow the story of the symbolic loss of determination. Of the numerous interpretations which have served the text, I propose to address those

that most directly involve it: the early illustrations.[38] I began with the premise that illustrations are interpretations of the text. This takes on a particular importance in the case of *Peter Schlemihl*, for it deals with the loss of determination as though it were a loss of image. My first choice are the engravings – very much appreciated by Chamisso – made by George Cruikshank for the first illustrated edition of the novel (London, 1827). Whenever possible I shall compare them to two subsequent sets: Adolf Schrödter's for the first edition of the collected works of Chamisso (Leipzig, 1836), and Adolf Menzel's more complicated illustrations (Nuremberg, 1839). Moreover, I have selected four key scenes.

Let us begin with the episode that precipitates the plot: the exchange of the shadow (illus. 66). Peter Schlemihl has his back to us. In his hand he is holding Fortunati's purse while the man in grey is in the process of claiming his shadow. Cruikshank introduces two new ideas into the engraving. The first is that the shape of the shadow is similar to the Devil's. In the foreground of the engraving the arabesque formed on the ground by the Devil's silhouette – his own shadow – and that of Schlemihl's form a continuous line that closes in on itself. Our hero's shadow would appear to be engaged in a silent dialogue with that of the man in grey. The final point of contact between Schlemihl and his shadow is about to be severed by the Devil's nimble fingers. The deviation from the text is both evident and significant:

> I eagerly extended him my hand. 'Agreed! the business is done; for the purse you have my shadow!'
>
> He closed with me; kneeled instantly down before me, and I beheld him, with an admirable dexterity, gently loosen my shadow from top to toe from the grass, lift it up, roll it together, fold, and, finally, pocket it.

We might quite rightly wonder why Cruikshank chose to deviate from the text and to have the shadow being taken from the feet rather than the head. The question becomes even more crucial when we see that a decade later Schrödter returned to a more faithful representation of the text (illus. 67) by having the shadow rolled from the head as its owner looked on, while Menzel (illus. 68) opted for a compromise: Schlemihl witnesses the taking of the shadow (as he does in the text and in Schrödter) from the feet as in Cruikshank. He

67 Adolf Schröd-
ter, 'The Man in
Grey Seizes Peter
Schlemihl's
Shadow', engrav-
ing for Chamisso's
Peter Schlemihl,
Leipzig, 1836.

68 Adolf Menzel,
'The Man in Grey
Seizes Peter Schle-
mihl's Shadow',
engraving for
Chamisso's *Peter
Schlemihl*, Nurem-
berg, 1839.

goes a step further than Cruikshank though, for the Devil is holding the shadow's two feet in both hands.

The explanation behind the first illustration's deviation from this first key scene in the novel can be found in the fact that Cruikshank's engraving was focused on the loss of the shadow as a loss of the 'reality principle'. This principle, however, involves the hero's body, his weight, his contact with the ground. Since the point of contact between shadow and owner is at the feet, he feels the act of detaching the shadow should begin there. Finally, it is the same logic that was to prompt Wendy, in J. M. Barrie's *Peter Pan* (1904), to bestow a degree of 'reality' on the young boy by sewing his shadow back onto his feet (illus. 69).

If we now turn to the second key scene in the novel, the one where the Devil is willing to return the hero's shadow in exchange for his soul (illus. 70), we see that Schlemihl is half levitating while the Devil is well anchored to the ground because of the extraordinary fact that he possesses (as mentioned in the text) – two shadows. In Cruikshank's engraving these have the status of autonomous agents. The shadow in the foreground contains all the evidence to lead us to suppose that it belongs to the Devil, for it repeats the gesture of invitation and proffers, through duplication, a black pact to our innocent hero. The second shadow is a threadlike silhouette, stripped of personal clues. But it is Schlemihl's shadow, since it seems to recognize its master and to display a

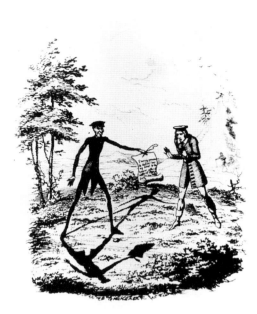

desire to return to him. It is interesting to see how the
illustrator made use of intuitive knowledge on the psychology
of form and perception in order to transmit his message to the
reader/viewer. For example, the interaction of shadows on
the ground creates a kind of rectangle intersected by a
pronounced diagonal. However, the rectangle is not closed. It
remains open as it were, since the pact miscarries.

This very detailed scene of Cruikshank's is virtually
ignored by the other two illustrators. It is unnoticed by
Schrödter, and nor does Menzel change it in any way. There
is, on the other hand, another episode that seems to have
given all three illustrators an opportunity to display their
fundamental differences. I am referring to the episode of the
pursuit of the shadow:

> On the fourth morning I found myself on a sandy plain
> bright with sun and sate on the fragment of a rock in its
> beams, for I loved now to enjoy its long-withheld
> countenance. I still fed my heart with its despair. A light
> rustle startled me. Ready for flight I threw round me a
> hurried glance – I saw no one, but in the sunny sand there
> glided past me a human shadow, not unlike my own, which

wandering there alone seemed to have got away from its possessor. There awoke in me a mighty yearning. 'Shadow,' said I, 'dost thou seek thy master? I will be he,' and I sprang forward to seize it. I thought that if I succeeded in treading on it so that its feet touched mine, it probably would remain hanging there, and in time accommodate itself to me.

The shadow, on my moving, fled before me, and I was compelled to begin a strenuous chase of the light fugitive, for which the thought of rescuing myself from my fearful condition could have alone endowed me with the requisite vigour. It flew towards a wood, at a great distance, in which I must, of necessity, have lost it. I perceived this – a horror convulsed my heart, inflamed my desire, added wings to my speed; I gained evidently on the shadow, I came continually nearer, I must certainly reach it. Suddenly it stopped and turned towards me. Like a lion on his prey, I shot with a mighty spring forwards to make seizure of it – and dashed unexpectedly against a hard and bodily object. Invisibly I received the most unprecedented blows on the ribs that mortal man probably ever received.

The effect of the terror in me was convulsively to close my arms, and firmly to enclose that which stood unseen before me. In the rapid transaction, I plunged forward to the ground, but backwards and under me was a man whom I had embraced and who now first became visible.

The part desert/part forest area where this scene takes place is highly symbolic. The desert is solitude personified, it is the full sun that delineates the contours of the shadow like a mirage. The forest is the kingdom of darkness where the shadow, and with it our hero, might get lost. Cruikshank (illus. 72) is once again the one who deviates most from the text. He invents a dramatic moment, where the shadow is about to cross the frontier between these two diametrically opposed spaces. While in the story the forest is still some distance away, in the engraving the shadow has almost entered it. Another step and it would cross into nothingness. The engraver knew how to exploit his artistic skills to the full. The whole scene is centred around the magnetism of the large stain that seems relentlessly bent on absorbing the shadow. The tension is further heightened because the hero is also much closer to his goal. Another step and he would

apparently be able to attach his feet to those of the shadow. The shadow, a long black sign diagonally spanning the image, is both on the point of being recaptured and on the point of being swallowed up by the indistinguishable blackness.

The concentration of tension is eased in Menzel's illustration (illus. 71) for he chooses to remain absolutely faithful to the text. He increases the physical distance and emphasizes, in a way that Cruikshank does not, the otherness of the shadow in comparison to the running man. In the first engraving (illus. 72), the reader could still be in some doubt as to who owns the shadow, although a close examination would reveal that the movements of the pursuer and those of the prey do not correspond at all, and that, consequently, the shadow cannot be Schlemihl's. In Menzel's (illus. 71), any doubt evaporates and the futility of the race is accentuated.

Schrödter's engraving (illus. 73) is different again. It makes an obvious choice within the episode, by only illustrating the very last phase: the struggle with the shadow. By using the frame to isolate the event, the engraver is emphasizing the fact that he is focusing entirely on that one incident. He does, however, differentiate the areas and he positions the forest like a screen for the moment depicted. With the help of apparently insignificant details, he also emphasizes the otherness of the shadow: the feet of the two adversaries do not touch and the shadow of the falling stick accentuates Schlemihl's lack of a shadow.

Among Chamisso's illustrators, Schrödter is probably the

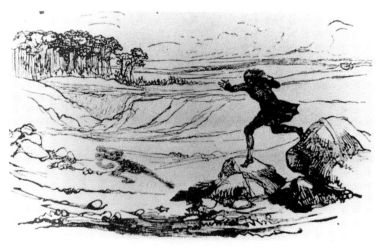

71 Adolf Menzel, *The Pursuit of the Shadow*, engraving for *Peter Schlemihl*, Nuremberg, 1839.

72 George Cruik-
shank, *The Pursuit
of the Shadow*, en-
graving for *Peter
Schlemihl*, London,
1827.

73 Adolf Schröd-
ter, *The Struggle
with the Shadow*,
engraving for *Peter
Schlemihl*, Leipzig,
1836.

most artificial, not only because his images concentrate on a
point of maximum conflict but because he only made four
engravings, of which the one we have just analysed is the
third. The fourth is an illustration of the episode in which
Schlemihl throws the magic purse into the abyss (illus. 77). By
not doing any more, the engraver brings the 'wonderful
history' to a premature conclusion and displays his lack of
interest in the second part of the novel. As to the other
engravers, Cruikshank but more especially Menzel, produced
several more images that had the effect of emphasizing the
unity of the text.

Let us now examine the way in which Schrödter (illus. 77)
and Cruikshank (illus. 74) illustrated the scene when the purse
was thrown into the abyss, first as a final scene and second as
an intermediary episode. As usual, Schrödter concentrated his
visual field on the characters. We see how, having finally
refused the Devil's deal, Schlemihl is in the process of
separating himself from his purse once and for all. In the
lower left-hand corner is the abyss – the grey area hatched
with rapid lines – described in such detail in the text:

> We sat, one day, before a cave which the strangers who
> frequent these mountains are accustomed to visit. We heard

there the rush of subterranean streams roaring up from the immeasurable depths, and the stone cast in seemed, in its resounding fall, to find no bottom.

Just like the desert and forest, the abyss – a cultic locus for the Romantic movement – is a symbolic area. Schrödter does not portray this image, it is barely suggested, he prefers to leave it outside the field of his vignette. Moreover, the moment he has selected is not the real end of the episode, which also remains outside the frame:

> I shuddered with horror, and dashing the ringing purse into the abyss, I spoke to him the last words:
> 'I abjure thee, horrible one, in the name of God! Take thyself hence, and never again show thyself in my sight!' He arose gloomily, and instantly vanished behind the masses of rock which bounded this wild, overgrown spot.

The way the final episode is described in the text, is like a double disappearance: that of the purse/that of the Devil. It is of course difficult for an image to portray absence, which is why Schrödter opts for a narratively more realistic solution, that of recounting a separation. He constructs his figure on the diagonal beginning at the bottom on the left and moving up to the right. The abyss is at one end, the Devil's head at the other. In the middle of the page is the purse about to be cast into the abyss. Corresponding to this, below and towards the right – the Devil, dragging behind him the spectre, which symbolizes the ultimate loss of the shadow.

Cruikshank's engraving (illus. 74) is more focused on conflict than separation. Whereas with Schrödter, Schlemihl's body and the Devil's body are two mutually exclusive tangents. With Cruikshank, pointed lines span the area between the two characters, which translate the violence of the dialogue into a language of forms. Here, as in the illustration for *The Pursuit of the Shadow* (illus. 72), the engraver shows a real propensity for the darkest of blacks, although black in the first plate was the nothingness which called the shadow; in this instance (illus. 74) black is the nothingness into which the money is about to disappear. This immense black stain does not, however, only open up at Schlemihl's feet (as the text would have us believe), it also surrounds him on three sides, thus suggesting that the person

74 George Cruik-
shank, *Peter
Schlemihl throws the
Purse into the Abyss*,
engraving for *Peter
Schlemihl*, London,
1827.

himself is suspended between two horizons: that of the abyss
on the right, and that of the spectre on the left.

Cruikshank is careful not to finish his vision of the story at
the edge of the abyss. He wants to show us that in this scene,
the most crucial of all, Schlemihl loses both shadow and
money, but saves his soul. It is for this reason that in the two
vignettes that come at the end of the story of the shadowless
man (illus. 75, 76), he is portrayed as both light and
weightless, flying above seas and leaping from mountain
peak to mountain peak with the help of his wonderful boots.
Because of its formal and symbolic structure, the very last
illustration is extremely significant. Schlemihl is at the North
Pole (the story begins, if you remember, on the *Nordstrasse*,
near the *Nordtor*), and is blithely proceeding with his tour of
the world. The lightness of his flight is accentuated by the tip
of an iceberg that forms an ascending diagonal, so large that it
even breaches (and this is rare in Cruikshank) the boundaries
of the image. It is an ending of a very different calibre from
that of Schrödter (illus. 77)!

Menzel goes further still and proves to be the one who best
understood the message of this 'wonderful history'. His last

narrative vignette (illus. 78) shows Schlemihl in the Thebaïd cave, where he has found his final refuge:

> As I surveyed the ancient pyramids and temples in passing through Egypt, I descried in the desert, not far from hundred-gated Thebes, the caves where the Christian anchorites once dwelt. It was suddenly firm and clear in me – here is thy home!

By illustrating the eremitical cave, Menzel shows how faithful he has been to the spirit of Chamisso's novel. He has performed a return to the earth's cave, which is thematized by the text itself, but which the other illustrators appeared to find cumbersome. Schrödter in effect abandons Schlemihl near the abyss (illus. 77), and Cruikshank leaves him flying around the North Pole (illus. 76). The cave *on* the mountain, the cave *in* the mountain, both merge height and depth, peak and abyss. We see the narrator–hero, in melancholy mood, contemplating his life and writing his own story. The black background, symbolic surrogate of the shadow, the loss of which the hermit is recounting (and the reader is reading) in his book, transforms the cave into a mechanism of reversed visualization. It is here that the reversed telescoping of the

75 George Cruikshank, *Peter Schlemihl flies over the Seas*, engraving for *Peter Schlemihl*, London, 1827.

76 George Cruikshank, *Peter Schlemihl at the North Pole*, engraving for *Peter Schlemihl*, London, 1827.

77 Adolf Schrödter, *Peter Schlemihl throws the Purse into the Abyss*, engraving for *Peter Schlemihl*, Leipzig, 1836.

78 Adolf Menzel, *Peter Schlemihl in the Grotto in the Thebaïd*, engraving for *Peter Schlemihl*, Nuremberg, 1839.

story takes place. The vignette is a self-reflective image that demands that the novel be rethought. During the whole of it Schlemihl never ceases to search for himself, while he is telling his story in the first person singular. Through an allegorical vignette on the blank page at the end of the book, Menzel offers a helping hand to anyone who might not have understood the message. The serpent biting his own tail is the

emblem of the eternal return – the same one which allows the butterfly to fly away – the symbol of the immortal *psyche*.

To rethink the story of the man without a shadow is to leave the unfolding of the images open, to revive fantasies and to give a semblance body. To some extent it is the process into which we have allowed ourselves to be drawn in this chapter, a process – on a hermeneutic level – that is both misguided and justified. It is misguided in as much as it puts too much trust in images and gives the margins of the text and the figures generated by it too much credit. It is also misguided – but on another level – because of the way we have connected, in one single chapter, two methods of research: the first (Lavater's) which focused on the lines left on the projection screen by a face; the other (Chamisso's and Schlemihl's) which was committed to recovering the being following the reprehensible and cruel loss of all projection. If, despite these differences, our approach claims to be legitimate, it is within the bounds of the fundamental question that marks the turning-point of modernity. This question – 'What is man?' / *Was ist der Mensch*? – formulated by Kant in 1797 within the context of a nascent modernity,[39] is different from any other comparable question that we thought we might have heard over the centuries, because it leads to a conscious anthro-pology on the nature of representing all determination. It should come as no surprise therefore, if, in response to the great question 'What is man?', we take as our starting-point his images, representations and doubles.

Lavater does not immediately scrutinize the face of his fellow man, but its outlined shadow. Schlemihl does not immediately scrutinize himself or his actions, but their representation. Analysing likenesses is therefore a funda-mental process. From now on, myths of origin – of drawing, of knowledge – will be placed in the foreground of all anthropological analysis. The examples given in this chapter – Lavater and Chamisso – are no more than borderline cases within a persistent and obsessive murmur. The choice of possible explanations is considerable and the solutions are dramatically polarized. In a portrait of 1778 by Johann Ehrenfried Schumann (illus. 79), Goethe, to name just one of the giants from the turn of the century, is himself indulging in the practice of analysing the black stain of a Lavaterian

No lo encontraras.

79 Johann Ehren-
fried Schumann,
*Goethe Studying a
Silhouette*, 1778, oil
on canvas. Freies
Deutsches Hoch-
stift-Goethe
Museum, Frank-
furt.

80 Francisco de
Goya, *Diogenes*,
1814–23, wash.
Museo del Prado,
Madrid.

silhouette. A 'complete man' himself (the spectator can verify this by reading his profile or gazing at his beautiful hands), relaxed, Goethe, is 'physiognomizing', contemplating the man reduced to a stain, from a distance that reflects the funda-mental gulf between the 'self' and 'the other' rather than long-sightedness. Goya's Diogenes on the other hand has embarked, lantern in hand and in broad daylight, on the impossible search for man (illus. 80). He searches high and low in the hope of finding him, but all he finds is the black reflection of himself. A whole era weeps in the pessimism of the inscription that accompanies the drawing ('you will not find him'/*no lo encontraras*). The historic advent of the soul,[40] to which Lavater and Chamisso were already sensitive and with which Goethe as well as Goya were familiar, did not lead to a viable solution. Rather than being a definitive response to the question 'what is man?' this alternative was nothing but a delusion, an illusory end used in the perpetual challenging of representations. For is the soul, in turn, nothing but yet an-other representation – a butterfly, a shadow?

6 Of Shadow and its Reproducibility during the Photographic Era

BLACK SQUARE

It is no easy task to discuss Malevich's *Black Square*. It is more difficult than any other hermeneutic process given that his aim was to create an 'a-logical' painting. By this he did not actually mean an image devoid of meaning but rather an image that went further than meaning, beyond meaning. The only way of interpreting cultural forms is by way of an indirect and paradoxical study: the object of our analysis will therefore not be the *Black Square* of 1915 (illus. 81), but its a-logicality. We shall examine the significance of the lack of meaning, the significance of its transcendence. We must begin by establishing whether the (relative) lack of meaning (of figure) is the result of a reduction, or of a figurative process that cancels itself out. In other words: is the *Black Square* a figure that is *derived* from the form of the painting, from the boundaries of the canvas, from their being laid bare? Or is it an a priori that has virtually nothing to do with the form of its support? Is it the symbolic object referred to as 'painting' that produces the 'Black Square' from within itself? Or does this vestige of figuration (a 'Black Square') come from the outside to attach itself to the white canvas, as a desperate and ultimate attempt at figuration?

In order to answer these questions we need to recall the context of their genesis. We know that the *Black Square* was exhibited in St Petersburg in 1915, as part of 'The Last Futurist Exhibition'. It was therefore a genuine 'painting' that Malevich showed in 1915, but a painting in a borderline state, for in the stratagem of the title under which the exhibition was presented hovered the word 'last' in such a way that it would be difficult (and wrong) to establish an exact zone of reference: The last exhibition? The last painting exhibition? The last Futurist exhibition?[1]

One of the first reactions regarded Malevich's work as a

81 Kazimir Malevich, *Black Square*, 1915, oil on canvas. State Tretyakov Gallery, Moscow.

phenomenon to be understood only within a dialectic that spanned the whole of art history:

> Here a form was displayed which was opposed to everything that was understood by 'pictures' or 'painting' or 'art'. Its creator wanted to reduce all forms, all painting to zero.[2]

Malevich never said whether he agreed with this interpretation or not. The only confirmation we have is indirect and to be found in the *Manifesto of Suprematism*, where the painter performs a translation of the dialectical reduction on himself:

> I have transformed myself *in the zero of form* and have fished myself out of the *rubbishy slough of academic art*.[3]

But there is no reference to anti-painting in this extract, where he appears to target classical representation rather than its support. More than once, in fact, does the author stress that the origins of the *Black Square* must be sought in the scenery he designed in 1913 for the Futurist opera *Victory over the Sun*. This apocalyptical production dramatized the conflict between light and darkness by proclaiming the implacable triumph of night.[4] Malevich, in a letter he wrote in 1915, describes the curtain for the first act:

> It represents a black square, the embryo of all that can possibly be generated in the formation of terrible powers ... In the opera it signals the beginning of victory.[5]

The purpose of Malevich's letter is somewhat marginal to us; in this case it pre-dates his *Black Square*, at least its initial stages, to 1913. Nevertheless, through its indirect implications it is priceless evidence. The first of these implications, if we are to believe Malevich, is that the *Black Square* was first conceived as a stage curtain. For the curtain is not a 'representation' but what covers it or, by raising it, what makes a representation possible.

By suggesting that the *Black Square* was born from the project of the curtain, Malevich is unquestionably acknowledging its anti-representational nature. This painting (just like the curtain) is an 'embryo of infinite possibilities'. Its strength lies in its silence, in its mystery. It covers the representation, but it is already an indeterminate image: the image of the representation's infinite possibilities. We know – for Malevich

told us – that in this 'terrible power' lies the sum total of all the images of the universe waiting to be formed. The zenith of the mimesis kills the mimesis.

It should come as no surprise that the most immediate prefigurations of Malevich's *Black Square* are to be found in the marginal glosses of the nineteenth-century photographic miracle (illus. 82). We need to examine closely Cham's caricature (1839).[6] What it expresses is without a doubt the ironic and sceptical viewpoint of an academically trained draughtsman on this new technique of reproducing reality. Through the medium of caricature, Cham discourses on the illusions of the triumphant mimesis to reveal its other side: the nothingness of the image produced by the indiscriminate recording of optical perception. What is so impressive about this discourse is that Cham had the unusual idea of recounting the operation through the iconic/narrative split. In the first rectangle of the vignette, there is an immediate nullification of the mimetic in the form of a black icon, a zero-image that acts like the representation's screen. The second rectangle portrays the account of the image's genesis through the creation of a technical catastrophe. Powerless, the architect of this act contemplates the fogged photograph, which lies on the photographer's table between his camera and a bottle of fixative. Even though the *fogged photograph* is not in itself pure absence, but rather the eclipsing of an image, we know that what we are seeing is a representation that has been spoilt, a calamity that no technology can ever repair. The image is there, but hidden, 'fogged', concealed for ever by a curtain of shadow, which no one is capable of raising.

The discourse of the caricature should quite clearly be set

apart from that of the Suprematist painter. Cham's premonition can be regarded as inadvertent though significant, in so far as it presents the story of a mini-mimetic catastrophe. It is valuable as a prototype in as much as Malevich, in his curtain for the *Victory over the Sun* and later in the *Black Square*, intensifies the underlying dialectic of the ludic discourse by staging a veritable cata-strophe (in the original sense of the word: upheaval) of Western representation. By insisting on representing the *Black Square* as a translation into painting of a representational veil (of the curtain in the *Victory over the Sun*), Malevich presents the zero of forms as the product of a maximum impression, as the effect of a photo/graphic apocalypse.

Malevich's experiment is however nothing more than an exclusive – and maybe purest through its nihilism – manifestation of a discourse ever reiterated by artistic reflection during the second decade of the twentieth century. I intend to approach other phenomena from the same family, which mark this great moment in the history of Western representation, where the shadow, given the status of non-figure, forms one body with the representation.

THE BEGINNING OF THE WORD

That is to say the photo Brancusi took around 1921 of his sculpture entitled *The Beginning of the World* (illus. 83). However, before analysing it we need to recall briefly the story behind the sculptor's encounter with this method of mechanical reproduction.[7] We know that Brancusi saw photography as a kind of portable 'double' of his sculptures. Its function was to *show* the work, not an easy task, but it led to the sculptor learning the technical secrets of reproduction so that he could become their 'exhibitor'. We also know that Brancusi saw photography as a form of re-production as well as a kind of commentary. Moreover, we could say that to him, photography was *the* commentary *par excellence*, the one to replace all critical discourse:

> What is the point of criticism? … Why write? Why not simply show photographs?[8]

In reading this testimony we need to go beyond the cliché ('the artist's reticence in the face of criticism'). It becomes clear

that to Brancusi, photography was a discourse, or, to be more precise, a meta-discourse, given that he would only accept photographs of his work taken by him. Man Ray, who initiated him in this area, left us a valuable piece of testimony, which here must be given *in extenso*:

> I went to visit Brancusi with the intention of taking his photograph so that I could add it to my collection. He frowned when I broached the subject, saying that he did not like having his photo taken. . . . Then he showed me a print Stieglitz had sent him during the Brancusi exhibition in New York. It was one of his marble sculptures, and both light and grain were perfect. He told me that although it was a very beautiful photograph it did not embody his work, and that only he Brancusi could do that. He then asked me whether I would help him procure the necessary equipment and give him a few lessons. I replied that I would be more than willing to do so and the very next day we set off to buy a camera and tripod. I suggested he take on an assistant to develop the photos in a dark room, but this too he wanted to do himself. And so in the corner of his studio he set up a dark room. . . . I showed him how to take a photo and in the dark room I showed him how he should develop it. From then on he worked alone and never consulted me again. Soon after, he showed me his prints. They were blurred, over- or under-exposed, scratched and stained. There you are, he said, that's what my work should look like. Maybe he was right – one of his golden birds had been photographed with the sunlight falling on it, so much so that it emanated a kind of aura which made the work look as though it were exploding.[9]

With these axioms in mind (which, given their clarity, need no explanation), we can examine more closely Brancusi's photographic discourse on *The Beginning of the World* (illus. 83). The sculpture, a huge marble egg, is lying on a polished surface and is illuminated by a burst of light from the top left-hand corner. The background to the sculpture reflects the source of light in the form of a great semi-circle that covers the entire upper part of the page. The egg itself is half in light and half in shadow. The whole of the lower part of the page is covered by a completely dark reflection. It would be difficult to ascertain whether this second egg is a projection of the

83 Constantin Brancusi, photograph of his sculpture *The Beginning of the World*, c. 1920.

shadow or the specular reflection of the sculptural form. It is most likely both, thereby taking on something of the ancient Platonic ambiguity concerning the degrees of reality produced by reflections.

The sculpture, but even more so its photographic version, reveal Brancusi to have had a speculative mind with an inclination for metaphysical reflection, thus bringing him closer to contemporaries like Malevich. Brancusi, unlike Malevich, is less apocalyptic and more positive. He is not obsessed with thoughts of the end, but with those of the beginning. He indicates this quite clearly in the title of the work, and sees its representation as a creation of the Genesis metaphysics where the symbolic form of the beginning – the egg – miraculously emerges from the light/shade conflict. This conflict, however, portrayed so well by the almost

geometric light-dark divide and pictured as the real power that 'created' the sculpture's volume, is taken a step further than was absolutely necessary. It is the function of the reflective split that gives the photographic discourse its characteristic and uncomfortable appearance, and which, at the same time, results in the representation being questioned.

Though less ambiguous, this solution is to be found in other Brancusi photographs, the one depicting *Prometheus* (1911, illus. 84) for example. Here the scenography is much simpler: the basic shape of the demiurge-Titan's head rests on a square plinth. It is illuminated from above and projects a large black stain onto the plinth. All this is produced against a solid black background. The symbolic figure of the Titan, as guardian of the fire stolen from the gods and as prisoner of the Tenebrae, emerges defined through a figurative process of flawless simplicity. On the other hand, in the photo depicting *The Beginning of the World* (illus. 83) the plinth has been removed, which results in the primordial shape of the egg looking as though it is floating in indefinite space. In relation to Prometheus' clear projection, the egg's shadow (or reflection) is an a-spatial presence. In the final analysis, this black shape

84 Constantin Brancusi, photograph of his sculpture *Prometheus*, 1911.

is neither specular reflection nor shadow. Neither is it the projection of a physical body. It is the negative image of the physical body – both its nothingness and its model. It is the negative matrix from which the shape must free itself.

I do not think I am mistaken if I state that in Brancusi's commentary it is not the egg that engenders the shadow but the shadow – that black bodiless stain – which emerges into the world of existence in the shape of an egg. It is a kind of Platonic reversal,[10] where the shadow takes on the role of the paradigm and the marble egg that of the object. We should not forget that the whole operation came out of the darkroom Brancusi had installed in a corner of his studio, a symbolic gesture no doubt, through which the imaging of his sculpture is seen as a second act linked, however, with that of the creation of shapes. The photo is not just a shot, it is an archetypal re-production of the work, it is the form in which the work presents itself by re-producing itself in the infinity of its possible replicas.

We may quite rightly wonder how Brancusi, the 'amateur' Man Ray described, was able to produce such a sophisticated discourse. It could be that the sculptor learned more from his first teacher than the rudiments of photography – some of the twists and turns maybe. Although Man Ray never made the claim, the process of splitting through the projection of the shadow – so crucial to *The Beginning of the World* – belongs to him. In 1917/18 he had already taken his famous photograph of an eggbeater and its cast shadow, entitled *Man* (illus. 85). When he was describing it some time later, the artist stressed that in this photograph 'the shadow is as important as the real thing'.[11] In the apparent gratuity of the photographic act and the resulting image, Man Ray's experiment is fundamental to the elaboration of a rhetoric of splitting. What Brancusi did was to offer us one, though not the only one, of its most important possible developments.

Man Ray, in his photographic reflections, repeated the impulses that had come to him from Duchamp, who a few years earlier had invented the Readymade as an act of revolt against the aura of the 'unique and unrepeatable', which traditionally surrounded the work of art. What Duchamp did was to remove the object (bicycle wheel, urinal, bottle-carrier, etc.) not only from the industrial order to which it belonged but also from its function, by conferring on it the pseudo-quality

85 Man Ray, *Man*, 1917–18, silver print photograph. Musée National d'Art Moderne, Paris.

of unique object with the pseudo-shape of an exhibition object. But if Duchamp's 'found object' is displayed as an intentionally ambiguous phenomenon, belonging both to the world of objects and to that of images, the photograph of an everyday object (in this instance an eggbeater), as pictured by Man Ray, is the product of a new phenomenological reduction capable of restoring the image's rights. The restoration proposed by the photographer is not mimetic but symbolic, because, by leaving the infinite reductions to emerge as a unique characteristic, it does not reflect the real, but returns it to within itself: the repeated threads form the object, the object forms its shadow double, the photo redoubles everything by opening up the infinite sequence of all possible reproductions.

Brancusi's great originality lies in having been able to translate Man Ray's process into a vision of the act of the *en abyme* creation. The sculptural object could just about be considered to be a *sui generis* 'found object', the pure product of a *lusus naturae*, a primordial form whose creator is Chance itself. This is one of the reasons behind what is to many

commentators a mystery – in this case Duchamp's enormous admiration for Brancusi. Their affinity lies in the fact that they are two extremes that come together.

Through the photographic creation of the primordial form, Brancusi recounts 'the beginning of the world' in the shape of a split drama, in the shape of an upheaval (a *kata-strophe*) of the shadow in the object. In this way, Brancusi has translated Man Ray's split into something higher and more hazardous: the shadow is not 'equal to the object', it is more important than the object in as much as it is instated as its paradigm. Unlike his contemporary Malevich, Brancusi performs this reversal in all its positiveness. Malevich's black square nullifies the surface of the figuration (the Painting); Brancusi's black egg, the shadow egg, generates the figured form (the Sculpture).

TU M'

A third route is that of Duchamp's. In his last painting, entitled *Tu m'* (illus. 86), he addresses in a very specific way the question of the boundaries of painting. We should remember that Duchamp had for years renounced the traditional mode of expression and substituted it first with 'found objects' and secondly with a para-pictorial experiment like *Readymade Shadows*. This return, in 1918, was against his better judgement, and only on the insistence of his American patron, Katherine Dreier.

The extraordinary size of the 'last painting' is unusual, but can be attributed to the fact that the sponsor was after a particular surface area, as she wanted to fill a gap on a wall in her library. It was as though Duchamp, by going along with this shocking subservience, wanted to subject himself one last time to the rigours of the commission. However, he takes advantage of the opportunity – and it was Duchamp himself who admitted it – to recap on the whole of his early work.[12] In it we see the shadow of three Readymades: the bicycle wheel, the hat-stand and, between the two, a corkscrew. This last object, depicted as an anamorphotic projection of its shadow, was never painted, for it was Duchamp's intention that the shadow alone be considered as a 'real readymade'.[13] An indeterminate string of lozenges superimposed in an accelerated perspective spans the area of the painting. It

starts from the shadow of the hat-stand, crosses the wheel (its
shadow?) and finally embeds itself in the upper left-hand
corner of the painting. A round file (a 'real' and unique ready-
made) is embedded in the canvas, level with the hat-stand and
projects into the spectator's space. Next to it there is a false
tear in the canvas held together with real safety pins. Finally a
hand, painted with all the naïve realism of a fairground
painting, points in the opposite direction from the corkscrew.

We must have noticed that the description of this canvas
came up against some of the difficulties Duchamp had
anticipated. There is actually no way of putting the signs in
this canvas into any kind of order, for they have been taken
from a variety of categories that signify different things: found
objects, views in perspective, *trompe-l'œil*, false *trompe-l'œil*,
shadows, false shadows... As was the case with the a-
logicality of Malevich's 'last painting' (illus. 81), all attempts at
interpretation must abandon any pretence at direct under-
standing and concentrate on second degree understanding.
Once again, the most pressing question has nothing to do with
the meaning of the figuration, but with the meaning of the
lack of meaning.

Before pursuing this line of questioning, we must (as we did
with Malevich) question the origins. The first testimony that
relates to *Tu m'* is a note that probably dates from around
1913, that is to say from when Duchamp abandoned oil
painting and began *The Bride Stripped Bare* and the series of
Readymades:

after the bride...
make a picture. of *shadows cast* ...
– the *execution* of the picture by
means of luminous sources.
and by drawing the shadows on these planes.
simply following the
real outlines projected ...

all this to be completed and
specially to relate with the subject?
Isometric projections: see book . . .
cast shadows formed by the splashes coming from below
like some jets of water which weave forms in the
transparency.[14]

In the meanderings of this text we recognize the theme of a painting, where the projection of shadows must unite with the perspective. The project would appear to have already been envisaged as the replica or extension of *The Bride*. What seems to have been overlooked is any kind of reference to the Readymades, an understandable omission given that the note was written a few years before the painting was undertaken.

The idea of representation by cast shadow appeared a second time in the same year, 1918, as *Tu m'*. This was in the form of a photograph where the author (Duchamp? Man Ray?)[15] combined the shadows of the best-known found objects (hat-stand, wheel) against the sketched out background of the *Shadows of a Readymade* (illus. 87). There was a single, but fundamental, step to take between this photograph and *Tu m'* that was to return to the philosophy of 1913: 'to do a painting with cast shadows'.

What then is this 'painting' made with 'cast shadows', which, in its final version, is above all a recapitulation of 'found objects', described, represented as phantoms of themselves, as shadows, in fact? It is a derisory representational surface that unveils the ghostly nature of the pictorial representation,[16] together with its early and recent history, by submitting itself as a 'complex and scrupulous counterpart of its absence'.[17] It is to be 'pointed out' that the phantom of the painting is to be found at its very centre. We know that Duchamp had arranged for a graphic designer to paint the hand suspended in mid-air with its index finger stretched out. We must once again ask ourselves: why is it there, what is that disturbing and alarming foreign body?[18] To me the message is very clear: in this anti-painting made up of shadows, the hand symbolizes the act, it is a unique 'piece of painting' in the traditional sense of the phrase. It is the sign of a radical reversal, since – we will recall – classical mimesis allowed the instrument of the act to be inserted into the pictorial statement, but only in the form of a shadow (illus. 22, 23, 26,

87 (?)Marcel
Duchamp, *Shadows
of a Readymade*,
1918, photograph
taken in his studio
in New York.

27, 28). However, in a painting of shadows, the representation
turns in on itself, and the creative/presenting hand can only
be the product of an ironic composition, an isolated sign of the
presence of a 'painter', there where there is no longer any
painting.

7 In the Shadow of the Eternal Return

In the 1920s the avant-garde movement challenged the status of the image from a standpoint completely opposed to that of the triumphant mimesis launched by photography. The foundations of both the Plinian and the Platonic myths had been shaken and the representation was drifting. This point could therefore have marked the end of our journey, had a deep mistrust of the over-perfect circularities not become firmly ensconced. A close examination of the signs of our era reveals that following the vision of the shadow *en abyme*, produced by the different experiments of the historical avant-garde movement, came research at various levels, two of which strike me as being the most important, despite (or because of) their being radically opposed: first as an independent image and second as a series of images.

Christian Boltanski (born in 1944) best represents the first direction. His installations (illus. 88) are reminiscent of a time when studio experiments with parastatic projectors were being carried out (illus. 46). The aim of his installations is, however, different. Let us listen to what the artist has to say:

> I relate many things to shadows. First of all because they remind us of death (do we not have the expression 'shadowlands?'). And then, of course, there is the connection with photography. In Greek the word means writing with light. The shadow is therefore an early photograph. I once set up an exhibition of giant photographs in the Pompidou Centre in Paris. It was due to go on to Bonn and then to Zurich but the heavy frames were extremely difficult and awkward to transport. I wanted to work with things that were lighter, things I could put in my pocket. I realized that just by projecting a microscopic puppet I could obtain a large shadow. At last I could travel with the

88 Christian Bol-
tanski, *Shadows*
(1986), installation
at the Kunsthalle
Hamburg, 1991.

minimum of luggage and work with incorporeal images. Of
course, there was Plato's cave, but I have to admit that I
only learned of that afterwards.

But the shadow is also an inner deception. Do we not say
'to be frightened of one's own shadow?' The shadow is a
fraud: it appears to be the size of a lion but it is in fact no
larger than a microscopic cardboard figurine. The shadow is
the representation within ourselves of a deus ex machina. It
is this aspect of the shadow which intrigues me, for it is
pure theatre in the way that it is an illusion ... What appeals
to me so much about shadows is that they are ephemeral.
They can disappear in a flash: as soon as the reflector is
turned off or the candle extinguished there is nothing there
any longer.[1]

We find in Boltanski an acknowledged convergence of several
catalysts involving the ludic use of the shadow – photographic
reversal, allusion to Plato, funereal symbolism – all of which
give his approach the quality of an introductory synthesis.
One of its most striking aspects, however, is the one involving
the reification of the projection, his wanting to turn the
shadow into 'a thing' he could put in his pocket, and take out
whenever he felt like it. These are actions whose implications

can be understood by anyone who has read the Peter Schlemihl story. It is interesting to see how Boltanski's major preoccupation – the dance of ephemeral semblances – quite by chance connects up with the technique of creating series of shadow images, favoured by Andy Warhol on the other side of the Atlantic.

It was in 1979, at the Heimer Friedrich Gallery in New York that Warhol exhibited a series of 66 canvases he had painted a year earlier and that all bore the title *Shadows* (illus. 94). The number 66 accentuates the notion of repetition, but it is vaguely unsettling since, according to the ancient art of numerology, 66 was the sign of the Devil, and 666 that of the Apocalypse. But if the last two implications can only be accessed through an advanced hermeneutic process, the sequencing of the images is steadfastly displayed. On the white wall, just above ground level, so as to accentuate the fact that they are positioned on a base line that is different from that of the spectator's, the frameless canvases are placed one after the other, in a steady rhythm and following a route that ends precisely where it began. This continuous and circular frieze is, however, made up of independent units. It would be difficult to classify them as traditional 'paintings' (*tableaux*), since neither their shape nor their contents, nor their exhibitional context allows this. The most important feature is without a doubt the fact that a unit isolated from the series – a unit bought separately and exhibited on its own – is, in principle, invalidated. Furthermore, they are 'canvases' in the technical sense of the word, and it is significant that Warhol used synthetic polymers applied through the process of silkscreen printing to transfer the image to this support (that is the one bequeathed us by the tradition of the *tableau*). This rare combination allowed for the direct intervention of hand and printing techniques used in photography. We know that Warhol and his assistants based this series on photographs that reproduced the interaction of shadows cast by several papier mâché silhouettes manufactured *ad hoc*. The addition of synthetic colour at a later stage gives the *Shadows* a heterogeneity and rhythm they did not originally possess.

Rather than launching straight into an analysis of Warhol's method, it would be useful to make a brief incursion into how the series was viewed by the critics.[2] This incursion is necessary before the hermeneutic act, because what we are

being confronted with here is a complete phenomenon that could be described as *exhibition art*,[3] and which can only be defined within the actual context of the exhibition and within the context of immediate critical response. Removed from this context, a Warhol 'canvas' frays beyond repair and loses its *raison d'être*. Let us see what the veritably learned body of critics had to say in 1979 about Warhol's shadows.

This is what Jane Bell said in *Art News*:

> The *Shadows* was silkscreened onto a painted background which itself negates the cool smooth surface associated with almost all Pop art. The hand is everywhere in these paintings – a generously sensuous hand that is clearly Warhol's, although, as always, the artist accepted a little help from his friends at the Factory.

This observation would appear to be significant, particularly if we relate the unusual and paradoxical 'autographical' properties of the work – created by the sweeping brushstrokes (illus. 89) and the mechanism of a double conjecture – first to the title – *Shadows* – and then to the dying tradition of the 'tableau'. By performing this double hermeneutic (that the *Art News* critic only mentioned in passing) we come to the conclusion that Warhol's screenprints belong at the opposite extreme (and at the end) of a fundamental problematic of Western representation, which began with Cennini's reflections on the relationship between line and shadow, and which was progressed by automimetic thematization (see chapters Two and Three). We could claim, therefore, that through Warhol's *Shadows* the pure line of the 'shadow in the painting' invades and defines the representation in its integrality. But we should at this point guard against seeing this as nothing more than a mere legacy of Abstract Expressionism, since the significance bestowed on touch, its thematization and hyperbolization is – in *Shadows* – the product of a process descended from hyper-realist aesthetics. In the final analysis, everything speaks in favour of a synthesis. Warhol puts forward a limited solution that garners, continues and transcends the experiments of the historical avant-garde movements. Not only are Malevich and Duchamp his direct predecessors, but also (through a paradoxical combination) action painting and hyper-realism.

If we continue skimming through the reviews, we see that

89 Andy Warhol, *Shadow*, 1979, silkscreen ink on synthetic polymer paint on canvas (detail). Dia Art Foundation, New York.

another critic, Thomas McGonigle from *Arts*, was of the opinion that Warhol 'creates a terrible dilemma for the viewer of this painting', although he acknowledges that he is predisposed to see in the series an autobiographical confession, inspired to expose the marginality of the shadow that characterizes the person of the artist. Further on in the same magazine, the critic Valentin Tatransky returns to the exhibition. Interestingly enough, his interpretation is a combination of the two earlier ones. The whole series therefore can be regarded as an abstract self-portrait, manifested through

the giant brushstrokes that confirm autography in a world dominated by mechanical repetition. Even though there has been no attempt to place it within a historical context, this interpretation is nevertheless highly provocative. Carrie Richey is guilty of the same omission in her highly complex review for *Artforum*, that must be quoted *in extenso*:

Sixty-six large (76 x 52 inches) canvases are abutted – filling up the entire gallery. Bright acrylic colors thicken the surfaces, and the accumulation of paint seems to take on one or two configurations. Warhol's press release assures that each of the canvases bears the same image, so if I detect two, could this mean there's a positive and negative version of the same image? One looks like a flame – or a lighter, or a kerosene lamp; the second looks like a void. But this speculation is specious because the images are so manifestly non-representational. Nonetheless, there's a *Blow-up* quality of criminality to this exhibition; each canvas looks like an over-enlarged photograph of some unmentionable event.

The reference to *Blow-up* is doubly justified, because the installation suggests these images be read sequentially, like movie frames. Very cinematic. Examining the colors on the canvases for a possible narrative, I realize that, reading clockwise, the acid colors of the first 60 are replaced by silvers and black and white in the last half dozen. A fade-out?

What am I to make of this? Warhol obliges me to play detective. I'm obsessed with finding evidence. Criticism's supposed to be policy work and here I am down in the fingerprint bureau.[4]

Despite the divergence of opinion it is interesting to see how the critics for the most part were adamant that *Shadows* was enigmatic. It is quite striking that none of them attempted to place Warhol's experiment in a historical context, apart maybe from Richey's (controversial but interesting) reference to Antonioni's film. In the spirit of Warhol's aesthetics, they all confined themselves to the surface of the phenomenon, scrutinizing its enigmatic nature, never for one moment facing the problem that the enigma (if enigma there be) might reside in the fact that a historical layer had been translated into an exhibitional surface. As the *Artforum* critic suggested, it is our turn to play detective by climbing – which we are

90 Gianfranco Gorgoni, *Andy Warhol and Giorgio de Chirico, N.Y.C.*, c. 1974.

allowed to do – into the skin of a detective who has some sense of history. In this way we very quickly come upon a photograph (illus. 90) that goes a long way to solving the enigma. It dates from 1974, and was taken in New York by Gianfranco Gorgoni. It is a photo of Warhol and Giorgio De Chirico attending a social function. Glass in hand, a hint of a smile on his face, the old master of Pittura Metafisica is facing the camera, while Warhol, the (still) young master of Pop Art, is looking away from the camera with a twist of the head that gives his face a very dramatic quality. Though probably a snapshot, it nevertheless has the force of an oracle. It is the lighting that makes the photograph so dramatic, so much so that it is difficult to believe the snapshot has not been touched up. In any case, due to the unusual lighting, what could have remained a simple social record becomes an image of a transfer of power:[5] through the freak pose, De Chirico passes his shadow world over to Warhol, together with an entreaty that he be its master.

Four years must have passed before Warhol was able to exorcize, in 1978, his 66 variations of one single nightmare. In light of this, the *Shadows* series, rather than eclipsing a mystery, reveals it to be the public acknowledgement of a debt and a murder. The creation of *Shadows* coincided with De Chirico's death (he died on 19 November and Warhol began his series in the December of that same year), and it is strange that this coincidence has passed unnoticed. I do not think I am very much mistaken if I see the creation of *Shadows* as being

the direct result of the demise of one of the last representatives of the historical avant-garde movement. The exhibition, therefore, unveils Warhol's debt to De Chirico. If it is also the result of a murder, then this murder is by nature symbolic and involves the concept of *original*. Warhol replaces the Italian master's shadow stories with storyless shadows, and their seriality is just a reflection of the final demise of the pictorial narrative and its replacement by infinite diffraction and the infinite passage of appearances.

It should be acknowledged that our interpretation looks like an allegory. Perhaps it is, but only in the sense of a 'real allegory'. What Warhol fails to mention in New York in 1979 and what no critic (to my knowledge) has ever discerned by peering beneath the surface of the *Shadows* exhibition, emerges three years later in Rome, during the *Warhol verso De Chirico* exhibition. But this time there is a clear agenda. By being reproduced and multiplied, Pittura Metafisica is serialized and its sacred aura removed (illus. 91). During an interview with Achille Bonito Oliva, published in the accompanying exhibition catalogue, Warhol explains a posteriori his debt to De Chirico:

> I loved his work so much. I love his art and then the idea that he repeated the same paintings over and over again. I like that idea a lot, so I thought it would be great to do it. . . . De Chirico repeated the same images throughout his life. I believe he did it not only because people and dealers asked him to do it, but because he liked it and viewed repetition as a way of expressing himself. This is probably what we have in common ... The difference? What he repeated regularly, year after year, I repeat the same day in the same painting. . . . It's a way of expressing oneself! . . . All my images are the same ... but different at the same time ... They change with the light of colours, with the times and moods ... Isn't life a series of images that change as they repeat themselves?[6]

It is obvious that in this interview, Warhol, rather than accepting what he should above all accept, in this case the transfer of shadows and lengthening of enigmas, admits to being even more indebted to De Chirico, for he actually credits him with having thought up perpetual repetition, which instinctively led to seriality as a mode of expression.

The concept cannot be attributed to De Chirico, but to Monet (illus. 35, 36), the father of serial thought in Western art, but from a different point of view from Duchamp. This incongruity should not worry us too much, since Warhol was known to have admitted that he did not like telling the truth about his work and that in his statements he preferred to cloud rather than clarify the issue. The demarcation that Warhol is nevertheless determined to introduce in the course of his interview with Bonito Oliva is important, since it accentuates the *contiguity of the same*, which is fundamental to Warhol, in the face of the *return of the same*, which characterizes Pittura Metafisica. Let us go deeper into this difference.

De Chirico never concealed his debt to Nietzsche's philosophy. On the contrary, his insistence verged on the paradox:

I am the only man to have understood Nietzsche – all my work demonstrates this.[7]

And again:

I remember that often, having read Nietzsche's immortal work *Thus spake Zarathustra*, I derived from various passages of this book an impression I had already had as a child when I read an Italian children's book called *The Adventures of Pinocchio*. Strange similarity that reveals the profundity of the work![8]

Reading these two confessions, we might be justified in wondering what this understanding really was that the painter prided himself on. There can only be one answer: if there is a similarity between Zarathustra and Pinocchio it is to be found in the debate that surrounds the being's double, the questioning of simulated forms of existence and the creation of perpetual enigmas that surround freedom and ways of life. If De Chirico took anything from *Pinocchio*, it was the obsession with the puppet, with the imitation double that usurps man and the resulting tension that leads to a transcendence that remains in a constant and thwarted state of anticipation. What De Chirico takes from Nietzsche is his weightiest philosophy, the doctrine 'of the absolute and indefinitely repeated cycle of all things':[9]

What, if some day or night a demon were to steal after you into your loneliest loneliness and say to you: 'This life as

91 Andy Warhol, *Italian Square with Ariadne (after De Chirico)*, 1982, synthetic polymer paint and silkscreen ink on canvas. Andy Warhol Museum, Pittsburgh.

92 Pablo Picasso, *The Shadow on the Woman*, dated 29 December 1953, oil on canvas. Art Gallery of Ontario, Toronto.

93 Pablo Picasso, *The Shadow*, dated 29 December 1953, oil and charcoal on canvas. Musée Picasso, Paris.

95 Vincent van Gogh, *The Artist-Painter on the Road to Tarascon*, 1888, oil on canvas. Destroyed.

PAGES 212–13 94 Andy Warhol, *Shadows*, 1978, installation at the Andy Warhol Museum, Pittsburgh, silkscreen ink and synthetic polymer paint on canvas, installation showing 55 of 102 canvases.

96 Francis Bacon, *Study for Portrait of Van Gogh II*, 1957, oil on canvas. Private collection.

97 Andy Warhol, *The Shadow*, 1981, silkscreen print on paper.

you now live it and have lived it, you will have to live once more and innumerable times more; and there will be nothing new in it, but every pain and every joy and thought and sigh and everything that is unutterably small or great in your life will have to return to you, all in the same succession and sequence – even this spider and this moonlight between the trees, and ever this moment and I myself. The eternal hourglass of existence is turned upside down again and again, and you with it, speck of dust!'

Would you not throw yourself down and gnash your teeth and curse the demon who spoke thus? Or have you once experienced a tremendous moment when you would have answered him: 'You are a god and never have I heard anything more divine.' If this thought gained possession of you, it would change you as you are or perhaps crush you. The question in each and every thing: 'Do you desire this once more and innumerable times more?' would lie upon your actions as the greatest weight. Or how well disposed would you have to become to yourself and to life *to crave nothing more fervently* than this ultimate eternal confirmation and zeal?[10]

What Warhol takes from De Chirico is a little of Nietzsche and a lot of Pinocchio, in as much as he transforms the *eternal return of the same* into the *infinite contiguity of the same* in the form of indeterminate sequences of fallen idols (Marilyn, Jackie, the can of condensed soup . . .), or in the words of Gilles Deleuze, in the form of the vertiginous emergence of semblances formerly stifled by the Platonic tradition but now liberated, their power unshackled.[11] In *Shadows*, all of this at last finds an outlet dependent still on the ancient form of the 'painting' (*tableau*) and demanding the ancient metaphysics of 'painting' (*peinture*). Each canvas is a reflection of a shadow, each 'original' is (already) a reproduction, the canvases reflect the world, and the world itself is the re-duplication of an infinite screen.

Therefore we could say, that in the spring of 1979, during the private view of *Shadows*, when – it is said that the only drink available was *Perrier-Jouet Fleur de Champagne* – the New York SoHo gallery was transformed for a few hours (in Warhol's world the transitory *is* eternity) not only into the stomach of the Leviathan who swallowed Pinocchio and his

interminable lies, but also into a Platonic cave, proud (for just one evening) of its own shadows.

DOUBLE ANDY WARHOL

I'd prefer to remain a mystery. I never like to give my background and, anyway, I make it all different every time I'm asked. (Andy Warhol)[12]

In 1978, the year *Shadows* (illus. 89) was created, Warhol also worked on his self-portrait (illus. 98). It was not his first, but he had never before exploited so intensively the expressive forms of the photographic negative. Reduction and reversal, these were the themes on which Warhol was now discoursing. It was the same technique as the one he had used for the large series *Shadows* (silkscreen ink on synthetic polymer paint on canvas). It is important to mention this, not just because of the coincidence (in no way gratuitous) between this series and this self-portrait, but also because of the implications that derive from 'an iconology of materials',[13] so often neglected by commentators. By taking all the technical factors of the representation and their symbolic meaning into account, we could say that the self-portrait not only represents the negative and duplicated image of Andy Warhol, but also its polymerized image.

According to the *Oxford Reference Dictionary*, a polymer is a compound whose molecule is formed from many repeated units of one or more compounds. Polymerization is the combination of several molecules combined to become one large molecule. The operation produces the material that was to become fashionable in the twentieth century and generally referred to as plastic. Throughout the Sixties Warhol was to

98 Andy Warhol, *Self-portrait*, 1978, silkscreen ink and synthetic polymer paint on canvas, two joined panels. Dia Centre for the Arts, New York.

implement what I propose to call the 'polymerization of the image', in two ways: literally by going into the plastification of the semblance–representation, and symbolically, by giving a shiny, artificial, indestructible unity to the multiple of life. In his 1978 *Self-portrait* he pushed this combination of representational form and technique to its limit. It is an image based on a double interaction of the photographic negative. As always, the negative represents the object in its phantom state. In his *Self-portrait* Warhol is depicted in two groups, each made up of three images. In each group he is shown from three different angles: three-quarters, half-profile and profile. The lesson is clear: one is multiple, the same is different, the representation is the negative of the person.[14] Although in this instance the notion of shadow exists beneath the surface, it is constant. It is reliant on one of the features of Warhol's image, one that belongs to collective imagery and which is referred to by Warhol on more than one occasion. I am referring to his (virtually) white hair.[15] This physical characteristic of his (we should remember that to Warhol the 'exterior' *is* the person) is particularly relevant here, since this self-portrait portrays him, on the day of his fiftieth birthday (a well-kept secret), to be an 'old child' or a 'young old man', by giving him the mythical aura of a *puer senex*, of a childlike as well as a tremendously old 'genius' (in the original sense of the word). For the negative reversal is not powerful enough to render his mythical white hair, black; that shatters the notion of the negative representation. In short, the triple black, white-haired spectre is better able than the negative, to present the trebled shadow of the child–old man of the century.

The transition to the red-black contrast in the second group addresses a second polymer of the person. Red is also central to the 'real' Warhol, since it is the characteristic eye colour of all albinos. But in the second half of his *Self-portrait*, it is not only his eyes that are red. The colour has a more important function. It is as though by transforming itself from content of the form into form of the content, the vital flux has taken on a new role and a new direction. But this results in the vital substance becoming pure form and the *Self-portrait* being wholly transformed into an allegory of the self at a time when the individual is being polymerized. In order to put this procedure into its proper perspective, we must remember that a few years earlier – in 1974 – Warhol had made two films:

Andy Warhol's Frankenstein and *Andy Warhol's Dracula*, where the motif of the bloodied eyes and that of 'external blood' (that also appeared in Warhol's other self-portraits) had an important role to play. The titles of these two films are also significant, since their self-reflective form categorically states that the Pop artist had taken possession of the ancient imagery of terror.

The next self-portrait, entitled *The Shadow* (illus. 97), was done in 1981. It is an enormous silkscreen print measuring approximately 1 x 1 metre and containing two very large images of him. The right-hand section portrays half his face, partially cut by the frame, while the other half of the image is covered by his profiled shadow. His method of splitting is difficult to understand unless we relate it to the techniques previously used in the 1920s by the 'diabolical screen' (illus. 56). It would, however, be wrong to limit the implications of the Warhol self-portrait in this way. The title highlights the importance of this expanding ectoplasm, which greedily takes possession of the representational space. Both title and image allow us a glimpse into the complex relationship with the double, a relationship that cannot be over-emphasized.[16] It is not a fundamental, vitalist relationship like the one primitive man enjoyed with his shadow. On the contrary, it is the tense, dramatic relationship of post-modernist polymerized man. To discover its secrets, it must be subjected to a double contextualization: first in relation to Warhol's artistic output, and second in relation to its sources.

Apart from *The Shadow* (illus. 97), there was another important work to emerge in 1981. I am referring to *Double Mickey Mouse* (illus. 99). Mickey Mouse was to Warhol what Pinocchio was to De Chirico. Moreover, like Warhol, he was the *puer senex* of the United States and its mascot. The chronological coincidences once again transcend the boundaries of a purely metaphorical link, or, to be more precise, offer the latter a foundation: Warhol – we have come to know after much research – was born on 6 August 1928,[17] and Mickey Mouse – according to the historians of the cinema and comic strip – was born on 18 November of the same year. Warhol and Mickey are therefore products of the same 'generation', and I do not think I am mistaken when I say that the artist capitalized on the coincidence of this well-kept secret.

99 Andy Warhol, *Double Mickey Mouse*, 1981, silkscreen print (from a limited edition of 25, some with diamond dust).

Let us address the images directly. *Double Mickey Mouse* is not only double, he is also a giant, especially if you compare him to the size of a normal mouse: he measures exactly 77.5 x 109.2 cm. But then Mickey is not a 'normal' mouse. He is a mascot, a semblance. And it is in this capacity that he is naturally split. The 'two' in *Double Mickey Mouse* does not involve the original/copy dialectic and it is precisely this that is the most worrying factor: for the two *are* both original and copy. Identical and different, they are the same and the other, interchangeable and monumental. Warhol portrays him/them against a background of diamond dust, a technical (and symbolic) process he often used in his pseudo-icons. The whole of this procedure leads the image to the dizzy heights of post-modernism, regarded as the era that saw the rise and triumph of the semblance.[18]

Unlike *Double Mickey Mouse*, the self-portrait entitled *The Shadow* (illus. 97) addresses the problematic of re-duplication, which is the result of a split. The shadow shows the profile of a person (Warhol) whom we can (also) view from a (quasi-) frontal position. We should bear in mind that the whole dialectic of Western representation has taught us that frontality – and the mirror – constitutes the symbolic form of the relationship between the self and the same, whereas the profile – and the shadow – constitutes the symbolic form of the relationship between the self and the other.

While the permanent cheery profile of Mickey Mouse (illus.

99) is the estranged image of an 'other', in his self-portrait Warhol creates an unwavering tension between the two views. By playing around with words we could say that in *The Shadow* Warhol is 'unmasking' (*dévisager*, to stare/unmask) himself. The scrutiny of one's own features and the un-masking of them is a familiar procedure in the history of Western self-portraiture. This tradition, whose whole history can obviously not be retraced at this point, has bequeathed us a few examples that could shed some light on Warhol's method. Before doing so however, I should like to explain that this necessity has not been dictated by a desire to identify any immediate 'influences' or 'sources' in Warhol's self-portrait, but more by an archaeological curiosity focused on identifying the various strata of Western imagery, the top layer of which is all that Warhol reveals. If this study is to produce anything of value, then it will be that which emerges from the particular manner in which post-modernity, through Andy Warhol, has *en-visaged and de-visaged* its dealings with the double.

In the 1920s, the imagery of the avant-garde movement approached the frontality/profile relationship as a schize. The perfect example of this is Paul Klee's *Physiognomic Flash* (*Physiognomischer Blitz*) created in 1927 (illus. 100).[19] As the title suggests, his point of departure was inspired by Lavater's experiment, even though it was contemplated from as far away as possible. The great black zigzag that splits the face in half is the profile of the shadow itself. The solar homogeneity of the person cracks open and the shadow, rather than disengaging itself from the face, ironically remains inside it in order to comment on it. The power of Klee's representation resides in the fact that through the fissure, at the very heart of the image of the human face, it conceals in a very intense manner a whole process of symbolizing the depths that other artists have plumbed.

Be that as it may, so as to return to our point of departure, we need to examine more closely the experiments that immediately preceded Warhol's *The Shadow* (illus. 97) – those of the two painters who had the greatest influence on the American artist: Duchamp and De Chirico. With the help of De Chirico, Warhol entered into a direct and earnest dialogue with Western tradition, for in his 1920 *Self-portrait* (illus. 101), we see how clearly the Italian master revived and combined two sources of inspiration. The first is Poussin's

100 Paul Klee,
Physiognomic Flash,
1927, watercolour.
Private collection.

Self-portrait of 1650 (illus. 32). From this painting De Chirico reproduces the half-length pose, the motif of the book and to a certain extent the split through the cast shadow. This is where the greatest differences are to be found. In Poussin's painting, the large dark stain that is superimposed on the prepared canvas next to the artist's name pertains to the symbolic function of the 'general likeness', whereas in De Chirico's work the shadow detaches itself from all support and, as it were, turns in on itself: from being black it becomes white and instead of being a background it becomes a figure.

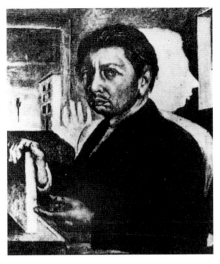

101 Giorgio de Chirico, *Self-portrait*, 1920, tempera on canvas. Private collection.

In fact, this shadow is no longer a shadow, but a living spectre. It duplicates none of the model's movements and has its own gestures, and though it has its own likeness, it does nevertheless look like an 'estranged' profile. The metaphysical transposition, which so radically usurps Poussin's style of representation, is brought about through the intervention of a second stimulus, originating from one of De Chirico's favourite painters, Arnold Böcklin. In his *Self-portrait* of 1893 (illus. 102), Böcklin portrays himself in front of his easel, on which there is a white, virtually untouched canvas. However, we do not see him in the act of painting, but in a rather bizarre and somewhat rare stance, within the framework of the Western tradition of the self-portrait. Its only possible explanation must be sought not within the painting's internal logic but within a logic that lies outside the representation. The artist holds his palette in his left hand and his brush in his right, but rather than getting on with what he should be doing, he is turned towards the viewer's undesignated area. He is an artist who is 'showing himself', an artist who is 'representing himself'. On the canvas, level with his head and *en abyme*, is the outline of his barely sketched image. The creation of this image is such that it must be read and interpreted through a violation of the levels of reality, behind (but also *near*) the artist's head 'in the representation', the outline *en abyme* must be regarded as the counterpart essential to the completion of the actual

102 Arnold Böcklin, *Self-portrait in the Studio*, 1893, varnished distemper on canvas. Öffentliche Kunstsammlung, Basel (Kunstmuseum).

representation, as the global theme of the painting. De Chirico probably loved all that transcended pure logic. His *tour de force* was to have combined an outline that was not a shadow (Böcklin) with a shadow that was not an outline (Poussin) in a 'metafisico' painting whose theme was the artist and his double. Warhol's skill was to have examined De Chirico's painting, which he probably knew first-hand, so minutely that he was able to retrieve its most deep-seated essence. He was indirectly assisted in this enterprise by his second 'godfather' – Duchamp.

225

We know that Duchamp liked to double himself, to multiply himself even. To acknowledge Warhol's debt to him as far as this area is concerned would necessitate the writing of another, larger and more complex book than this one. Let us limit ourselves to those aspects that shed light on *The Shadow* (illus. 97).

In 1963 Duchamp had just been discovered by the American Pop Art movement and proclaimed as its founder. At the time he was preparing an exhibition for the Pasadena Art Museum in California. An old collage of 1923 had been used for the exhibition poster (illus. 103). In the empty frames of a wanted poster he had placed two photographs of himself. The effect was intentionally clumsy but eye-catching: the photos were too small for their frame, they were blurred and not properly stuck on. Moreover, they reversed the order that a poster of this kind would have respected – frontal view and profile were the other way round.[20]

The custom of photographing criminals (or suspects) from angles set 90 degrees apart dates from the time when the camera first became a piece of police equipment. This can be attributed to the notion that only the double mug-shot guarantees *identity*. To photograph full-face and in profile is like 'casting a mould' of the person's face, and it is no coincidence that fingerprints are taken at the same time. 'Face' *and* 'profile' – together – make up the impression of the face. Through the codification of the double mug-shot, a clear stratification is eventually produced: the first (and most important) is the view from the front, while the view from the side has only one value, which – in all senses of the word – is secondary. In traditional Western representations of a person, it is the profile that corroborates the identity of the frontal view and not vice versa. This is why official photographs were able without too much difficulty to take the shortest route: in wanted posters as well as in the police files, the side shot comes first and the frontal shot second. Moreover, the side view must be looking at the frontal view as though the person's identity were thought to be engaged in the stimulating conversation of a schize.

By masking this ancient dialogue, Duchamp unveils the illusion: what we see is a disrupted representation, a representation where the mould of the double mug-shot introduces a concealed but significant breach, a representation

103 Marcel Duchamp, Replica of *Wanted: $2000 Reward*, 1923, from *Boîte-en-Valise*. Philadelphia Museum of Art.

WANTED

$2,000 REWARD

For information leading to the arrest of George W. Welch, alias Bull, alias Pickens, etcetry, etcetry. Operated Bucket Shop in New York under name HOOKE, LYON and CINQUER. Height about 5 feet 9 inches. Weight about 180 pounds. Complexion medium, eyes same. Known also under name RROSE SÉLAVY

that does not promote an affirmation of identity but of false identity. In the final analysis, it is as though Duchamp had detached the shadow from the original, or to use the Surrealist language with which he would have been familiar, the shadow from the prey.

Such a process should come as no surprise given Duchamp's interest over a long period, first in the shadow, and second in the technique of reversal. There is a hint of this interaction in the majority of his self-portraits, but I shall limit myself to only a few more examples. A fondness for the use of the profile as a 'signature' is to be found on more than one occasion, in his early photographic (self-)portraits as well as in some of his later experiments. For example, for Robert Lebel's monograph *Sur Marcel Duchamp* (1958) he designed a frontis-

piece where he appeared as an outlined profile against the green background of his famous 'boxes' (the *green box*). The composition (illus. 104) was also used for the poster advertising the exhibition organized to launch the book in the Latin Quarter bookshop 'La Hune'. It is not difficult to recognize in this composition the tradition of Lavater's physiognomic silhouettes (illus. 61). Why did Duchamp not use this technique earlier? The La Hune poster offers us a fairly clear explanation: both the book and the exhibition challenge a mysterious and – in the final analysis – indecipherable 'Duchamp'; we might even go so far as to say that what they offer is a 'shadow-analysis'.

In this same context, we should point out that during the same period he did another self-portrait where his profile is delineated in the positive (illus. 105), a copy of that he sent to a few friends. To anyone vaguely familiar with the rhetoric of Duchamp's gestures and Lavater's tradition, the door is open to a separate interpretation of these two images: as with Lavater, positive and negative are counterparts, but – and this is where Duchamp comes along – it is the black profile that, although it remains indecipherable, is on offer to the public domain. As to the white profile, although it is nothing more than an illusion, it is destined for friends since its 'original' no longer exists.

In order to complete Duchamp's reflection on the schize it is necessary to quote at least one final example. I am referring to

104 Marcel Duchamp, frontispiece for Robert Lebel, *Sur Marcel Duchamp*, Paris, 1959.

105 Marcel Duchamp, *Profile Self-portrait*, 1959.

a photographic portrait dating from 1953 and taken by Victor Obsatz (illus. 106). As usual in other similar cases, it is extremely difficult to know just how far the model contributed to the image, but, given its extraordinary ludic nature, we might hazard a guess that this contribution was in fact considerable. The photo is made up of two superimposed shots (full face and profile). In the main shot (the frontal one) the model stares at the viewer, smiles at him and, at the same time, begins a kind of me–you conversation. The profile does not participate, however, and would be unable to do so. He is gazing into infinity, and his eyes cannot meet ours. The superimposition of these two shots is so perfect that we have all the evidence we need since they are of the same person: the profiled line of the brow is progressed by the contour of the frontal head and there is a point where we no longer know where one view begins and the other ends. That this apparent unit is in fact a duality stems from the weakness of the frontal view. Though smiling and ostensibly 'there', it has the transparency of a ghost, since the ear of the profile is where the nose should be. There is without a doubt an allusion to a particular rhetoric of deconstruction used by the founding father of Cubism (illus. 40), but I feel that the aim of

106 Victor Obsatz, composite photo-graph of Marcel Duchamp, 1953.

Duchamp's discourse goes much further: to the schize of the way the face was represented in the West.

Now that our detour through the vagaries of tradition has come to an end, let us return once more to Warhol's *The Shadow* (illus. 97). The shot focuses exclusively on the face. This enormous face (almost one square metre) demands a heightened rhetoric and a format that is not that of the Western pictorial portrait, but that of the cinematographic close-up. As has been said time and again, Warhol considered the image to be more real than the real.[21] Enlargement is just one method of hyper-realization, another is splitting and multiplying. This last and very widely used method in all Warhol's post-modernist icons is in this instance addressed in a very particular way: through the device of the cast shadow. Shadow and face together form an antinomy: the shadow reaches into the space of the representation, whereas the frontal face is cut off by its boundaries. Where are we? The blue background is reminiscent of the sky, the unusual colour of the face is more like the reflections in a photographer's darkroom. Can these two areas be reconciled? Maybe, but only on one condition: that the link be made in a symbolic way. In the dark room of his studio, Warhol *develops himself*. In so doing he 'un-makes' himself. What we see is both a self-portrait and a scenario of production. Needless to say, a self-portrait/scenario of production that could only have been created in the photographic age. Let us examine the shadow: it has no boundaries, and the outlined profile, so crucial to the myth of the origin of painting, is replaced by an ambulatory line that goes on indefinitely. The shadow is flat, one-dimensional, and its actual shape is unstable. It is the result of the face having been developed – not just as a photogram, but also more tangibly, from solid body to surface:

> I see everything that way, the surface of things, a kind of mental Braille, I just pass my hands over the surface of things.[22]

Or:

> If you want to know all about Andy Warhol, just look at the surface: of my paintings and films and me, and there I am. There's nothing behind it.[23]

Because the surface *is* the self, because it *is* the person, the extraordinary unfolding of the face in the cast shadow is no longer a process that confirms 'real presence', as the whole tradition of Western representational art (illus. 20, 21, 25) had dictated. It is a process that focuses on the final stage of the hyper-realization of the person: its ultimate realization in its own nothingness. Great ectoplasm projected onto a blue background sprinkled with diamond dust, the depthless, shapeless face of one who examines himself signs the paradox of a representation of the self, seen as a monumental and cosmic disappearance.

ACTION DEAD MOUSE

At seven o'clock in the evening on 24 November 1970, the American Terry Fox and the German Joseph Beuys organized a happening at the Academy of Fine Art in Düsseldorf entitled *Isolation Unit*.[24] The extraordinary photographs found in Beuys's archives were on this occasion taken by Ute Klophaus (illus. 107). They carry the caption: *Action Dead Mouse*. It is the photographer herself who best describes the event:

> The happening took place in the cellar of the Academy. It was actually made up of two different actions each containing two separate itineraries. Joseph Beuys and Terry Fox performed together in the same space, but each on his own. There was very little physical contact between them. I photographed Fox and Beuys separately.
>
> Beuys stood in front of the brick wall of the cellar vault. He was wearing one of the hundreds of felt suits that could at that time be purchased 'off the peg' from the art market. The suit had been tailor-made with extra long sleeves and legs. The over-sized garment looked like an ill-fitting loose cover. Worn over his everyday clothes he looked both strange and familiar [*fremd und vertraut*]. The oversize dimensions [*die Uebergrosse*] corresponded to his superego. That was how I saw it.
>
> In his right hand Joseph Beuys held a dead mouse. This mouse had been living in his room for some time. A few days before the action, Beuys dreamed that the mouse had died and that it had transmigrated. When he woke up, he realized that the mouse was actually dead.

Having stood in the cellar for quite a time, in front of the brick wall, mouse in his outstretched hand, Beuys set it down on the record playing on the record-player placed on the ground. Then he split open a passion fruit [*eine indische Chrispana-Frucht*] Terry Fox had brought him. He held the two halves in his left hand and ate them with a spoon. While he was doing this his whole being was focused on the act of eating and on the fruit. He ate with his face, with his whole body. He ate the way animals eat. You could see from his face that the fruit was ripe. It was as though through the act of eating, he wanted to become one with the fruit. There he was, standing in front of the brick wall of the cellar vault, quite alone, completely isolated from everyone else in the room.

I watched him spit out the stone from the fruit, which fell loudly into a silver dish at his feet.[25]

107 Ute Klophaus, *Action Dead Mouse*, photograph of Joseph Beuys and Terry Fox's performance *'Isolation Unit'* in Düsseldorf, 24 November 1970.

Let us concentrate on just one of Ute Klophaus's photographs (illus. 107). In it we see Beuys in his felt suit, wearing his famous hat and standing in front of a closed window, which is actually all we see of the brick wall. His left hand hangs loose at his side, the right is stretched out, palm open, to reveal the dead mouse he is staring at. His face is in the full light. We know that Fox had extended from the vaulted ceiling of the cellar an electric light that almost touched the floor. It is from here that the light illuminating Beuys's face comes, throwing his shadow against wall and window. The shadow is in a complex relationship with the screen onto which it is projected: the window is in the centre of the shadow, but the shadow escapes from its over-geometrical control and like a symbolic gesture of rebellion, transcends it. Consequently, the head reaches up as far as the cellar vault, the hand of the shadow touches (and overshoots) the window frame, while the real hand – the one holding the dead mouse and showing it to the spectator – is perfectly centred in the first rectangle of the window. All in all, this extraordinary shot is not only an invaluable piece of documentary evidence, it reveals exceptional artistic sensitivity. Ute Klophaus explains:

When I took this photograph I wanted the shadow to look like a body and Beuys himself to look like a shadow, hence

the emphasis on the shadow which looks as though it were peeling off the wall and window and the disappearance of the ground level: shadows have no feet.[26]

In retrospect this photograph can be placed in the context of a long line of images that illustrate experiments done with artificial lighting. This was common practice in art academies from the sixteenth century onwards (illus. 44, 45). A second path links it to portraits, particularly to those nineteenth-century self-portraits where, on more than one occasion, the cast shadow appears to be an important means of expression. As early as Courbet's *Meeting* (1854, illus. 109), the large shadow cast on the path by the artist gives him a monumental, steadfast quality that, through being superimposed on the white boundary marker, implies it is a symbolic one. It is the shadow of the traveller who has reached a milestone, of the prophet–artist on the threshold between two social orders, caught in the act of a symbolic transgression: this shadow, belonging to the legendary 'Wandering Jew' (illus. 108),[27] is also monumentalized and shows, especially when compared to the engraving in Eugene Sue's popular novel, that even though it is lying in the dust at the edge of a road, its owner can proudly hold his head up high, a free and independent man.

In a painting entitled *The Artist–Painter on the Road to Tarascon* (illus. 95), Van Gogh also depicted himself in the company of his large, blue-black shadow, which the strong midday light casts on the light-brown earth of the path. In a letter to Theo, where he discusses the canvas, he makes no mention of the shadow, but refers to 'a quick sketch I have made of myself, laden with boxes, sticks and a canvas, on the sunlit road to Tarascon'.[28] In the eyes of posterity it was to become a metaphoric image of life in general and of the artist's life in particular. In Wilhelm Uhde's monograph (Phaidon, 1936), where the colour reproduction served as frontispiece, we find ourselves in a golden legend:[29]

> The name of Vincent Van Gogh calls to mind a number of brilliant pictures, but at the same time we think of the shadows of a pitiful life which its bearer dragged like a cross to an untimely Golgotha. His story is ... the tale of a lonely heart which beat within the walls of a dark prison, longing and suffering without knowing why, until one day

108 Paul Gavarny, 'The Wandering Jew', illustration for Eugène Sue, *Le Juif Errant*, Paris, 1845.

109 Gustave Courbet, *The Meeting (Good Morning, Mr Courbet!')*, 1854, oil on canvas. Musée Fabre, Montpellier.

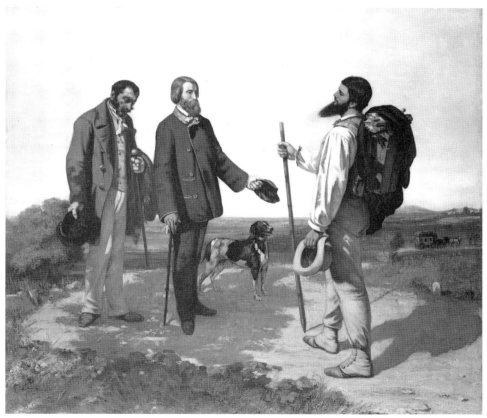

it saw the sun, and in the sun recognised the secret of life. The heart flew towards it and was consumed in its rays.[30]

These lines, which tell us so much about the way artistic myths are born, had at least the virtue of inspiring Francis Bacon's series of the six variations he painted between 1956 and 1957 based on the reproduction of the Phaidon monograph (illus. 95). Bacon claimed he wanted to represent 'the haunted figure on the road ... like a phantom of the road' and to show how Van Gogh dissolved into his shadow 'the way a gutting candle runs into its own grease'[31] and reached the conclusion that

> [Death] follows [artists] around like their shadow, and I think that's one of the reasons most artists are so conscious of the vulnerability and nothingness of life.[32]

But what all that these examples seem to bring out is the singularity of Beuys's *mise-en-scène*, especially that implicit in Ute Klophaus's shot. The greatest of these differences concerns the verticalization of the shadow, which, as we have seen, goes back to the even older tradition of the ancient nocturnal scenarios.

Before continuing with our analysis, there is a need for clarification. The rhetoric of the Happening, as it evolved in the Sixties in the Fluxus milieu, saw the 'action' as a ritualized form of expression that led to the violation of the frontiers separating art from existence. It evaded the captured image because an isolated photograph can in no way portray its entire meaning. Ute Klophaus's photos, the most 'powerful' of which we have selected, all show that the action was produced in harmony with a very particular lighting effect turning Beuys's shadow into an agent and the blind window into a symbolic screen. We are, therefore justified in wondering quite what the *mise-en-scène* of the event signified, since it is only partially, though impressively, illustrated by the photograph.

We shall, therefore, take *Action Dead Mouse* for what it is – a symbolic representation – and attempt to interpret it. Let us begin with the décor. Physically, we are in the cellar of the Academy of Fine Art in Düsseldorf, where Beuys had for several years been a charismatic professor. Symbolically, however, the action takes place in the 'Cellar of the

Academy'. We are also – through an enlargement, so to speak – in the basement of the representation, in the underworld where images are formed. The frame onto which Beuys, his shadow, and – *en abyme* – the dead mouse are projected, is that of a window whose symbolic value – so well defined by Alberti at the dawn of the early modern era – Beuys knew only too well:

> Here alone, leaving aside other things, I will tell what I do when I paint.
> First of all about where I draw. I inscribe a quadrangle of right angles, as large as I wish, which is considered to be an open window through which I see what I want to paint. Here I determine as it pleases me the size of the men in the picture. I divide the length of this man in three parts. These parts are proportional to that measurement called a *braccio*, for in the measuring the average man it is seen that he is about three *braccia*. With these *braccia* I divide the base line of the rectangle into as many parts as it will receive. To me this base line ... etc. etc. etc.[33]

If at this point I end the quotation of the famous passage that is the cornerstone of classical representation, it is because the function of Beuys's revival is not to recall the academic doctrine, but rather to forget it. Duchamp had already done this when, in 1920, through his *Fresh Widow* (illus. 110), he gave the Dadaist response to Alberti's window[34] by closing its shutters, thereby replacing traditional Western representation with its own emptiness. Through a play on words that relies heavily on the quasi-homophone *window/widow*, Duchamp replaces Alberti's 'ancient window' with a new one, one that mourns the death of classical representation. Beuys is therefore projected not only onto Alberti's *finestra aperta*, but also onto Duchamp's 'closed window'. But he goes further still in as much as even the *fresh widow* – here comes the play on words – becomes an *old window*. In truth, Beuys's importance by far exceeds the revitalization of painting, which was why Alberti's and Duchamp's *mise en abyme* was produced within a ritual action whose role it was to re-establish the status of the representation in general.

What Beuys is seeking, is to forget all surface-representation, all codified frame-work. He advocates that networks of components be transgressed in the name of the 'artist' directly

(albeit underground) intervening in the flux of things and beings. In this way, the 'action' verges on magic ceremonies, and the happening promotes itself as the authentic reactualization of ancient Shaman gatherings. It is certainly significant that the 'dead mouse' action (and the legacy of Ute Klophaus's shots) corresponds almost exactly to images that portray the occult, one of which we have already had occasion to examine (illus. 47). The vaulted cave, the special lighting effects, the mouse, the corpse, the gigantic shadow, the double significance of the arm, the repetition of these elements is no mere coincidence and raises an unavoidable hermeneutic problem. We could even go so far as to say that in this shot (illus. 107), the 'artist's shadow' is verticalized and hyperbolized (illus. 95, 96, 109) according to the requirements of the representation of occult scenarios.

To speak of Beuys's Shamanism has become common currency in more recent literature.[35] His existential itinerary, interspersed with incredible experiences, such as the legendary plane crash in the Crimea in 1943, his stay with the Tartars who nursed him back to health and cured him of his double cranial traumatism, his nervous breakdowns, the growth of his charismatic personality, his anthroposophic faith, are factors too numerous and too complex to go into here. If, however, I feel it is still necessary to examine some of the aspects of this problem, it is because in *Action Dead Mouse*, more than in any other happening, the inherent symbolic significance of Beuys's Shamanism emerges. A meticulous reading of this *ex-position* – and of the role played by the shadow – is therefore imperative.

According to the classic work on ancient techniques of ecstasy (which according to more recent hypotheses, Beuys would have known inside out),[36] Shaman clothing can endow the Shaman with a new magical body in the form of an animal. It bestows on whomsoever wears it a resistance to the cold, which is tantamount to attaining a superhuman state.[37] The spectators at the happening (Ute Klophaus for one) were quite rightly surprised by the originality of Beuys's appearance, particularly when they compared it to his other actions, where he had performed in jeans and a shirt.[38] The famous felt suit was neither a practical nor a standard outfit, but as Beuys himself said, it was a symbolic outfit, an 'image', a 'work of

110 Marcel Duchamp, *Fresh Widow*, 1920, miniature French window, painted wood frame, and eight panes of glass covered with black leather. Museum of Modern Art, New York.

art'. He went on to explain: the felt suit is the house nearest to man, a cave that envelops and insulates him. It is unusually warm and prevents the heat from escaping: it is a 'different' heat, of a spiritual nature, but also primitive, primary (*eine ganz andere Wärme, nämlich geistige oder einen Evolutionsbeginn*).[39]

As for the hat, Beuys was less open about it, but unlike the suit he was hardly ever without it, and it very soon became an integral part of his *public image*. It had a practical function (it covered the consequences of his cranial traumatism) but also a symbolic one. The hat signalled (by hiding) its owner's deviation from the norm, his *difference*. In relation to the suit/hat format the latter had a synecdotal role to play. The felt suit is the Shaman's ritual cover; the hat, according to anthropologists, is his permanent and requisite attribute:

> The hat is considered to be the Shaman's most important garment. According to the Shamans, much of their power is concealed by these hats. That is why it is customary when the profane request a Shaman to perform, that he does so without his hat. When I queried this I was told that when they performed Shaman ceremonies without a hat they were stripped of any real power, and that the whole ceremony was therefore nothing more than a parody designed to entertain those who watched it.[40]

The Shaman's paranormal powers surface in two ways: they have the gift of knowledge (such as the ability to understand animals and interpret dreams) and the gift of deeds. *Action Dead Mouse* would appear to be a genuine ceremony of primary Shamanic oversimplification because of the way these two categories of power are performed. The predicted death of the mouse, as recalled by witnesses, belongs to the first order of Shamanic powers. The journalist Helga Meister, who was present at the action, was able to add some vital details: Beuys told her that the mouse, transformed into a dormouse, had appeared to him in a dream and bitten him three times on the hand. That is how he came to know that the mouse, which had been living under his bed for three years, was dead.[41] The interpretation of dreams, confirmed by Beuys's statement, is based on the ability of the dreamer to decipher the predetermined contents of the dream (three bites = three years; transformation into a dormouse = death)[42] and

on the premise that the mouse (and through it nature, existence, the world) wishes to communicate with the dreamer.

The second order of Shamanic powers, the gift of deeds, surfaces during their actual magical rituals. In his famous *A General Theory of Magic* (1902–03) Mauss stresses that

> Ritual acts, on the contrary, are essentially thought to be able to produce much more than a contract: rites are eminently effective; they are creative; they *do* things. It is through these qualities that magical ritual is recognized as such. In such cases even, ritual derives its name from a reference to these effective characteristics: in India the word which best corresponds to our word ritual is *karman*, action; sympathetic magic is the *factum*, *krtyâ* par excellence. The German word *Zauber* has the same etymological meaning; in other languages the words for magic contain the root *to do*.[43]

We could elaborate on Mauss's observations and say that what the artistic circles of the Sixties and Seventies referred to as *action* was actually nothing more than a distant legacy of the ancient *actum*. In this context, Beuys's action entitled *Isolation Unit* (or *Dead Mouse*) took on a special significance, since it was not an 'action' like any other action, but an action that exposed its magical structure, a self-reflective act if you like, which staged the actual blueprint of Shaman scenarios; it was a representation that – in the basement of an institution where one learned how to make images – reflected on the representation.

In the final analysis, what was Beuys trying to achieve through the action *Dead Mouse*? Bearing in mind that the chief function of the Shaman is that of a healer,[44] the *action* should in principle result in the revitalization of the representation itself. But this 'representation' is not the 'art' that is practised on the top floor of the building. The only representation is the underground action itself. Beuys's *acts* (meditation on death, the cult of the fruit of life) will therefore be symbolic and will go around in circles. Beuys probably knew that, while he was recovering, the *medicine-man* often split and that his soul would leave his body for varying lengths of time and in different forms – as a shadow for example.[45] But, and this is where the full significance of Beuys's *actum* is revealed, all of

this has as its background canvas the blind window on which the oversized shadow, that should revitalize art, appears like a gigantic question-mark.

References

INTRODUCTION

1 On this subject see H Blumenberg, 'Licht als Metapher der Wahrheit. Im Vorfeld der Philosophischen Begrifsbildung', *Studium Generale*, VII (1957), pp. 432–47. There is one history of light in painting: W. Schöne, *Über das Licht in der Malerei* [1954] (Berlin, 1989).

2 G. W. F. Hegel, *The Science of Logic*, trans. A. V. Miller (London, 1969), Book 1, first section, ch. I, remark 2.

3 There is at present R. Verbraeken's book, *Clair-Obscur, histoire d'un mot* (Nogent-le-Roi, 1979), a work rich in material but disappointing when it comes to theoretical proposals and conclusions.

4 E. H. Gombrich, *Shadows: The Depiction of Cast Shadows in Western Art* (London, 1995); M. Baxandall, *Shadows and Enlightenment* (New Haven and London, 1995). I have only been able to take limited account of these books since my text had been completed by the time they appeared.

5 R. Rosenblum, 'The Origin of Painting: A Problem in the Iconography of Romantic Classicism', *Art Bulletin*, XXXIX (1957), pp. 279–90; T. DaCosta Kaufmann, 'The Perspective of Shadows: The History of the Theory of Shadow Projection', *Journal of the Warburg and Courtauld Institutes*, XXXVIII (1979), pp. 258–87. It is now possible to consult addenda and amendments made to this article in T. DaCosta Kaufmann, *The Mastery of Nature: Aspects of Art, Science and Humanism in the Renaissance*, (Princeton, NJ, 1993), pp. 72–8.

6 J. von Nägelein, 'Bild, Spiegel und Schatten im Volksglauben', *Archiv für Religionswissenschaft*, V (1902), 1–37; F. Pradel, 'Der Schatten im Volksglauben', *Mitteilungen der Schlesischen Gesellschaft für Volkskunde*, XII (1904), pp. 1–36; J. G. Frazer, *Le Rameau d'Or* (London, 1915), I, pp. 529–42.

CHAPTER 1

1 Unless otherwise indicated, all quotations from Pliny's *Natural History* are taken from the Loeb Classical Library version translated by H. Rackman (Cambridge, MA, and London, 1952).

2 Pliny the Elder, *Natural History*, XXXV, 43.

3 Athenagoras, *Legatio pro Christianis*, in *Patrologia Cursus completus*, 6, coll. 923–4 (translator's version).

4 Details in P. W. van der Horst, 'Der Schatten im hellenistischen Volksglauben', in M. J. Vermaseren, ed., *Studies in Hellenistic Religions* (Leiden, 1979), pp. 26–36, and in J. Novakova, *Umbra. Ein Beitrag zur dichterischen Semantik* ·(Berlin, 1964), pp. 57–63.

5 See for example, Ovid, *Amorum liber*, III; VII (VI).

6 Regarding this question, it is now possible to refer to J. J. Pollitt, *The Ancient View of Greek Art, Criticism, History and Terminology* (New Haven and London, 1974), pp. 73–80.

7 P. Fresnault-Deruelle, 'Le reflet opaque: Le revenant, la mort, le diable (petite iconologie de l'ombre portée)', *Semiotica*, LXXIX (1990), p. 138. See also H. Damisch, *Traité du Trait. Tractatus tractus* (Paris, 1955), pp. 61–76.

8 A. Rouveret, *Histoire et imaginaire de la peinture ancienne (Vème siècle av. J.C.*

– 1er siècle ap. J.C.) (Rome, 1989), pp. 18–19. See also J. Bouffartigue, 'Le Corps d'argile: quelques aspects de la représentation de l'homme dans l'antiquité grecque,' *Revue des Sciences Religieuses*, LXX (1996), pp. 204–23. Thanks to a conversation with Françoise Frontisi, I have now examined the excellent book by M. Bettini, *Il ritratto dell'amante* (Turin, 1992).

9 E. Rohde, *Psyche. Seelenkult und Unsterblichkeitsglaube der Griechen* [1898] (Darmstadt, 1980), I, pp. 3–7; J. Brenner, *The Early Greek Concept of Soul* (Princeton, NJ, 1983), pp. 78–9.

10 Weynants-Ronday, *Les Statues vivantes. Introduction à l'étude des statues égyptiennes* (Brussels, 1926); F. Frontisi-Ducroux, *Dédale. Mythologie de l'artisan en Grèce ancienne* (Paris, 1975); J. Ducat, 'Fonctions de la statue dans la Grèce archaïque: *Kouros* et *Kolossos*', *Bulletin de Correspondance Hellénique*, C (1976), p. 242. S. P. Morris, *Daidalos and the Origins of Greek Art* (Princeton, NJ, 1992), pp. 215–37.

11 G. Maspéro, *Etudes de Mythologie et d'Archéologie égyptienne*, I (Paris, 1893), pp. 46–8, 300 and 389–95. From the abundance of literature on *Ka* see K. Lang, 'Ka, Seele und Leib bei den alten Aegyptern', *Anthropos, Revue Internationale d'Ethnographie et de Linguistique*', XX (1925), pp. 55–76; as to the functions of the shadow it would be useful to consult N. George, *Zu den altägyptischen Vorstellungen vom Schatten als Seele* (Bonn, 1970); for certain aspects linked to the ritual function of statues, see J. C. Goyon, *Rituels funéraires de l'ancienne Egypt* (Paris, 1972), p. 89ff. and to R. Tefnin, *Art et Magie au temps des Pyramides. L'énigme des têtes dites de 'remplacement'* (Brussels, 1991), pp. 75–95.

12 J.-P. Vernant, 'De la présentification de l'invisible à l'imitation de l'apparence', in *Rencontres de l'Ecole du Louvre. Image et Signification* (Paris, 1983), p. 35; J.-P. Vernant, *L'Individu, la mort, l'amour. Soi-même et l'autre en Grèce ancienne* (Paris, 1989), pp. 8–79.

13 In this context it would be beneficial to read K. Kereny's study, 'Agalma, Eikon, Eidolon', in E. Castelli, ed., *Demitizzazione e immagine* (Padua, 1962), pp. 161–71.

14 E. Beneviste, 'Le sens du mot κολοσσος et les noms grecs de la statue', *Revue de philologie* (1932), pp. 118–35; J.-P. Vernant, *Mythe et pensée chez les grecs. Etudes de psychologie historique* (Paris, 1965), pp. 251–63.

15 All quotations from Plato's *The Republic* are taken from the translation by H.D.P. Lee, Penguin Books (Harmondsworth, 1964).

16 At this point, refer to M. Jay's recent deliberations, *Downcast Eyes: The Denigration of Vision in Twentieth-century French Thought* (Berkeley, Los Angeles and London, 1993).

17 See, for example, A. Diès, 'Guignol à Athènes', Bulletin Budé, XIV (1927) and P.-M. Schuhl, *La Fabulation platonicienne* (Paris, 1947) pp. 45–74.

18 For details refer to M. Heidegger, *Platons Lehre von der Wahrheit. Mit einem Brief über den 'Humanismus'* (Berne, 1947), pp. 5–52 and to H. Blumenberg, *Höhlenausgänge* (Frankfurt am Main, 1989), pp. 163–9.

19 The quotations from the *Sophist* are taken from Francis MacDonald Cornford's translation of Plato's 'Theory of Knowledge' (London, 1951).

20 Regarding this question, see S. Rosen, *Plato's 'Sophist': The Drama of Original and Image* (New Haven and London, 1983), pp. 147–203.

21 Plotinus, in *Enneads*, VI, 4, 10, removed the *eikon* (image/portrait) from Plato's triadic system by emphasizing its singular dissimilarity to the shadow and mirror. For its subsequent developments refer to S. Michalski, 'Bild und Spiegelmetapher. Zur Rolle eines Vergleichs in der Kunsttheorie und Abendmahlsfrage zwischen Plato und Gadamer' (forthcoming).

22 J.-P. Vernant, *Religions, histoires, raisons* (Paris, 1979), pp. 105–37; G. Sörbom, *Mimesis and Art: Studies in the Origins and Early Development of an Aesthetic Vocabulary* (Uppsala, 1966), pp. 152–63; D. Freedberg, 'Imitation and its Discontents', in T. W. Gaehtgens, ed., *Künstlerischer Austausch/*

Artistic Exchange. Akten des XXVIII. Internationalen Kongresses für Kunstgeschichte Berlin, 15-20 Juli 1992 (Berlin, 1993), II, pp. 483ff.

23 Regarding the notion of 'simulacrum' or 'semblance', refer also to G. Deleuze's developments, *Logique du sens* (Paris, 1969), pp. 292–307.

24 See especially J. Derrida, *La Dissémination* (Paris, 1972), pp. 174–5.

25 The origins of this particularly thorny problem can be found in Pollitt, *The Ancient View of Greek Art*, pp. 247–53. The different interpretations are often at variance with one another. See the synopsis of the problem in J.-M. Croisille's note to Pliny the Elder, *Histoire Naturelle. Livre XXXV* (Paris, 1985) pp. 297–300. See also V. J. Bruno, *Form and Color in Greek Painting* (New York, 1977), pp. 23–44; Rouveret, *Histoire et imaginaire de la peinture ancienne*, pp. 15–63; W. Trimpi, *Muses of One Mind: The Literary Analysis of Experience and its Continuity* (Princeton, NJ, 1983), pp. 100–3 and 114–29.

26 E. C. Keuls, *Plato and Greek Painting* (Leiden, 1978), pp. 72–87.

27 J. Piaget, *La Causalité physique chez l'enfant* (Paris, 1927), pp. 203–18. (The dialogue quoted in the introductory quotation to this sub-chapter is taken from the same work, p. 205.)

28 In J. Lacan, *Ecrits I* (Paris, 1966), pp. 89–97, first published in 1949.

29 Piaget, *La Causalité physique*, p. 207.

30 All quotations from Ovid's *Metamorphosis* book III are from Frank Justus Miller's translation (Cambridge, MA, 1984, reprint).

31 Novakova, *Umbra*, p. 40.

32 Bernard de Vantadour, *Quant vei la lauzeta mover*, in L. Vinge, *The Narcissus Theme in Western European Literature up to the Early 19th Century* (Lund, 1967), pp. 66–7.

33 It would be useful to read, by way of an introduction, T. Junichiro, *Eloge de l'Ombre* [1933], French trans. by R. Siefferet (Paris, 1977).

34 For the role of the Ovidian myth in the development of Western representation, see H. Damisch, 'D'un Narcisse l'autre', *Nouvelle Revue de Psychanalyse*, XIII (1976), pp. 109–46; S. Bann, *The True Vine: On Visual Representation and Western Tradition* (Cambridge, 1989), pp. 105–56.

35 L. B. Alberti, *On Painting/De Pictura* (1435), trans. C. Grayson (Harmondsworth, 1991), p. 61.

36 Alberti, *De Pictura*, Book II.

37 See Cl. Nordhoff, *Narziss an der Quelle. Spiegelbilder eines Mythos in der Malerei des 16. und des 17. Jahrhunderts* (Munster and Hamburg, 1992) and C. L. Baskins's reflections: 'Echoing Narcissus in Alberti's "Della Pittura"', *Oxford Art Journal*, XVI (1993), pp. 25–33.

38 Same difficulty but otherwise resolved by Joachim von Sandrart, *L'Accademia Todesca della Architettura, Scultura et Pittura, oder Teutsch Academie der Edlen Bau-, Bild und Mahlerey-Künste* (Nuremberg and Frankfurt, 1675–9) I, pp. 6–7. On this subject see O. Bätschmann, *Nicolas Poussin: Dialectics of Painting* (London, 1990), 45–6.

39 G. Vasari, *Le Vite* (Florence, 1878), I, p. 218; French translation under the supervision of A. Chastel (Paris, 1989), I, p. 217.

40 F. H. Jacobs, 'Vasari's Vision of the History of Painting: Frescoes in the Casa Vasari, Florence', *The Art Bulletin*, LXVI (1984), pp. 397–417; J. Albrecht, 'Die Häuser von Giorgio Vasari in Arezzo und Florenz', in E. Hüttinger, ed., *Künstlerhäuser von der Renaissance bis zur Gegenwart* (Zurich, 1985), pp. 83–100.

41 See M. Schapiro, *Words and Pictures: On the Literal and Symbolic in the Illustration of a Text* (The Hague and Paris, 1973), pp. 37–49; O. Calabrese, *La Macchina delle pittura* (Bari, 1986); R. Tefnin, 'Regard de Face – Regard de profil. Remarques préliminaires sur les avatars d'un couple sémiotique', *Annales d'Histoire de l'Art et d'Archéologie. Université Libre de Bruxelles*, XVII (1995), pp. 7–25; and F. Frontisi-Ducroux, *Du Masque au visage* (Paris, 1995), pp. 79–130.

1 Details in D. Angùlo Iñiguez, *Murillo*, II (Madrid, 1981), pp. 592–3.

2 V. I. Stoichita, 'Der Quijotte-Effekt. Bild und Wirklichkeit im 17. Jahrhundert under besonderer Berücksichtigung von Murillos Oeuvre', in H. Körner, ed., *Die Trauben des Zeuxis. Formen künstlerischer Wirklichkeitsaneignung* (*Münchner Beiträge zur Geschichte und Theorie der Künste*, 2) (Hildesheim, Zurich and New York, 1990), pp. 106–39.

3 Other extracts from the *Natural History* could be added, such as those on Nykias (XXXV, 38 and XXXV, 130–31), which 'paid great attention to the treatment of light and shade' through the use of scorched earth; and the one on Pausias (XXXV, 123) which, like Murillo further on in his manifesto-painting, 'was able to find a shadow in the shadow itself', etc.

4 See D. C. Lindberg, *Theories of Vision from Al-Kindi to Kepler* (Chicago, 1976).

5 See J. Wirth, *L'Image médiévale. Naissance et développements (VIème-XVème siècle)* (Paris, 1989).

6 I am relying here on comments made by E. Gilson, 'Qu'est-ce qu'une ombre? (Dante, Purg. XXV)', *Archives d'Histoire Doctrinale et Littéraire du Moyen-Age*, (1965), pp. 94–111. See also M. T. Lanza, 'I meriti dell'"ombra", in *Annali della Facoltà di Lingue e Letterature Straniere (Bari)*, 3rd series, X (1989–1990), pp. 7–19, and C. W. Bynum, 'Imagining the Self: Somatomorphic Soul and Resurrection Body in Dante's "*Divine Comedy*"', in P. Lee and Blackwell, eds, *A Festschrift for Richard Reinhold Niebuhr* (Scolar Press, 1995), pp. 83–106.

7 All quotations have been taken from Henry Francis Cary's translation of Dante's *Divine Comedy* (Oxford, 1957).

8 This passage can be compared to that of Homer's *Iliad* (XXIII, 59–107), where Achilles is making futile attempts to embrace Patrocles' *eidolon*.

9 For the tradition, see J.-Cl. Schmitt, *Les Revenants. Les Vivants et les morts dans la société médiévale* (Paris, 1994).

10 For information on the origins of this process, see K. Christiansen, *Gentile da Fabriano* (London, 1982), pp. 21–43. For other 'strange shadows' in Giovanni di Paolo, see M. Meiss, 'Some Remarkably Early Shadows in a Rare Type of Threnos', in Festschrift Ulrich Middeldorf (Berlin, 1968), pp. 112–18). For the earliest experiences of cast shadows, see 'Cast Shadow in the Passion Cycle at San Francesco, Assisi: A Note', *Gazette des Beaux-Arts*, LXXVII/113 (January 1971), pp. 63-6.

11 J. Pope-Hennessy, 'Paradiso', *The Illuminations to Dante's 'Divine Comedy' by Giovanni di Paolo* (London, 1993).

12 See A. Parronchi, 'La perspettiva dantesca', in *Studi sulla dolce prospettiva* (Milan, 1964), pp. 3–90.

13 Cennino Cennini, *Il Libro dell'Arte*, ch. VIII. Edited quotations follow Cennino d'Andrea Cennini, *The Craftsman's Handbook*, translation and notes by Daniel V. Thompson, Jr. (New York, 1954), p. 5.

14 For a detailed approach it would be an advantage to consult: E. Webster Bulatkin, 'The Spanish Word "Matiz". Its Origin and Semantic Evolution in the Technical Vocabulary of Medieval Painters', *Traditio*, X (1954), pp. 459–527.

15 This manual's level of technical knowledge does in fact give quite a good account of the achievements of the fourteenth-century school known as 'Cretan'.

16 See P. Hetherington, *The 'Painter's Manual' of Dionysius of Fourna* (London, 1974).

17 The term Cennini uses (*esempio*) is ambiguous (see also *Libro dell'Arte*, ch. XXVIII). In the lexis of the Dugento and Trecento it could have referred to the iconographic model to follow. This is how Dante uses it in *Purgatorio*,

XXXII, 64–5. The fact that Cennini mentions sunlight would lead us to believe that he is referring to the unmodified copy of a natural object.

18 For a cross-section of the history and theory of this problem, see G. Didi-Huberman, *La Peinture incarnée* (Paris, 1985). The key text on the subject of the shade/flesh relationship in the theory of Italian art is G. P. Lomazzo's *Trattato dell'arte della pittura, scoltura et architettura* (1584); *Scritti sulle arti*, ed. R. P. Ciardi (Florence, 1974), II, pp. 270–71.

19 For further information on this notion see P. Hills, *The Light of Early Italian Painting* (New Haven and London, 1987), pp. 108–113; M. B. Hall, ed., *Color and Technique in Renaissance Painting. Italy and the North* (Locust Valley, N.Y., 1987), pp. 1–54.

20 However, see chapters LXXXVII and LXXXVIII of the *Libro dell'arte*.

21 I am echoing L. Freedman's comments in 'Masaccio's "St *Peter Healing with his Shadow*'': A Study in Iconography', *Notizie da Palazzo Albani*, XIX (1990), pp. 13–31.

22 Such is the case with the related scene in the church of S Piero a Grado, Pisa. See J. T. Wollesen, *Die Fresken von San Piero a Grado bei Pisa* (Bad Oeynhausen, 1977), pp. 30–32.

23 L. Kretzenbacher, 'Die Legende vom heilenden Schatten', *Fabula*, IV (1961), pp. 231–47, and P. W. van der Horst, 'Peter's Shadow', *New Testament Studies*, XXIII (1976–7), pp. 204–13.

24 Nicolaus de Lyra, *Biblia sacra cum glossis* (Leiden, 1545) (Postilla, VI, 173r). For an account of this work's popularity at the time of Masaccio and for its possible influence on the creation of the Carmine frescoes, see A. Debold von Kritter, *Studien zum Petruszyklus in der Brancaccikapelle* (Berlin, 1975), pp. 60–65; 121–7 and more particularly 219–21.

25 Giorgio Vasari, *The Lives of the Painters, Sculptors and Architects*, trans. ??? (London: J. M. Dent, 1949), II.

26 There were no shadows depicted in the S Piero a Grado fresco (see Reference 16). On the other hand, a ray of light radiates from the tower of the 'portico' and falls directly on the sick.

27 This procedure is largely dealt with by W. Schöne, *Über das Licht in der Malerei*, and by P. Hills, *The Light of Early Italian Painting*.

28 This is probably why R. Longhi, 'Gli affreschi del Carmine. Masaccio e Dante', *Paragone*, IX (1950), pp. 3–7 considered that 'this piece could serve as an unconscious symbol of Masaccio's deepest intention: that of healing "through the shadow" painting itself' (p. 5).

29 Vasari, *The Lives*, II, pp. 263–4.

30 See S. Y. Edgerton, Jr., 'Alberti's Colour Theory: A Medieval Bottle Without Renaissance Wine', *Journal of the Warburg and Courtauld Institutes*, XXXII (1969), pp. 109–34; J. S. Ackerman, *Distance Points: Essays in Theory and Renaissance Art and Architecture* (Cambridge, MA, 1991); M. Barasch, *Light and Color in the Italian Renaissance Theory of Art* (New York, 1978).

31 Alberti, *On Painting/De Pictura*, translated by Cecil Grayson (Harmondsworth, 1991), p. 46.

32 Alberti, *On Painting*, pp. 82–3.

33 *The Literary Works of Leonardo da Vinci*, ed. J. P. Richter (New York, 1970), I, V 529.

34 From the plethora of literature to choose from dealing with this theme see especially J. Shearman, 'Leonardo's Colour and Chiaroscuro', *Zeitschrift für Kunstgeschichte*, XXV (1962), pp. 13–47; M. Kemp, *Leonardo da Vinci: The Marvellous Works of Nature and Man* (London, Melbourne and Toronto), pp. 96–135 and 332–9; A. Nage, 'Leonardo and "*sfumato*"', *Res*, XXIV (1993), pp. 7–20.

35 Always refer to T. DaCosta Kaufmann, 'The Perspective of Shadows', pp. 267–75.

36 *The Literary Works of Leonardo da Vinci*, no. 111, p. 164.
37 See E. Panofsky, *The Codex Huyghens and Leonardo da Vinci's Art Theory* (London, 1940), p. 61, and G. Bauer, 'Experimental Shadow Casting and the Early History of Perspective', *The Art Bulletin*, LXIX (1987), pp. 211–19 (here p. 215).
38 DaCosta Kaufmann, 'The Perspective of Shadows', p. 275.
39 R. de Piles, *Cours de peinture par principes* [1708] (Paris, 1989), p. 180 (translator's version).
40 De Piles, *Cours de peinture*, p. 363 (translator's version). See also T. Puttfarken, *Roger de Piles' Theory of Art* (New Haven and London, 1985), pp. 72–5.
41 See D. Daube, *The New Testament and Rabbinic Judaism* (London, 1956), pp. 27–36.
42 A. Allgeir, 'Ἐπισκιάξειν Lk 1, 35.', *Biblische Zeitschrift*, XIV (1917), pp. 338–43.
43 Theophylacti Bulgariae, *Enarratio in Evangelium Lucae*, in Migne, *Patrologia Graeca*, CXXIII, coll. 705–06. On this subject see B. Haensler, 'Zu Mt 21, 3b und Parallelen', *Biblische Zeitschrift*, XIV (1917), pp. 147–51; H. Leisegang, *Pneuma Hagion. Der Ursprung des Geistbegriffs der synoptischen Evangelien aus der griechischen Mystik* (Leipzig, 1922), pp. 24–31 and 60–63; A. Allgeir, 'Das gräco-ägyptische Mysterium im Lukasevangelium', *Historisches Jahrbuch*', XLV (1925), pp. 1–20.
44 See *Vangeli apocrifi. Natività e infanzia*, ed. A.M. di Nola (Lodi, 1977), p. 180 (translator's version).
45 Jacobus de Voragine, *The Golden Legend*, first English edition by William Caxton 1483, edition of 1900 used here (London: J. M. Dent, 1967), III, p. 99.
46 See D. M. Robb, 'The Iconography of the Annunciation in the Fourteenth and Fifteenth Centuries', *The Art Bulletin*, XVIII (1936), pp. 480–526; D. Arasse, 'Annonciation/Enonciation. Remarques sur un énoncé pictural du Quattrocento', *Versus*, XXXVII (1984), pp. 3–17 (here p. 7); G. Didi-Huberman, *Fra Angelico. Dissemblance et figuration*, (Paris, 1990), pp. 152ff.
47 Concerning the technical and iconographic problems of the Frick *Annunciation*, see J. Ruda, *Fra Filippo Lippi, Life and Work. With a Complete Catalogue* (New York, 1993), pp. 14–15.
48 See P. Philippot, 'Les grisailles et les "degrés de réalité" de l'image dans la peinture flamande des XVe et du XVIe siècles', *Bulletin des Musées Royaux des Beaux-Arts*, XIV (1966), pp. 225ff; D. Martens, 'L'Illusion du réel', in B. de Patoul and R. van Schoute, eds, *Les Primitifs flamands et leur temps* (Louvain la Neuve, 1994), pp. 255–77 (here pp. 264–70).
49 See R. Preimesberger, 'Zu Jan van Eycks Diptychon der Sammlung Thyssen-Bornemisza', *Zeitschrift für Kunstgeschichte*, LX (1991), pp. 459–89; C. Harbison, *Jan van Eyck: The Play of Realism* (London, 1995).
50 B. Facius, *De Viris Illustribus: De Pictoribus* (1456), published by M. Baxandall, 'Bartholomaeus Facius on Painting: A Fifteenth-century Manuscript of De Viris Illustribus', *The Journal of the Warburg and Courtauld Institutes*, XXVII (1967), pp. 90–107.
51 For information on this problem see Ruda, *Fra Filippo Lippi*, pp. 399–402.
52 Details in C. Gardner von Teuffel, 'Lorenzo Monaco, Filippo Lippi und Filippo Brunelleschi: die Erfindung der Renaissancepala', *Zeitschrift für Kunstgeschichte*, XLV (1982), pp. 1–30 (here p. 18).
53 I am reiterating L. Marin's comments, *Opacité de la peinture. Essais sur la représentation au Quattrocento* (Paris, 1989), pp. 148–9.
54 Details in M. Baxandall, *Painting and Experience in Fifteenth-century Italy* (London, Oxford and New York, 1972), ch. 2, and Didi-Huberman, *Fra Angelico*, pp. 25–7 and 120ff.
55 M. Meiss, 'Light as Form and Symbol in Some Fifteenth-century

Paintings', *The Art Bulletin*, xxvii (1945), pp. 175–81; F. Ames-Lewis, 'Fra Filippo Lippi and Flanders', *Zeitschrift für Kunstgeschichte*, xlii (1979), pp. 255–73 (here pp. 260–61).

56 Ruda, *Fra Filippo Lippi*, pp. 123–5; S. Y. Edgerton, Jr., *The Heritage of Giotto's Geometry. Art and Science on the Eve of the Scientific Revolution* (Ithaca, ny, and London, 1991), pp. 103–05.

57 E. Maurer, 'Konrad Witz und die niederländische Malerei', *Zeitschrift für Schweizerische Archäologie und Kunstgeschichte*, xviii (1958), pp. 158–66.

58 H. Kehrer, *Die heiligen drei Könige in Literatur und Kunst* (Leipzig, 1908); H. Anz, *Die lateinischen Magierspiele* (Leipzig, 1905).

59 Kehrer, *Die heiligen drei Könige*, ii, pp. 250–69.

60 See M. Barrucand, *Le Retable du Miroir du salut dans l'oeuvre de Konrad Witz* (Geneva, 1972), pp. 117–19. For information on the relationship between 'grisailles' and 'prefiguration' see M. Grams-Thieme, *Lebendige Steine. Studien zur niederländischen Grisaillemalerei des* 15. *und frühen* 16. *Jahrhunderts* (Cologne and Vienna, 1986), pp. 9–11 and D. R. Täube, *Monochrome Plastik. Entwicklung, Verbreitung und Bedeutung eines Phänomens niederländischer Malerei der Gothik* (Essen, 1991), pp. 165–7.

61 Ambrosius, *De Mysteriis*, ch. 8, in P. L. Migne, xvi, coll. 405. Regarding this problem see E. Auerbach, 'Figura' in *Neue Dantestudien* (Istanbul, 1944), pp. 11–71, and H. De Lubac, *Exégèse Médiévale. Les quatres sens de l'Ecriture* (Paris, 1959), pp. 316–21.

62 For details see E. Pax, 'Epiphanie', in *Reallexikon für Antike und Christentum* (Stuttgart, 1962), v, coll. 876–9, and E. Pfuhl, 'Apolodoros Ο Σκιαγραφοσ', *Jahrbuch des Kaiserlich Deutschen Archäologischen Instituts*, xxv (1910), pp. 12– 28 (here p. 25).

63 On this subject see B. G. Lane, *The Altar and the Altarpiece: Sacramental Themes in Early Netherlandish Painting* (New York, 1984), pp. 25–35, who goes so far as to support the hypothesis according to which this small picture was the door of a tabernacle where hosts were stored.

64 See the texts in Anz, *Die lateinischen Magierspiele,* pp. 130–58.

65 U. Nilgen, 'The Epiphany and the Eucharist: On the Interpretation of Eucharistic Motifs in Medieval Epiphany Scenes', *Art Bulletin*, xlix (1967), pp. 311–16; B. G. Lane, ' "Ecce Panis Angelorum": The Manger as Altar in Hugo's Berlin Nativity', *Art Bulletin*, lvii (1975), pp. 476–86.

66 K. Young, *The Drama of the Medieval Church* (Oxford, 1933), pp. 29–101; R. Hatfield, *Botticelli's Uffizi 'Adoration'* (Princeton, nj, 1976), p. 61.

67 A. C. Quintavalle, *La Regia Galleria di Parma* (Rome, 1939), pp. 150–53. My thanks to Thierry Lenain for drawing my attention to this painting.

CHAPTER 3

1 See the more recent: G. Kraut, *Lukas malt die Madonna. Zeugnisse zum künstlerischen Selbstverständnis in der Malerei* (Worms, 1986), pp. 80–96.

2 K. Gross, 'Lob der Hand im klassischen und christlichen Altertum', *Gymnasium*, lxxxiii (1976), pp. 423–40; M. Warnke, 'Der Kopf in der Hand', in W. Hofmann, ed., *Zauber der Medusa. Europäische Manierismen* (Vienna, 1987), pp. 55–61, and especially for the motif of the hand's shadow, Oskar Bätschmann and Pascal Griener, 'Holbein–Apelles. Weltbewerb und Definition des Künstlers', *Zeitschrift für Kunstgeschichte*, lvii (1994), pp. 626–50.

3 For details see A. Chastel, *Art et Humanisme à Florence au temps de Laurent le Magnifique* (Paris, 1959), pp. 102–05; M. Kemp, 'Ogni dipintore dipinge sé: A Neoplatonic Echo in Leonardo's Art Theory', in C. H. Clough, ed., *Cultural Aspects of the Italian Renaissance: Essays in Honour of Paul Oskar Kristeller* (New York, 1976), pp. 311–23; F. Zöllner, ' "Ogni Pittore Dipinge

Sé''. Leonardo da Vinci and ''Automimesis'' ', in M. Winner, ed., *Der Künstler über sich selbst. Internationales Symposium der Bibliotheca Hertziana Rom 1989* (Weinheim, 1992), pp. 137–60.

4 Boileau's statement was obviously inspired by a statement of Augustine's (*De Civitate Dei*, xi, xxiii, 71), according to whom 'like a painting which contains black, the world itself can be beautiful despite the existence of sin' (*sicut pictura cum colore nigro loco suo posito, ita universitas rerum, si quis possit intueri, etiam cum peccatoribus pulchra est, quamvis per se ipsos consideratos sua deformitas turpet*). In terms of aesthetics, it is interesting to note how the translation of this moral statement of Boileau's would in turn be picked up and traced back to its moral and ontological roots by Leibnitz, who was to make it one of the tenets of his theodicy. See his letter to Friedrich von Braunschwieig-Lüneburg, dated October 1671, in G. W. Leibniz, *Sämtliche Schriften und Briefen herausgegeben von der Preussischen Akademie der Wissenscahften zu Berlin*, zweite Reihe (Darmstadt, 1926), I, p. 162, where he states that 'das bild durch schattierung lieblicher (wird)', a concept he was to develop in his *Confessio philosophi* (1673), ed. Otto Saame (Frankfurt am Main, 1967), pp. 36–7 ('*per harmoniam rerum universalem, picturam umbris, consonantiam dissonantiis distinguentem*'). For the philosophical fortunes of this adage, see the passage from Hegel cited earlier (my *Introduction*, Reference 2).

5 My comments were inspired by J. Roudaut, *Une ombre au tableau* (Chavagne, 1988), pp. 220ff.

6 See the recent article by O. Bätschmann, 'Giovan Pietro Belloris Bildbeschreibungen', in G. Boehm and H. Pfotenhauer, eds, *Beschreibungskunst-Kunstbeschreibung. Ekphrasis von der Antike bis zur Gegenwart* (Munich, 1995), pp. 279–300 (here p. 293).

7 Details in E. Panofsky, *Idea. Contribution à l'histoire du concept de l'ancien théorie de l'art* [1924], French trans. by H. Joly (Paris, 1983), pp. 128–35.

8 G. P. Bellori, *L'Idea del pittore...* (1672), in Panofsky, *Idea*, pp. 168–9.

9 Bellori, *L'Idea del pittore ...*, pp. 174–5.

10 M. Winner, '''... una certa idea''. Maratta zitiert einen Brief Raffaels in einer Zeichnung', in Winner, ed., *Der Künstler über sich selbst*, pp. 511–51 (here pp. 538–9).

11 I am grateful to S. Waldmann for his comments on Carducho's emblem and self-portrait, in *Der Künstler und sein Bildnis im Spanien des Siglo de Oro* (Frankfurt am Main, 1995) pp. 155–7.

12 *Correspondance de Nicolas Poussin publiée d'après les originaux par Ch. Jouanny*, (Paris, 1968), v, 147.

13 *Correspondance*, 2 August 1648.

14 *Correspondance*, v, 172.

15 *Correspondance*, v, 181

16 G. P. Bellori, *Le Vite de' pittori, scultori e architetti moderni* [1675], ed. E. Borea (Turin, 1976), p. 455.

17 See especially Bätschmann, *Nicolas Poussin*, pp. 47–9 and L. Marin, 'Variations sur un portrait absent: les autoportraits de Poussin', 1649–1650', *Corps écrit*, v (1983), pp. 87–106; M. Winner, 'Poussins Selbstbildnis im Louvre als kunsttheoretische Allegorie', *Römisches Jahrbuch für Kunstgeschichte*, xx (1983), pp. 419–51, and Stefan Germer, 'L'Ombre du peintre: Poussin vu par ses biographes', in M. Wascheck, ed., *Les 'Vies' d'artistes. Actes du colloque international organisé par le Service culturel du musée du Louvre les 1er et 2 octobre 1993* (Paris, 1996), pp. 105–24.

18 Bätschmann, *Nicolas Poussin* pp. 49–52; E. Cropper, 'Painting and Possession: Poussin's Portrait for Chantelou and the Essays of Montaigne', in Winner, *Der Künstler über sich selbst*, pp. 485–510.

19 P. F. de Chantelou, *Journal du Voyage du Cavalier Bernini en France* (Paris, 1930), p. 124 (19 August, 1665).

20 For Poussin's thoughts on the shadow see Bätschmann, *Nicolas Poussin*, passim.

21 For information on the scenario of production in the seventeenth century, see V. I. Stoichita, *The Self-Aware Image: An Insight into Early Modern Meta-Painting* (Cambridge and New York, 1997).

22 I was unable to take into account the interesting topic of M. D. Sherif, *The Exceptional Woman: Elisabeth Vigée-Le Brun and the Cultural Politics of Art* (Chicago, 1996), pp. 230–35, which appeared after my text was finished.

23 Details in B. Schubiger, 'Allegorien der Künste und Wissenschaften. Ein Zyklus des französischen Malers Sébastien II Le Clerc (1676–1763) aus dem Jahre 1734 im Schloss Waldegg bei Solothurn', *Zeitschrift für Schweizerische Archäologie und Kunstgeschichte*, LI (1994), pp. 77–92.

24 E. Zola, *L'Oeuvre*, vol. XIV in the series *Les Rougon Macquart* (Paris, 1966), p. 84.

25 S. Mallarmé, 'The Impressionists and Edouard Manet', *The Art Monthly Review* [London] (30 September 1876). I have edited P. Verdier's French translation, which appeared in D. Riout, ed., *Les Ecrivains devant l'Impressionnisme* (Paris, 1989), pp. 88–104 (here p. 97).

26 See R. L. Herbert, *Le Plaisir et les jours. L'Impressionnisme* (Paris, 1991), p. 6.

27 C. Baudelaire, 'L'Art Philosophique', *Ecrits sur l'art*, II (Paris 1971), p. 119.

28 C. Baudelaire, 'Le Peintre de la vie moderne' , *Ecrits sur l'art*, II, pp. 176. Walter Benjamin's studies on Baudelaire and nineteenth-century Paris should also be consulted.

29 Monet, letter V, 1854, dated 11 August 1908, in D. Wildenstein, *Claude Monet. Biographie et catalogue raisonné*, IV [1899–1926] (Lausanne and Paris, 1985), p. 374.

30 See also the collected texts and commentaries by S. Z. Levine, *Monet and His Critics* (New York 1976).

31 E. Sarradin, in *Journal des Débats* (12 May 1909), quoted by S. Z. Levine, *Monet, Narcissus and Self-Reflection: The Modernist Myth of the Self* (Chicago, 1994), p. 217.

32 Ghéon, *Nouvelle Revue Française*, I (1 July 1909), p. 533, quoted by Levine, *Monet and His Critics*, p. 314

33 See Levine, *Monet, Narcissus and Self-Reflection*.

34 In this context see T. Junichiro, *Eloge de l'ombre* [1933], French trans. by R. Sieffert (Paris, 1977). Very little has been written on the representation of the shadow in Oriental painting, although I have come across an unpublished conference paper by H. Brinker: '*Spuren der Wirklichkeit. Vom Schatten in Ostasiens Malerei und Graphik*', which the author was good enough to lend me and which proved to be extremely useful.

35 Geffroy, in Levine, *Monet and His Critics*, p. 380.

36 A. Scharf, *Art and Photography* (London, 1968).

37 For examples, see Stoichita, *The Self-Aware Image*.

38 S. Greenough and J. Hamilton, *Alfred Stieglitz. Photographs and Writings* (Washington, D.C., 1983), V, 45.

39 W. Kandinsky, *Rücklblicke* (Berlin, 1913).

40 W. Benjamin, 'Kleine Geschichte der Fotografie', in *Angelus Novus* (Frankfurt am Main, 1988), pp. 232ff.

41 See R. Täpffer (1841) in W. Kemp, *Theorie der Fotografie I, 1839–1912* (Munich, 1980), pp. 70–77.

42 C. S. Pierce, *Ecrits sur le signe*, French trans. by G. Deledalle (Paris, 1978), p. 158. For the links between photography and sign, you can now refer to R. Krauss, *Le Photographique. Pour une théorie des écarts*, French trans. by M. Bloch and J. Kempf (Paris, 1990) and P. Dubois, *L'Acte photographique* (Paris and Brussels, 1983).

43 D. Roche, *Autoportraits photographiques 1898–1981* (Paris, 1981); E. Billeter

et al., *L'Autoportrait à l'âge de la photographie. Peintres et photographes en dialogue avec leur propre image* (Lausanne, 1985).

44 D.-H. Kahnweiler, 'Gespräche mit Picasso', *Jahresring*, 59/60 (Stuttgart, 1959), pp. 85–6. I quote from Y.-A. Bois, 'The Semiology of Cubism', in W. Rubin et al., *Picasso and Braque: A Symposium* (New York, 1992).

45 I quote an expression coined by Y.-A. Bois, in Rubin et al., *Picasso and Braque*.

46 See for example C. Zervos, *Pablo Picasso* (Paris, 1956), VII, nos. 126–122[??], 245–8, 426, 445, 451, etc. I was unable to take acount of the interesting topic of Kirk Varnadoe, 'Les Autoportraits de Picasso,' in W. Rubin, ed., *Picasso et le portrait*, exh. cat. (Paris and New York, 1996–7), pp. 149–61, which appeared after I had finished my own text.

47 Zervos, *Pablo Picasso*, VII, 143. On this subject, see K. L. Kleinfelder, *The Artist, His Model, Her Image, His Gaze: Picasso's Pursuit of the Model* (Chicago and London, 1993), pp. 24–8.

48 Denis Hollier, in his very interesting article 'Portrait de l'artiste en son absence (Le peintre sans son modèle)', *Les Cahiers du Musée d'Art Moderne*, XXX (Winter 1989), pp. 5–22 dates these two paintings differently (the one in the Musée Picasso to 29 December and the one in the Art Gallery of Ontario to 30 December). Consequently, the pictorial narrative Hollier proposes is different from mine.

49 See: C. Gottlieb, 'The Bewitched Reflection', *Source*, IV (1985), pp. 59–67.

CHAPTER 4

1 J. von Sandrart, *Academie der Bau-, Bild- und Mahlerey-Künste von 1675*, ed. A. R. Peltzer (Munich, 1925), p. 297.

2 See P. Della Valle, *Viaggi di Pietro della Valle, Il Pellegrino* (Venice, 1667), Book I.

3 See Rosenblum, 'The Origin of Painting', pp. 279–80.

4 See Bätschmann, *Nicolas Poussin*, pp. 45–6.

5 See the more recent N. Choné, *L'Atelier des nuits. Histoire et signification du nocturne dans l'art de l'Occident*, (Nancy, 1992), and B. Borchhardt-Birbauner, 'Das "Nachtstück": Begriffsdefinition und Entwicklung vor der Neuzeit', *Wiener Jahrbuch für Kunstgeschichte*, XLVI/XLVII (1993/1994), pp. 71–85.

6 *Anecdotes des Beaux-Arts* (Paris, 1776), I, p. 6.

7 Alberti, *On Painting*, trans. J. R. Spencer, Book I, p. 50.

8 G. Bauer, 'Experimental Shadow Casting and the Early History of Perspective', *Art Bulletin*, LXIX (1987), pp. 211–19.

9 J. Dubreuil, *Perspective Pratique* (Paris, 1651), p. 127.

10 C. Ridolfi, *Le meraviglie dell'arte, ovvero le vite degli più illustri pittori veneti e dello stato*, (Berlin, 1924), II, p. 15.

11 E. J. Olszewski, 'Distortions, Shadows and Conventions in Sixteenth-century Italian Art', *Artibus et Historiae*, XI (1985), pp. 101–24.

12 Samuel Van Hoogstraten, *Inleyding tot de Hooge Schoole der Schilderkonst* (Rotterdam, 1678), p. 25.

13 See the more recent C. Brusati, *Artifice and Illusion: The Art and Writing of Samuel van Hoogstraten* (Chicago, 1995), pp. 90, 193–9.

14 A. Kircher, *Ars Magna Lucis et Umbrae* (Rome, 1646), pp. 128–9. For the context see M. Casciato, M. G. Ianniello and M. Vitale, eds, *Enciclopedismo in Roma Barocca. Athanasius Kircher e il Museo del Collegio Romano tra Wunderkammer e museo scientifico* (Venice, 1986).

15 In addition to Nägelein, Pradel and Frazer's studies (cited in the introduction) see M.-L. von Franz, *Shadow and Evil in Fairy Tales* (Irving, 1974) where he develops the Jungian notion of 'shadow', and to O. Rank, *Don Juan et le Double* [1914] (Paris, 1973).

16 Sigmund Freud, 'The Uncanny' [*Das Unheimliche*, 1919], in *Art and Literature*, ed. A. Dickson, vol. XIV of the Pelican Freud Library (Harmondsworth, 1985), pp. 347 and 358. This translation was first published in 1955 in vol. XVII of *The Standard Edition of the Complete Psychological Works of Sigmund Freud*, trans. and ed. by J. Strachey, 24 vols (London, 1953–74).

17 Corneille, *The Theatrical Illusion*, V, i, 3–6, trans. J. Cairncross (Harmondsworth, 1980).

18 H. Sckommodau, 'Die Grotte der "*Illusion comique*" ', in *Wort und Text. Festschrift für Fritz Schalk* (Frankfurt am Main, 1963), pp. 280–93.

19 For details see M. Löwensteyn, 'Helse hebzucht en wereldse wellust. Een iconografische interpretatie van enkele heksenvoorstellingen van Jacques de Gheyn II', *Kwade mensen. Toverij in Nederland Volkskundig Bulletin*, XII/1 (1986), pp. 241–61.

20 See also M. Nadin's comments in *Die Kunst der Kunst. Elemente einer Metaästhetik* (Stuttgart and Zurich, 1991), pp. 214–15.

21 Rank, *Don Juan et le Double*, p. 186.

22 A. Furetière, *Dictionnaire universel* (The Hague and Rotterdam, 1727), s. v. *Ombre*.

23 J. Sambucus, *Emblemata* (Antwerp, 1564), p. 246

24 W. Kraus, *Das Doppelgängermotiv in der Romantik* (Berlin, 1930); A. Hildenbrock, *Das andere Ich. Künstlicher Mensch und Doppelgänger in der deutsch- und englischsprachigen Literatur* (Tubingen, 1986); B. Boie, *L'Homme et ses simulacres. Essai sur le Romantisme allemand* (Paris, 1979).

25 C. A. Sarnoff, 'The Meaning of William Rimmer's "*Flight and Pursuit*" ', *The American Art Journal*, V (1973), pp. 18–19; M. Goldberg, 'William Rimmer's "*Flight and Pursuit*": An Allegory of Assassination', *Art Bulletin*, LVIII (1976), pp. 234–40.

26 G. De Chirico, 'Meditations of a painter. What the painting of the future might be', Appendix B: Manuscript from the Collection of Jean Paulhan, in James Thrall Soby, *Giorgio de Chirico* (New York, 1966), p. 252.

27 G. De Chirico, Appendix A: Manuscript from the Collection of the Late Paul Eluard, in Soby, *Giorgio de Chirico*, p. 247.

28 G. De Chirico, Appendix A, in Soby, *Giorgio de Chirico*, p. 245.

29 G. De Chirico, 'Meditations of a painter', p. 251.

30 R. Arnheim, *Art and Visual Perception: A Psychology of the Creative Eye* (Berkeley and Los Angeles, 1954).

31 G. De Chirico, *Noi, Metafisici* (Rome, 1919).

32 G. De Lairesse, *Le Grand Livre des Peintres* (Paris, 1787), I, pp. 421–2.

33 C. Metz, *Essais sur la signification au cinéma* (Paris, 1983), I, p. 39ff.

34 See M. Henry, *Le Cinéma expressionniste allemand: un langage métaphorique* (Fribourg, 1971), p. 26, and L. Eisner, *L'Ecran démoniaque* (Paris, 1952).

CHAPTER 5

1 *Encyclopédie* (Neuchâtel, 1765), XII, p. 267.

2 J.-J. Rousseau, *Essai sur l'origine des langues*, ch. 1.

3 On this subject, see J. Derrida's commentary, *De la grammatologie* (Paris, 1967) p. 327–44.

4 R. Rosenblum, 'The Origins of Painting'; G. Levitine, 'Addenda to Robert Rosenblum's "The Origins of Painting": A Problem in the Iconography of Romantic Classicism', *Art Bulletin*, XL (1958), pp. 329–31; H. Wille, 'Die Erfindung der Zeichenkunst', in *Beiträge zur Kunstgeschichte. Eine Festgabe für H. R. Rosemann zum* 9. *Oktober* 1960 (Munich, 1960), pp. 279–300; H. Wille, 'Die Debutades-Erzählung in der Kunst der Goethezeit', *Jahrbuch der Sammlung Kippenberg*, N. F., II (1970), pp. 328–51; E. Darragon, 'Sur Dibutade et l'origine du dessin', Coloquio Artes, II series, 52/1 (1982)

pp. 42–9; J.-Cl. Lebensztejn, *L'Art de la tache. Introduction à la* 'Nouvelle Methode' *d'Alexander Cozens* (Paris, 1990), pp. 277–300; H. Damisch, *Traité du Trait*, pp. 61–76.

5 A.-L. Girodet-Trioson, *Oeuvres posthumes* (Paris, 1829), I, p. 48.

6 J. H. Füssli, from *The Life and Writings of Henry Fuseli, Esq.*, ed. John Knowles, II, pp. 25, 26.

7 J. C. Lavater, *Physiognomische Fragmente zur Beförderung der Menschenkenntnis und Menschenliebe. Eine Auswahl*, (Stuttgart, 1984). Unless otherwise stated, all quotations from Lavater are taken from *Essays on Physiognomy* translated by Thomas Holcroft (here, pp. 187–8). Where the translator was unable to locate the English version, she undertook them herself, basing them on the French version.

8 Lavater, *Essays on Physiognomy*, pp. 188–9.

9 Lavater, *Essays on Physiognomy*, p. 65.

10 G. C. Lichtenberg, *Werke in einem Band* (Stuttgart, 1935), taken from the *Remarks on an Essay upon Physiognomy*, by Professor Lichtenberg, in Holcroft's edition of *Essays on Physiognomy*, p. 267.

11 J. C. Lavater, *Physiognomische Fragmente. Eine Auswahl*, p. 60 (translator's version).

12 J. P. Eckermann, *Gespräche mit Goethe in den letzten Jahren seines Lebens* (Munich, 1984), pp. 273–4 (17 February 1829).

13 For information regarding this problem, see E. Benz, 'Swedenborg und Lavater. Ueber die religiösen Grundlagen der Physiognomik', *Zeitschrift für Kirchengeschichte*, III Folge, LVII (1938), pp. 153–216, and B. M. Stafford, *Body Criticism: Imagining the Unseen in Enlightenment Art and Medicine* (Cambridge, MA, 1991), pp. 84–103; E. Shookman, ed., *The Faces of Physiognomy: Interdisciplinary Approaches to Johann Caspar Lavater* (Drawer/Columbia, 1993); K. Pestalozzi and H. Weigelt, *Das Antlitz Gottes im Antlitz des Menschen. Zugänge zu Johann Kaspar Lavater* (Göttingen, 1994).

14 J. C. Lavater, *Physiognomische Fragmente zur Beförderung der Menschenkenntnis und Menschenliebe*, II (Leipzig and Winterthur, 1776) p. 132 (translator's version).

15 J. C. Lavater, *Essays on Physiognomy*, (*Physiognomische Fragmente zur Beförderung der Menschenkenntnis und Menschenliebe*), IV (Leipzig and Winterthur, 1778), p. 390.

16 J. C. Lavater, *Physiognomische Fragmente. Eine Auswahl*, p. 275 (translator's version).

17 See the texts ins C. Steinbrucker, *Lavaters Physiognomische Fragmente im Verhältnis zur bildenden Kunst* (Berlin, 1915), p. 168.

18 A. Cozens, *Principles of Beauty, Relative to the Human Head* (London, 1778), pp. 1–3 and 7–10.

19 E. Burke, *A Philosophical Enquiry into the Origins of our Ideas of the Sublime and Beautiful* (London, 1757), Part II, sections XIV-XVII.

20 Lavater, *Essays on Physiognomy*, p. 47.

21 Lavater, *Physiognomische Fragmente. Eine Auswahl*, pp. 377–94 (translator's version).

22 G. Gessner, *Johann Kaspar Lavaters Lebensbeschreibung von seinem Tochtermann G. G.*, 3 vols (Winterthur, 1802–10); R. C. Zimmermann, *Das Weltbild des jungen Goethe* (Munich, 1969–79), II, pp. 213–34.

23 For example C. A. Peuschel, *Abhandlung der Physiognomie, Metoskopie und Chiromantie* (1769).

24 See H. D. Kittsteiner, 'Die Abschaffung des Teufels im 18. Jahrhundert. Ein kulturhistorisches Ereignis und seine Folgen', in A. Schuller and W. von Rahden, eds, *Die andere Kraft. Zur Renaissance des Bösen* (Berlin, 1993), pp. 55–92.

25 Anon. (C. W. Kindleben), *Ueber die Non-Existenz des Teufels. Als Antwort auf*

die demüthige Bitte um Belehrung an die grossen Männer, welche an keinen Teufel glauben, (Berlin, 1776), pp. 4 and 17ff.

26 C. W. Kindleben, *Der Teufelein des achtzehnten Jahrhunderts letzter Akt ...* (Leipzig, 1779), p. 50.

27 H. D. Kittsteiner, 'Die Abschaffung des Teufels im 18. Jahrhundert', p. 73.

28 J. C. Lavater, Von der *Physiognomik* (Leipzig, 1772), p. 79.

29 D. Diderot, *Eléments de psychologie* (1778), ed. J. Mayer (Paris, 1964), p. 266. Regarding this issue, see B. M. Stafford, 'From "Brilliant Ideas" to "Fitful Thoughts": Conjecturing the Unseen in Late Eighteenth-century Art', *Zeitschrift für Kunstgeschichte*, XLVIII (1985), pp. 329–63 (here p. 345).

30 On this question, see W. Sauerländer, 'Überlegungen zu dem Thema Lavater und die Kunstgeschichte', *Idea*, VII (1988), pp. 15–30.

31 J. C. Lavater, *Physiognomische Fragmente zur Beförderung der Menschenkenntnis und Menschenliebe*, I (Leipzig and Winterthur, 1775), (Lavater's underlining) p. 134 (translator's version).

32 See Reference 7 above.

33 Adelbert von Chamisso, *Pierre Schlémihl* (Paris, 1822) (translator's version). [Translator's note: the preface to the French edition did not appear in the English version from which the quotations to follow have been taken.]

34 It is possible to consult G. von Wilpert, *Der verlorene Schatten. Varianten eines literarischen Motivs* (Stuttgart, 1978); D. Walach, ed., *Adelbert von Chamisso. Peter Schlemihls wundersame Geschichte. Erläuterungen und Dokumente* (Stuttgart, 1987).

35 All the quotations are taken from *The Wonderful History of Peter Schlemihl* (London, 1954).

36 Achim von Arnim, *Jemand und Niemand. Ein Trauerspiel* (1813), *Achims von Arnim Sämtliche Werke*, VI (Berlin, 1840), pp. 109–38.

37 Since this interpretation does not seem to have been taken into account by German scholars and is in danger of being ignored, I would like to point out that the English linguistic system is fundamental to the plot of Peter Schlemihl (the name of our hero's main enemy being Rascal).

38 My point of departure was R. Lehmann's thesis: *Der Mann ohne Schatten in Wort und Bild. Illustrationen zu Chamissos 'Peter Schlemihl' im 19. und 20. Jahrhundert* (Frankfurt am Main, 1995), although I do not accept all his conclusions.

39 I. Kant, *Logik, Werke*, VIII (Berlin, 1923) p. 343. See also M. Foucault, *Les Mots et les choses. Une archéologie des sciences humaines* (Paris, 1966) p. 352.

40 J. Baudrillard's term, *L'échange symbolique et la mort* (Paris, 1976), p. 216ff.

CHAPTER 6

1 This questioning comes from Yve-Alain Bois, 'Malévich, le carré, le degré zéro', *Macula*, I (1976), pp. 28–49 (here p. 49).

2 El Lissitzky, 'New Russian Art: A Lecture', in Sophie Lissitzky-Küppers, *El Lissitzky* (London, 1969), p. 333.

3 K. Malevich, *Manifesto of Suprematism* (St Petersburg, 1915), Malevich's underlining. See also F. Ph. Ingold, 'Welt und Bild. Zur Begründung der suprematistischen Aesthetik bei Kazimir Malevič', in G. Boehm, ed., *Was ist ein Bild?* (Munich, 1994), pp. 367–410.

4 I used the German version of the text that appears in the exhibition catalogue *Sieg über die Sonne. Aspekte russischer Kunst zu Beginn des 20. Jahrhunderts* (Berlin, 1983), pp. 53–73. See also C. Douglas, *Swans of Other Worlds. Kazimir Malevich and the Origins of Abstraction in Russia* (Ann Arbor, 1980), pp. 35–47; W. Sherwin Simmons, *Kasimir Malevich's Black Square and the Genesis of Suprematism 1907–1915* (New York and London, 1981). J. A. Isaak, *The Ruin of Representation in Modernist Art and Texts* (Ann Arbor, 1986), pp. 75–85, and H. Günther, 'Die Erstaufführung der

futuristischen Oper "Sieg über die Sonne" ', *Wallraf-Richartz-Jahrbuch*, LIII (1992), pp. 189–207.

5 Letter quoted by J. Kowtun, 'Sieg über die Sonne. Materialien', in the catalogue *Sieg über die Sonne*, p. 49.

6 I am grateful to P. Garlach for this example, 'Zeichenhafte Vermittlung von Innenwelt in konstruktivistischer Kunst', in H. Holländer and C. W. Thomsen, eds., *Besichtigung der Moderne: Bildende Kunst, Architektur, Musik, Literatur, Religion. Aspekte und Perspektive* (Cologne, 1986), pp. 157–90. For other related examples, see D. Riout, *La Peinture Monochrome. Histoire et archéologie d'un genre* (Nîmes, 1996), pp. 167–245.

7 The most recent studies are Fr. Teja Bach, 'La Photographie de Brancusi' in the exhibition catalogue *Constantin Brancusi 1876–1957* (Paris, 1995), pp. 312–20, E. A. Brown, *Constantin Brancusi photographe* (Paris, 1995), and A.-Fr. Penders, *Brancusi, la photographie* (Brussels, 1995). For the 'Beginning of the World' and Malevich's Suprematism see F. Teja Bach, *Constantin Brancusi: Metamorphosen plastischer Form* (Cologne, 1987), p. 192.

8 R. Payne, 'Constantin Brancusi', *World Review* (October 1949), p. 63.

9 Man Ray, *Self Portrait* (New York, 1979), p. 208.

10 From Nietzsche's *The Gay Science*, trans. W. Kaufmann (New York, 1974), pp. 273–4. The 'Platonic reversal' was one of Nietzsche's expressions (and metaphysical projects). Concerning 'reversal' as the appearance of likenesses, see G. Deleuze, *Logique du sens* (Paris, 1969), pp. 292–307). Concerning Brancusi and Plato, see C.-R. Velescu, *Brâncuşi iniţiatul* (Bucharest, 1993).

11 See M. Foresta u. a., *Perpetual Motif: The Art of Man Ray* (New York, 1988), p. 77.

12 The account is given by A. Schwarz, *The Complete Work of Marcel Duchamp* (New York, 1970), p. 471. Regarding *Tu m'*, see T. Lenain, 'Le Dernier tableau de Marcel Duchamp. Du trompe-l'oeil au regard Désabusé', *Annales d'histoire de l'art et archéolgie* [Brussels], VI (1984), pp. 79–104; R. Krauss, *Le Photographique*, pp. 70–87; K. Lüdeking, 'Über den Schatten', *Tumult*, XIV (1990). See also the more recent book by J. A. Ramìrez, *Duchamp, el amor y la muerte, incluso* (Madrid, 1994), p. 62.

13 Schwarz, *The Complete Work*, p. 471.

14 M. Duchamp, *The Essential Writings of Marcel Duchamp*, ed. M. Sanouillet and E. Peterson (London, 1975), p. 72.

15 Regarding this problem, see J. Clair, *Duchamp et la photographie* (Paris, 1977).

16 See Lüdeking, 'Ueber den Schatten', p. 98.

17 Lenain, 'Le Dernier tableau de Marcel Duchamp', p. 97.

18 Lenain, 'Le Dernier tableau de Marcel Duchamp', p. 102, and Krauss, *Le Photographique*, p. 80.

CHAPTER 7

1 C. Boltanski, *Inventar* (Hamburg, 1991), pp. 73–5.

2 I am relying on material collected and presented by P. S. Smith, *Andy Warhol's Art and Film* (Ann Arbor, 1986), pp. 198–202.

3 For more information on this idea, consult O. Bätschmann's book (forthcoming).

4 C. Richey, in *Artforum*, XVII (April 1979), p. 73. It should be noted that other authors have a different way of referring to the number of canvasas (67 + 16). See D. Bourdon, *Andy Warhol* (New York, 1989), p. 372.

5 For information on the Warhol and De Chirico relationship, see D. Kuspit's comments in *The Cult of the Avant-Garde Artist* (Cambridge and New York, 1993), pp. 67ff.

6 'Industrial metaphysics. Interview with Andy Warhol by Achille Bonito Oliva', in A. Bonito Oliva, ed., *Warhol verso de Chirico* (Milan, 1982), p. 70.

7 De Chirico, letter to F. Gratz quoted by G. Roos, 'Giorgio de Chirico und seine Malerfreunde Fritz Gratz, Georgios Busianis, Dimitrios Pikionis in München 1906–1909, in W. Schmied and G. Roos, *Giorgio de Chirico München 1906–1909* (Munich, 1994), p. 177.

8 See Soby, *Giorgio de Chirico*, p. 245.

9 Nietzsche, *Ecce Homo*, xv, 65.

10 Nietzsche, *Gaya Scienza*, 341.

11 G. Deleuze, *Logique du sens*, pp. 292–307. See also T. Lenain, *Pour une critique de la raison ludique. Essai sur la problématique nietzschéenne* (Paris, 1993), pp. 112–43.

12 Andy Warhol quoted by P. S. Smith, *Andy Warhol's Art and Films*, p. 202.

13 An expression of G. Bandman, 'Bemerkungen zu einer Ikonologie des Materials', *Städel Jahrbuch*, N. F. 2 (1969), pp. 75–100. See also T. Raff, *Die Sprache der Materialien. Anleitung zu einer Ikonologie der Werkstoffe* (Munich, 1994), and on A. Warhol in particular, 'Do it Yourself: Notes on Warhol's Techniques', in K. McShine, ed., *Andy Warhol. A Retrospective* (New York and Boston, 1986), pp. 63–80.

14 Regarding this problem, see C. F. Stuckey, 'Andy Warhol's Painted Faces', *Art in America*, 68 (May 1980), pp. 112–19 and more particularly R. A. Steiner, 'Die Frage nach der Person. Zum Realitätscharakter von Andy Warhols Bildern', *Pantheon*, xlii (1984), pp. 151–7.

15 Warhol on De Chirico: 'Every time I saw him I had the feeling I had always known him. I think he felt the same way ... He once remarked on the fact that we both had white hair!' ('Industrial metaphysics', p. 70).

16 We are pursuing the line of questionning recommended by Baudrillard, *L'Echange symbolique et la mort*, pp. 110–21 and 216–20.

17 Date discovered by A. Brown, *Andy Warhol: His Early Works, 1947–1959* (New York, 1971).

18 See also G. Deleuze, *Différence et Répétition* (Paris, 1968), pp. 164–8 and Deleuze, *Logique du sens*, pp. 292–307.

19 On this subject see the explanation given by the artist himself in P. Klee, *Das bildnerische Denken. Form- und Gestaltungslehre*, i (Basle and Stuttgart, 1971), pp. 330–32.

20 See R. Brilliant, *Portraiture* (London, 1991), pp. 171–4, as well as C. van Schoonbeek's comments, 'Alfred Jarry, un oublié de l'histoire de l'art', *Annales d'Histoire de l'Art et d'Archéologie. Université Libre de Bruxelles*, xvii (1995), pp. 94–6.

21 See J. Baudrillard, *L'Echange symbolique et la mort*, p. 113; R. A. Steiner, 'Die Frage nach der Person'.

22 Quotation taken from G. Berg, 'Andy: My True Story', *Los Angeles Free Press* (17 March 1967), p. 3.

23 Quotation taken from Berg, 'Andy: My True Story', p. 3. See also the research done by B. H. D. Buchloh, 'Andy Warhol's One-Dimensional Art: 1956–1966', in K. McShine, ed., *Andy Warhol: A Retrospective* (New York and Boston, 1986), pp. 39–61.

24 For the complete documentation concerning this action (including the debates surrounding its date) see U. M. Schneede, *Joseph Beuys. Die Aktionen. Kommentiertes Werkverzeichnis mit fotografischer Dokumentation* (Stuttgart, 1994), pp. 306–11.

25 U. Klophaus, *Sein und Bleiben. Photographie zu Joseph Beuys* (Bonn, 1986), p. 57. Other accounts are in U. M. Scheede, *Joseph Beuys. Die Aktionen.*, pp. 306ff.

26 Ute Klophaus, in a letter addressed to the author, dated 4 March 1996.

27 L. Nochlin, 'Gustave Courbet's "Meeting": A Portrait of the Artist as a Wandering Jew', *Art Bulletin*, (1967), pp. 209–22.

28 *Correspondance complète de Vincent van Gogh enrichie de tous les dessins originaux*, iii (Paris, 1960), p. 173.

29 See A. Gasten, 'Vincent van Gogh in Contemporary Art', in K. Tsukasa and Y. Rosenberg, eds., *The Mythology of Vincent van Gogh* (Asabi, 1993), pp. 100–08.

30 W. Uhde, *Vincent van Gogh* (Vienna and London, 1936), p. 7.

31 Quotation taken from J. Russell, *Francis Bacon* (London, 1971), p. 91.

32 Quotation taken from D. Ashton, *Twentieth-century Artists on Art* (New York, 1985), p. 139.

33 L. B. Alberti, *De Pictura/On Painting* (Book I), pp. 55—6.

34 See J. Masheck, 'Alberti's "Window": Art-historiographic Notes on an Antimodernist Misprision', *Art Journal*, L (1991), pp. 34–41.

35 From R. Stachelhaus's biography, *Joseph Beuys* (Dusseldorf, 1988), pp. 94ff. Beuys himself acknowledged his Shaman characteristics and spoke about them openly. See D. Kuspit, *The Cult of the Avant-Garde Artist*, pp. 83–99.

36 The work is that of M. Eliade, *Le chamanisme et les techniques archaïques de l'extase* [1951] (Paris, 1983). The theory that Beuys would have been familiar with the 1957 German edition can be found in S. Bocola, *Die Kunst der Moderne. Zur Struktur und Dynamik ihrer Entwicklung. Von Goya bis Beuys* (Munich and New York, 1994), p. 534.

37 Eliade, *Le chamanisme*, pp. 151, 342, 369.

38 See Scheede, *Joseph Beuys. Die Aktionen*, p. 307.

39 Quotation from a 1970 interview reported by Schneede in *Joseph Beuys. Die Aktionen*, p. 309.

40 Eliade, *Le Chamanisme*, p. 135.

41 Account reiterated by Schneede, *Joseph Beuys. Die Aktionen*, p. 306.

42 Regarding the notion of predetermination (*Überdeterminierheit*), see S. Freud, *Die Traumdeutung* [The Interpretation of Dreams, 1900] (*Studiensausgabe*, II, Frankfurt am Main, 1972), pp. 286–308.

43 M. Mauss, *A General Theory of Magic*, trans. from the French by Robert Brain (London, 1972), p. 19.

44 Eliade, *Le Chamanisme*, pp. 179ff.

45 Mauss, *A General Theory of Magic*, III; Eliade, *Le Chamanisme*, pp. 241–2.

List of Illustrations

all dimensions in centimetres

1 The soul and the shadow coming out of the grave at daybreak, *c.* 1400 BC, ch. 92 of the papyrus of Neferoubenef, Musée du Louvre, Paris.

2 Attic black-figure pyxis, *c.* 580-570 BC, 12.5 *cm* high. Musée du Louvre, Paris.

3 A detail from Girolamo Mocetto, *Narcissus at the Pool*, before 1531, tempera on wood. Musée Jacquemart-André, Paris. Photo: Photographie Bulloz

4 Antonio Tempesta, *Narcissus at the Well*, plate 28 from an edition of Ovid's *Metamorphoses* of 1606, engraving, 97 x 115. British Library, London.

5 Advertisement for Chanel perfume *Égoïste 'Platinum'*, 1994. Courtesy Chanel, Paris, © 1997 Chanel.

6 Giorgio Vasari, *The Origin of Painting*, 1573, fresco. Casa Vasari, Florence. Photo: Gabinetto Fotografico, Soprintendenza per I Beni Artistici e Storici, Florence

7 Bartolomé Esteban Murillo, *The Origin of Painting*, *c.* 1660–65, oil on canvas, 115 x 169. Muzeul National da Arta, Bucharest.

8 Giovanni di Paolo, *The Flight into Egypt*, 1436, tempera on wood, 50 x 50.7. Pinacoteca Nazionale di Siena. Photo: Soprintendenza per I Beni Artistici e Storici, Siena.

9 Giovanni di Paolo, illustration to Dante's *Paradiso*, canto 11, *c.* 1450. British Library, London.

10 A detail from Giotto, *Adoration of the Magi*, 1304–6, fresco. Scrovegni Chapel, Padua. Photo: Istituto Centrale per il Catalogo e la Documentazione, Rome

11 Leonardo da Vinci, study of shadow projection, from Ms C fol. 9r, *c.* 1492, 31.7 x 22. Bibliothèque de l'Institut de France, Paris. Photo: Photographie Bulloz

12 Albrecht Dürer, study of shadow projection, from the 1st edition of his *Underweysung der Messung...*, 7.5 x 21.5, Nuremberg, 1525.

13 Leonardo da Vinci, study of shadow projection, from Ms A fol. 93v, *c.* 1492, 14.5 x 22. Bibliothèque de l'Institut de France, Paris. Photo: Photographie Bulloz

14 School of Leonardo da Vinci, study of shadow projection, fol. 9or of the Codex Huyghens (MA 1139), after 1500, 23.2 x 18.3. The Pierpont Morgan Library, New York. Photo: David A. Loggie

15 Filippo Lippi, *Annunciation*, *c.* 1440, tempera on wood, 175 x 183. S Lorenzo, Florence. Photo: Gabinetto Fotografico, Soprintendenza per I Beni Artistici e Storici, Florence

16 Masaccio, *St Peter Healing the Sick with his Shadow*, 1426–7, fresco, 230 x 162. Brancacci Chapel, Santa Maria del Carmine, Florence. Photo: Scala

17 Filippo Lippi, *Annunciation*, *c.* 1440, tempera on wood, two panels, each 64 x 23. Frick Collection, New York.

18 A detail from illus. 17.

19 Jan van Eyck, *Annunciation*, 1437, oil on wood, two panels, each 27.5 x 8.

Gemäldegalerie Alte Meister, Dresden. Photo: Staatliche Kunstsammlungen Dresden

20 Konrad Witz, *Adoration of the Magi*, 1444, wing from a polyptych of *St Peter*, tempera on wood, 132 x 151. Musée d'Art et d'Histoire, Geneva. Photo: Yves Siza

21 Rogier van der Weyden, *The Virgin and Child*, c. 1433, oil on wood, 14.2 x 10.2. © Fundación Colección Thyssen-Bornemisza, Madrid.

22 Martin van Heemskerck, *St Luke Painting the Virgin's Portrait*, c. 1553, tempera on wood, 205.5 x 143.5. Musée des Beaux-Arts et d'Archéologie, Rennes. Photo: Louis Deschamps

23 Marie-Louise Elisabeth Vigée-Lebrun, *Self-portrait*, 1790, oil on canvas, 100 x 81. Uffizi, Florence. Photo: Scala

24 A detail from illus. 15.

25 Pier Maria Pennacchi, *The Redeemer Blessing*, c. 1500, oil on wood, 141 x 68. Galleria Nazionale, Parma. Photo: Gabinetto Fotografico, Soprintendenza per I Beni Artistici e Storici, Parma

26 Detail of illus. 22.

27 Giovan Pietro Bellori, engraved by Charles Errand, *Idea*, from Bellori's *Vite*, Rome, 1672.

28 Ciro Ferri, *The Drawing School*, c. 1665–75, drawing on paper. Galleria degli Uffizi, Florence.

29 Vicente Carducho, *Tabula Rasa*, engraving at the end of his *Dialogos de la pintura*, Madrid, 1633. Photo: Séminaire d'histoire de l'art, Fribourg

30 Gabriel Rollenhagen, *Nulla dies sine linea*, emblem from his *Nucleus Emblematum*, Paris, 1611. Photo: Séminaire d'histoire de l'art, Fribourg

31 Vicente Carducho, *Self-portrait*, c. 1633, oil on canvas, 91.9 x 85.1. The Stirling Maxwell Collection, Pollok House, Glasgow. Photo: Glasgow Museums and Art Galleries

32 Nicholas Poussin, *Self-portrait*, 1650, oil on canvas, 98 x 74. Musée du Louvre, Paris. Photo: Agence Photographique de la Réunion des Musées Nationaux

33 Sébastien LeClerc II, *Painting*, 1734, oil on canvas. Schloß Waldegg, Solothurn, Switzerland. Photo: Schweizerische Landesmuseum, Switzerland/Kantonale Denkmalpflege Solothurn/Jürg Stauffer/Historisches Museum Basel

34 Pierre Auguste Renoir, *The Pont des Arts, Paris*, c. 1867–8, oil on canvas, 62 x 103. Norton Simon Museum, Pasadena, CA. Photo: The Norton Simon Foundation, Pasadena, CA

35 Claude Monet, *Monet's Shadow on the Lily-Pond*, c. 1920, photograph, 4 x 5. Collection Philippe Piguet, Paris.

36 Claude Monet, *Water-lilies*, 1906, oil on canvas, 87.6 x 92.7. Art Institute of Chicago, Mr & Mrs Martin A. Ryerson Collection. Photo: © 1996, The Art Institute of Chicago, all rights reserved

37 Alfred Stieglitz, *Shadows on the Lake – Stieglitz and Walkowitz*, 1916, silver gelatin photograph, 11.3 x 8.9. Photo: National Gallery of Art, Washington, DC, Alfred Stieglitz Collection

38 André Kertész, *Self-portrait*, 1927, gelatin silver photograph, 20 x 19.8. J. Paul Getty Museum, Los Angeles; © Estate of André Kertész

39 Pablo Picasso, *Silhouette with a Young Girl Crouching*, dated 6 July 1940, oil on canvas, 162 x 130. Private collection. Photo: © Succession Picasso/DACS 1997

40 Pablo Picasso, *Sad Young Girl*, dated 10 June 1939, oil on canvas, 92 x 60. Private collection. Photo: © Succession Picasso/DACS 1997

41 Pablo Picasso, *Painter and Model*, 1928, oil on canvas, 130 x 163. Museum of Modern Art, New York, Sidney and Harriet Janis Collection. Photo: © Succession Picasso/DACS 1997

42 Albrecht Dürer, *The Draughtsman*, engraving for the 3rd and revised edition of his *Underweysung der Messung . . .*, 7.5 x 21.5, Nuremberg, 1538. Photo: Séminaire d'histoire de l'art, Fribourg

43 Johann Jacob von Sandrart, *The Invention of Painting*, engraving for p. 40 of Joachim von Sandrart's *Academia nobilissimae artis pictoriae*, Nuremberg, 1683. Photo: Séminaire d'histoire de l'art, Fribourg

44 Agostino Veneziano, *The Academy of Baccio Bandinelli*, 1531, engraving. Metropolitan Museum of Art, New York, The Elisha Whittelsey Collection, Elisha Whittelsey Fund.

45 Samuel van Hoogstraten, 'The Shadow Dance', engraving for p. 260 of his *Inleyding tot de Hooge Schoole der Schilderkonst*, Rotterdam, 1675. Photo: Séminaire d'histoire de l'art, Fribourg

46 Athanasius Kircher, *Parastatic Machine*, engraving for p. 905 of *Ars Magna Lucis et Umbrae*, Rome, 1656. Bayerische Staatsbibliothek, Munich.

47 Jacques de Gheyn II, *Three Witches Looking for Buried Treasure*, 1604, pen and ink with grey-brown wash, 28 x 40.8. Ashmolean Museum, Oxford.

48 Vasily Komar and Alexander Melamid, *The Origin of Socialist Realism* (from the 'Nostalgic Socialist Realism' series), 1982–3, oil on canvas, 72 x 48. Private collection. Photo: Ronald Feldman Fine Arts, Inc., New York/ D. James Dee

49 Eduard Daege, *The Invention of Painting*, 1832, oil on canvas, 176 x 135.5. National-Galerie, Berlin. Photo: Staatliche Museen zu Berlin Bildarchiv Preussischer Kulturbesitz

50 Johannes Sambucus, *Guilty Conscience*, engraving for his *Emblemata*, Antwerp, 1564. Photo: Séminaire d'histoire de l'art, Fribourg

51 Morris & Goscinny, *Lucky Luke* comic book, 1996. © Lucky Productions, 1996

52 William Rimmer, *Flight and Pursuit*, 1872, oil on canvas, 45.7 x 66.7. Museum of Fine Arts, Boston, Bequest of Miss Edith Nichols.

53 Giorgio de Chirico, *Melancholy and Mystery of a Street*, 1914, oil on canvas, 87 x 71.5. Private collection. © DACS 1997

54 Jean Dubreuil, *Study of Shadows*, engravings for p. 135 of volume I of *La Perspective practique*, Paris, 1651. Photo: Séminaire d'histoire de l'art, Fribourg

55 Gérard de Lairesse, *Study of Shadows*, engravings for pl. 22, p. 438 of volume I of *Le Grand Livre des peintres*, Paris, 1787. Photo: Séminaire d'histoire de l'art, Fribourg

56 A still from Robert Wiene and Willy Hameister's 1920 film *The Cabinet of Dr Caligari*.

57 A still from Friedrich Murnau's 1922 film *Nosferatu, a Symphony of Horror*.

58 Anne-Louis Girodet-Trioson, *The Origin of Drawing*, engraving from *Œuvres posthumes*, Paris, 1829. Photo: Séminaire d'histoire de l'art, Fribourg

59 Thomas Holloway et al., *Machine for Drawing Silhouettes*, engraving for p. 179 of part I of volume II of Lavater's *Essays on Physiognomy*, London, 1792. Photo: Séminaire d'histoire de l'art, Fribourg

60 Anonymous engraving, *The Soul of Man*, for pl. 42 of Jan Comenius, *Orbis Sensualium Pictus*, Nuremberg, 1629. Photo: Séminaire d'histoire de l'art, Fribourg

61 Johann Caspar Lavater, *Physiognomical Study*, Leipzig and Winterthur, 1776. Photo: Séminaire d'histoire de l'art, Fribourg

62 Alexander Cozens, *Simple Beauty*, engraving for Pl. 1 of his *Principles of Beauty, Relative to the Human Head*, London, 1777–8. Photo: Séminaire d'histoire de l'art, Fribourg

63 Johann Caspar Lavater, *Physiognomical Study of the Apollo Belvedere*. Photo: Séminaire d'histoire de l'art, Fribourg

64 Thomas Holloway, after Fuseli, *Silhouettes of Christ*, engraving for p. 212

of part I of volume II of Lavater's *Essays on Physiognomy* (London, 1792). Photo: Séminaire d'histoire de l'art, Fribourg

65 Johann Caspar Lavater, *Satyr in front of Silhouettes*, 1776, engraving.

66 George Cruikshank, *The Man in Grey Seizes Peter Schlemihl's Shadow*, engraving for *Peter Schlemihl* (London, 1824, 2nd edition 1827), Sir John Bowring's English translation of Adelbert von Chamisso's *Peter Schlemihls wundersame Geschichte*, 1814.

67 Adolf Schrödter, *The Man in Grey Seizes Peter Schlemihl's Shadow*, engraving for Chamisso's *Peter Schlemihls wundersame Geschichte*, Leipzig, 1836. Photo: Séminaire d'histoire de l'art, Fribourg

68 Adolf Menzel, *The Man in Grey Seizes Peter Schlemihl's Shadow*, engraving for Chamisso's *Peter Schlemihl*, Nuremberg, 1839. Photo: Séminaire d'histoire de l'art, Fribourg

69 Scene from Walt Disney's *Peter Pan*, 1953. © Disney, by special permission.

70 George Cruikshank, *The Man in Grey Offers Peter Schlemihl his Shadow in exchange for his Soul*, engraving from the 1827 London edition of *Peter Schlemihl*. Photo: Séminaire d'histoire de l'art, Fribourg

71 Adolf Menzel, *The Pursuit of the Shadow*, engraving from the 1839 Nuremberg edition of *Peter Schlemihl*. Photo: Séminaire d'histoire de l'art, Fribourg

72 George Cruikshank, *The Pursuit of the Shadow*, engraving from the 1827 London edition of *Peter Schlemihl*. Photo: Séminaire d'histoire de l'art, Fribourg

73 Adolf Schrödter, *The Struggle with the Shadow*, engraving from the 1836 Leipzig edition of *Peter Schlemihl*. Photo: Séminaire d'histoire de l'art, Fribourg

74 George Cruikshank, *Peter Schlemihl throws the Purse into the Abyss*, engraving from the 1827 London edition of *Peter Schlemihl*. Photo: Séminaire d'histoire de l'art, Fribourg

75 George Cruikshank, *Peter Schlemihl flies over the Seas*, engraving from the 1827 London edition of *Peter Schlemihl*. Photo: Séminaire d'histoire de l'art, Fribourg

76 George Cruikshank, *Peter Schlemihl at the North Pole*, engraving from the 1827 London edition of *Peter Schlemihl*. Photo: Séminaire d'histoire de l'art, Fribourg

77 Adolf Schrödter, *Peter Schlemihl throws the Purse into the Abyss*, engraving from the 1836 Leipzig edition of *Peter Schlemihl*. Photo: Séminaire d'histoire de l'art, Fribourg

78 Adolf Menzel, *Peter Schlemihl in the Grotto in the Thebaïd*, engraving from the 1839 Nuremberg edition of *Peter Schlemihl*. Photo: Séminaire d'histoire de l'art, Fribourg

79 Johann Ehrenfried Schumann, *Goethe Studying a Silhouette*, 1778, oil on canvas, 51.5 x 40. Freies Deutsches Hochstift-Goethe Museum, Frankfurt. Photo: Ursula Edelmann

80 Francisco de Goya, *Diogenes*, 1814–23, ink-wash drawing, 20.5 x 14. Museo del Prado, Madrid.

81 Kazimir Malevich, *Black Square*, 1915, oil on canvas, 79.5 x 79.5. State Tretyakov Gallery, Moscow.

82 'Cham' (Amédée de Noë), engraving for pl. 27–28 of *L'Histoire de Monsieur Jobard*, Paris, 1839. Photo: Séminaire d'histoire de l'art, Fribourg

83 Constantin Brancusi, photograph of his sculpture *Beginning of the World*, c. 1920. Photo: Documentations Photographiques des Collections du Musée National d'Art Moderne, Paris © ADAGP, Paris and DACS, London 1997

84 Constantin Brancusi, photograph of his sculpture *Prometheus*, 1911. Photo: Documentations Photographiques des Collections du Musée

National d'Art Moderne, Paris © ADAGP, Paris and DACS, London 1997

85 Man Ray, *Man*, 1917–18, silver print photograph. Musée National d'Art Moderne, Paris. © Man Ray Trust/ADAGP, Paris and DACS, London 1997

86 Marcel Duchamp, *Tu m'*, 1918, oil on canvas with bottle brush, three safety pins and a bolt, 69.8 x 313. Yale University Art Gallery, New Haven, gift from the Estate of Katherine Dreier. Photo: Joseph Szaszfai

87 (?)Marcel Duchamp, *Shadows of a Readymade*, 1918, photograph taken in his studio at 33 West 67th Street, New York.

88 Christian Boltanski, *Shadows* (1986), installation at the Kunsthalle Hamburg, 1991. Photo: courtesy of the artist

89 Andy Warhol, *Shadow*, one of 102 canvases in a group installation, 1979, silkscreen ink on synthetic polymer paint on canvas, 193 x 132.1. Dia Art Foundation, New York. Photo: © The Andy Warhol Foundation for the Visual Arts/ARS, NY and DACS London 1997

90 Gianfranco Gorgoni, *Andy Warhol and Giorgio de Chirico, N.Y.C.*, c. 1974, photograph.

91 Andy Warhol, *Italian Square with Ariadne (after De Chirico)*, 1982, synthetic polymer paint and silkscreen ink on canvas, 116 x 127. Andy Warhol Museum, Pittsburgh. Photo: © 1996 The Andy Warhol Foundation for the Visual Arts/ARS, NY and DACS London 1997

92 Pablo Picasso, *The Shadow on the Woman*, dated 29 December 1953, oil on canvas, 130.8 x 97.8. Art Gallery of Ontario, Toronto, gift of Sam and Ayala Zacks. Photo: © Succession Picasso/DACS 1997

93 Pablo Picasso, *The Shadow*, dated 29 December 1953, oil and charcoal on canvas, 129.5 x 96.5. Musée Picasso, Paris. Photo: © Succession Picasso/DACS 1997

94 Andy Warhol, *Shadows*, 1978, installation at the Andy Warhol Museum, Pittsburgh (on loan from the Dia Art Foundation, New York), silkscreen ink and synthetic polymer paint on canvas, rotating installation showing 55 of 102 canvases, each 193 x 132.1. Photo: The Andy Warhol Foundation for the Visual Arts/© ARS, NY and DACS London 1997

95 Vincent van Gogh, *The Artist-Painter on the Road to Tarascon*, 1888, oil on canvas, 48 x 44. Formerly in the Kaiser Friedrich Museum, Magdeburg; now destroyed.

96 Francis Bacon, *Study for Portrait of Van Gogh II*, 1957, oil on canvas, 198 x 142. Private collection. Photo: Prudence Cuming, courtesy Marlborough Gallery

97 Andy Warhol, *The Shadow*, 1981, silkscreen print on paper, 96.5 x 96.5. Courtesy Ronald Feldman Fine Arts, Inc., New York/© The Andy Warhol Foundation for the Visual Arts/ARS, NY and DACS London 1997

98 Andy Warhol, *Self-portrait*, 1978, silkscreen ink and synthetic polymer paint on canvas, two joined panels, each 102.6 x 102.6. Dia Centre for the Arts, New York. Photo: Paul Hester; © The Andy Warhol Foundation for the Visual Arts/ARS, NY and DACS London 1997

99 Andy Warhol, *Double Mickey Mouse*, 1981, silkscreen print (from a limited edition of 25, some with diamond dust), 77.5 x 109.2. Courtesy Ronald Feldman Fine Arts, Inc., New York; Photo: © The Andy Warhol Foundation for the Visual Arts/ARS, NY and DACS London 1997

100 Paul Klee, *Physiognomic Flash*, 1927, watercolour, 25.4 x 25.4. Private collection. Photo: Paul-Klee-Stiftung, Kunstmuseum Bern © DACS 1997

101 Giorgio de Chirico, *Self-portrait*, 1920, tempera on canvas, 60 x 50.5. Private collection. © DACS 1997

102 Arnold Böcklin, *Self-portrait in the Studio*, 1893, varnished distemper on canvas, 120.5 x 80.5. Öffentliche Kunstsammlung, Basel (Kunstmuseum). Photo: Martin Bühler

103 Marcel Duchamp, replica of *Wanted: $2000 Reward*, 1923, from *Boîte-en-Valise*. Philadelphia Museum of Art, Louise and Walter Arensberg Collection.
104 Marcel Duchamp, frontispiece for Robert Lebel, *Sur Marcel Duchamp*, Paris, 1959.
105 Marcel Duchamp, *Profile Self-portrait*, 1959.
106 Victor Obsatz, composite photograph of Marcel Duchamp, 1953.
107 Ute Klophaus, *Action Dead Mouse*, one of a series of photographs documenting Joseph Beuys and Terry Fox's performance *Isolation Unit*, Düsseldorf, 24 November 1970. © Ute Klophaus © ProLitteris, Zurich
108 Paul Gavarny, 'The Wandering Jew', illustration for Eugène Sue, *Le Juif Errant*, Paris, 1845.
109 Gustave Courbet, *The Meeting (Good Morning, Mr Courbet!)*, 1854, oil on canvas, 129 x 149. Musée Fabre, Montpellier. Photo: Frédéric Jaulmes
110 Marcel Duchamp, *Fresh Widow*, 1920, miniature French window, painted wood frame, and eight panes of glass covered with black leather, 77.5 x 44.8. Museum of Modern Art, New York, Katherine S. Dreier Bequest.